THE ARTIST'S REALITY

EDITED AND WITH AN INTRODUCTION BY CHRISTOPHER ROTHKO

YALE UNIVERSITY PRESS
NEW HAVEN AND LONDON

MARK ROTHKO

THE ARTIST'S REALITY PHILOSOPHIES OF ART

Designed by Daphne Geismar
Set in Minion and Syntax type by Amy Storm
Printed and bound in the USA by Thomson Shore
Color insert by Thames Printing Company, Inc.

Jacket illustrations: (front) Manila folder with Mark
Rothko's handwritten notation "Artists Reality";
(back) Mark Rothko in his studio, 1945–46

Library of Congress Cataloging-in-Publication Data
Rothko, Mark, 1903–1970.
 The artist's reality: philosophies of art / Mark Rothko;
edited and with an introduction by Christopher Rothko.
 p. cm.
Includes index.
ISBN 0-300-10253-4 (cloth: alk. paper)
1. Rothko, Mark, 1903–1970—Written works. 2. Rothko,
Mark, 1903–1970—Philosophy. 3. Painting—Philosophy.
I. Rothko, Christopher. II. Title.
ND237.R725A35 2004
759.13—dc22
2004011574

A catalogue record for this book is available from the
British Library.

The paper in this book meets the guidelines for perma-
nence and durability of the Committee on Production
Guidelines for Book Longevity of the Council on Library
Resources.

10 9 8 7 6 5 4 3 2 1

FOR KATE, WITHOUT WHOM THERE WOULD HAVE BEEN NOTHING

CONTENTS

Acknowledgments

I would like to thank the following people for their help and support: Marion Kahan for the ultimate discovery; Janet Saines for her excellent advice; Melissa Locker, Lauren Fardig, and Amy Lucas for their research; Ilya Prizel; and William and Sally Scharf for their many years of wisdom and care.

I also wish to thank the staff at Yale University Press, particularly Patricia Fidler for her enthusiasm and vision, Michelle Komie for her guidance and tireless transcription, Jeffrey Schier for his sensitive editing, John Long for his handling of the photographs, Mary Mayer for her production work, Daphne Geismar for her great modernist design, and Julia Derish, an exceptional sleuth for elusive facts.

I thank especially my wife, Lori Cohen, and children, Mischa, Aaron, and Isabel, for their continual inspiration.

Christopher Rothko

Introduction

CHRISTOPHER ROTHKO

THE BOOK. It was something of a legend to me, resting just on the periphery of my consciousness. It had a weightiness and grandeur that probably exceeded its contents and that were fueled no doubt by its very insubstantiality. There is nothing like mystery to swell the dimensions of the unknown or the dimly glimpsed, and in the murky and turbulent waters left in my father's wake there was indeed little that was certain to grasp.

Legends, of course, are often based on fact, but since I had never seen the book I could not know where story ended and truth began. Some of the book's aura no doubt came from my father, although little of it directly. It may have been filtered through my mother, who came on the scene not long after my father had ceased wrestling with the book. They spoke of it, but certainly not often, to friends and colleagues, but never to my sister or me. The sense of mystery surrounding the book was greatly reinforced during the battle for my father's papers that quickly followed his death in 1970. In those circumstances, the importance of this still unseen manuscript swelled to Herculean proportions.

This was part of the legacy my sister and I were left in the aftermath of our parents' sudden and unexpected deaths. It took nearly two decades to add voice to the whispers that first told us of the book. And it has taken fully thirty-four years to unwrap and then explore the full extent of the manuscript. Now that it is an edited and cleanly typeset document, a published entity, one can easily lose sight of its former state. But for most of my life, cobwebs were more visible than underlying substance.

All of this history of shadow and rumor has a certain irony in the context of my father's artwork. His best-known paintings are large and vibrant and decidedly iconic. They command attention in an immediate and physical way that this small stack of crumbling, haphazardly typed sheets could not hope to duplicate. His work communicates on a level that is explicitly preverbal. Indeed, it would be hard to find less-narrative painting. Like music, my father's artwork seeks to express the inexpressible—we are far removed from the realm of words. From their lack of identifiable figures or space to their lack of titles, my father's paintings make clear that reference to things outside the painting itself

is superfluous. The written word would only disrupt the experience of these paintings; it cannot enter their universe.

And yet these writings compel and fascinate us in a way that my father surely would have wanted. Far from discarding this book he never finished and that he wrote before his still unborn, boldly abstract style had brought him fame, my father guarded it and, consciously or unconsciously, stoked the fires of interest in all those who heard murmurs of its existence. His words might be outside his artwork, but they communicate philosophies he still held dear even after paint became his sole vehicle for expression.

One reason this book holds such fascination is that Rothko was explicitly a painter of ideas. He said so himself, over and over, and one can feel them percolating beneath the surface of his otherwise somewhat amorphous abstractions. Indeed, one can ask, if ideas do not exist here, what else is there? But just what might those ideas be? The paintings themselves hold only the most general clues, and no small number of viewers have found themselves sensually stimulated but deeply frustrated by the works' very abstractness. With little concrete to grasp, many have walked away from the works—moved or angered— assuming that, in fact, they must be voids.

So to have in hand a book by Rothko—and not just a book, but one that sets forth his philosophy of art—is truly a gift for those captivated by his work. It is like being given the keys to a mystical city that one has been able to admire only from afar.

Or is it?

As with all things regarding my father, the truth is more elusive, even dialectic. First of all, not once in *The Artist's Reality* does he discuss his own work directly. In fact, he never even alludes to it or to the fact that he is an artist. Secondly, the book was written several years before his work became fully abstract, so if he provides clues to the secrets of his floating rectangular forms, they are oblique and, in fact, prescient. In any case, the book does not address what paintings mean, or how to go about finding that meaning. Its essays tell us about what the artist does, what his or her relationship is to ideas, and how he or she goes about expressing those ideas.

These are very concrete reasons why *The Artist's Reality* does not provide a road map to Rothko's work, but they are frankly beside the point. Divining meaning from a painting is not so simple that it can be codified in a book, and Rothko certainly would not have wanted such a guide to his work. So much of understanding his work is personal, and so much of it is made up of the process of getting inside the work. It is like "the plastic journey" he describes in his "Plasticity" chapter—you must undertake a sensuous adventure within the world of the painting in order to know it at all. He cannot tell you what his paintings, or anyone else's, are about. You have to experience them. Ultimately, if he could have

expressed the truth—the essence of these works—in words, he probably would not have bothered to paint them. As his works exemplify, writing and painting involve different kinds of knowing.

The foregoing discussion may help us understand why Rothko never made the book public during his lifetime. It is not that he broke with the ideas or was embarrassed by what he had written. If this was the case, he most likely would have destroyed the manuscript, and he certainly would not have promised it to his chosen biographer, as my sister and I believe he may have done. No, I think he kept the book to himself because he feared that by offering people the beginning of an answer, or the illusion of an answer, to his artwork, they would never find a more complete one, perhaps never even ask the necessary questions. Regarding his own work, at least, he would have been concerned that he could set people running down the wrong paths, moving blindly with their little bit of knowledge, when ultimately, if carefully regarded, his painting spoke for itself. He knew of this danger and was therefore guarded in discussing his work, often finding that, the more he said, the more misunderstanding he generated. He did not wish to short-circuit the process by which people came to know the work, and I think he understood how difficult that process could be—that is, just how quickly people would move to avoid it. By the same token, I think he knew just how rewarding the process could prove when one was fully engaged in it.

It has therefore been with a great deal of mixed feelings and soul-searching that I, in consultation with my sister, Kate, have chosen to bring *The Artist's Reality* to light. Presenting the book to the public is like unsheathing a quintessentially double-edged sword. On the one hand, it is a treasure trove for scholars and a source of great interest for admirers of Rothko's work. On the other hand, because the book dates from relatively early in my father's career, was left unfinished, and does not directly address his painting, there is great potential for it to mislead. Furthermore, the book's incomplete state, and the fact that my father was not trained as either a philosopher or an art historian, make him an easy target for attack, as the arguments he puts forth sometimes lack polish, rigor, or both.

Ultimately my sister and I decided that these concerns were largely beside the point. Rothko is now so well known that most art lovers will at least have encountered his painting, and few are likely to pick up this book without a more substantial acquaintance with the artwork and how it operates. While some may wish to find a quick road map to my father's still-mysterious works, the book is sufficiently dense that this type of facile understanding is not readily at hand. Thus those readers will need to grapple with his philosophy, much as they need to with the paintings, in order to come away any wiser.

The family concerns about how the uncompleted manuscript presents our father as writer and thinker may be legitimate—the prose falls short of the level he achieved in

his few published statements, and the clarity of his reasoning is not always ideal. Critical focus on these matters is not the spirit in which I believe the book will be (or should be) read, however. Readers will delve in not because they expect the most powerful new statement in the philosophy of art (although perhaps his achievement in that area exceeds the scope of my knowledge); instead, they are interested in his views because they are compelled by the way they have seen him express them in paint. The true value of *The Artist's Reality* is not the thoroughness of Rothko's arguments or how consistently he wins his debates; rather, the treasure here is that we get a rare glimpse of an artist's worldview, expressed in the written word and in considerable detail.

In the final analysis, my sister and I believe, the public—both academic and enthusiast—has a right to see this book. Had my father destroyed or suppressed it, our conclusion might have been otherwise, but, much as he treated his early paintings, he has not appeared to disavow it or give any indication that its validity or importance is compromised in light of his later directions and achievements. He guarded the manuscript as part of his legacy, and I have attempted to do the same, by bringing it forward in as complete and faithful an edition as possible.

A brief history of the manuscript is therefore in order. My father generally did not discuss his artwork in any detail with the family, and I have no reason to believe that his behavior was any different with *The Artist's Reality*. If he did, Kate (who was nineteen at the time of his death) and I (who was six) do not have any recollection of it. As our mother, Mary Alice (Mell) Rothko, died six months after him, any knowledge she might have had of it did not come forward, at least not to us.

The manuscript first surfaced in the context of the ugly legal battles that followed my father's death. Briefly, the lawsuits pitted my sister and I (my sister, really, as I was so young) against the executors of our father's estate along with Marlborough Gallery, which had represented him during the previous decade. During the early months of contention, rumors that my father had written a book began to filter to Kate, and the alleged manuscript soon became a bone of contention between the executors and Robert Goldwater, who had agreed, the year before my father died, to write a scholarly, biographical, but primarily critical, evaluation of his life and work. As far as Kate knows, neither Goldwater nor the executors ever saw the manuscript, and, as Goldwater died within a year after my father, the issue became perhaps less hotly contested. In the end, the manuscript appears to have sat for nearly two decades in an accordion folder labeled innocuously: "Miscellaneous Papers."

How could my sister and I have let such an important document lie fallow for so long (in fact, nearly three and a half decades by the time of the publication of this book)?

To understand is to know something of the ambivalent relationship Kate and I have had with our father's estate and legacy. To begin with, we spent the first fifteen years following our father's death embroiled in legal complications surrounding the estate. During this time I was in school, and my sister earned her medical degree, entered postdoctoral training, married, had the first two of her three children, and served as the new executor of the estate after the original three had been removed by the court. Neither of us was in a position to look for, evaluate, or really even think much about the manuscript.

In the aftermath of that experience, my sister was both exhausted and, frankly, rather soured on the world of art. And my own associations with my father's artwork—I had yet to hang a painting when the estate closed in the mid 1980s—were of signing lots of forms and trying to make sense of seemingly endless two-hole-punched documents in which the number of subclauses far exceeded the amount of readily graspable information. Delving into the endless boxes of largely legal paperwork in search of The Book did not seem particularly appealing to either of us.

It was not until 1988 that Marion Kahan, who has served as our registrar and helped us manage our father's works for more than seventeen years, found the manuscript in an old manila folder among the papers in storage (Plate 1). She had not been specifically engaged by us to look for it but had chanced upon it during inventory work. She promptly photocopied the yellowed, crumbling pages and informed us that she thought she had found The Book. I do not remember great certainty or fanfare coming from Marion at the time—she assures me she remembers otherwise. In any case, I was still in no position psychologically to hear this announcement. I was in graduate school and had recently taken over the day-to-day management of matters Rothko from my sister. It was, at that time, a largely thankless and generally dull task.

I remember looking through the manuscript and related papers some time in the year after Marion had sent them to me. I did not allot a great deal of time to the process and concluded that there was not really much there. It was a foregone conclusion. I am sure I did not want to find anything of substance—it would only have been a nuisance, another matter to take care of, another distraction from my studies. And the manuscript made it easy for me to come to this judgment. It was sloppily typed, with numerous hand-marked additions and deletions—and more numerous typos—and it betrayed no obvious order or narrative direction (Plate 2). If there was something of interest—and at first glance there really wasn't—to make something of it truly *would* have been a nuisance.

And so the manuscript lay undisturbed. At times we considered making it available to scholars. We went so far as to seek out, on more than one occasion, an art historian to produce the comprehensive, critical evaluation of our father's work that Robert

Goldwater never had the chance to write. Access to the book would most likely have been a part of that process. All these searches proved abortive, however, and the book remained very much in the dark—to us as well as to the rest of the world.

There were a variety of reasons that we did not make greater efforts to evaluate the manuscript and make it public. Not least of these, as I have indicated, was weariness, but there was another reason that cuts deeper: I think we were simply not ready to cede control. The paintings—our father's legacy—and the two of us had been through such a tumultuous and lengthy period of uncertainty following his death that we were still getting our bearings and making certain the ground was firm beneath our feet. It is very hard to let go of something you have fought so hard for, and such battles make you naturally wary. It is only now, with interest in Rothko at an all-time high, as witnessed by consistent public and critical praise, and by exhibitions organized almost more frequently than we can manage, that we can relax a little.

But only a little. After all, look who is editing this volume (which, after first examining this daunting manuscript, I swore I would *never* do). This, of course, leads to the questions of just why *am* I editing the volume, and why are we publishing it *now*? The first reason is that I am a known quantity (that is, to my sister and me). If I have an axe to grind, it is a family axe. An outside source, however well-informed and well-intentioned, would not bring the same type of care to the project that a family member would. This is not to say that the attention this person would bring to it would have been worse—simply different. It *is* to say, however, that based on our own personal experience with our father's artwork, placing trust in those outside the family had some disastrous results. Moreover, having now worked intimately with my father's artwork for a decade, I have come to know his output in great detail and feel I have gained sufficient understanding of it to enable me to execute the project with both care and insight.

It was thus in the context of recent inquiries from scholars, along with independent interest from a publisher, that I took another look at the manuscript. And lo and behold, I found something very different on this pass. Without question, the work I found was incomplete and, in places, frustratingly obscure, but it was *a book*, and a substantial one. It was clearly written as a volume, its contents speaking to a public rather than constituting an artist's private musings. The time had come for it to see the light of day, and although I swallowed deeply before diving in, I knew that I was the one who should bring it out.

Rothko had been painting since the early 1920s when he dropped out of Yale College and found his way to New York City. While most of his time was spent in various odd jobs and teaching art to schoolchildren, he produced a consistent flow of work from the late 1920s through the 1930s, on both canvas and paper. Until 1939 the painting was figurative; muted colors depicted urban scenes, portraits, nudes, and strange, psychologically tinged dramas.

In 1940–41, however, around the time we think he wrote the bulk of this book, Rothko's work shifted notably. Embracing aspects of surrealism, which at that point was very much in the vanguard of modern European painting, he began to produce fanciful landscapes and wildly distorted figures with multiple heads and limbs often dismembered then reconstituted in striking and disturbing synthetic beings. As Rothko makes clear in the present volume, he did not espouse all the philosophical ideas of this movement, but he certainly adopted some of the stylistic trappings, along with those artists' fascination with mythic realms and the contents of the collective unconscious.

What follows is a bit shrouded in mystery. James Breslin, Rothko's biographer, notes the artist's claim that, in approximately 1940, he stopped painting for the better part of a year to read philosophy and mythic literature. He also states that Rothko suffered a bout of depression in 1940 or 1941 and stopped painting for a significant portion of time (James Breslin, *Mark Rothko: A Biography*, 1993). While I have not heard these stories elsewhere, Breslin is generally accurate about the facts of my father's life, so I am inclined to trust that some sort of interruption in his painting did occur. Although it is not clear whether the shift to myth-based, surrealistic painting occurred before, during, or after the writing of the book, we can surmise that the main body of the book was written during the interruption.

I should take a moment to clarify what we do know about the dating of the book. The only concrete piece of evidence we have is on the reverse side of one page of the manuscript, on which Rothko typed a draught of a letter dated March 23, 1941. His artistic mentor, Milton Avery, however, mentions in a letter that Rothko is working on a book as early as 1936 (see Breslin). While we cannot know that this is the same book, it is unlikely that Rothko produced two lost major works.

I am not inclined to believe that the majority of the book was written this early, however. First of all, another of Avery's letters (also quoted in Breslin), dated September 1941, mentions that Rothko has "eased up on his book," implying a period of intense activity immediately prior to that time. In addition, Rothko makes a number of references in the manuscript to later events, most notably the 1939 World's Fair and Germany's "warriors"

(presumably engaged in World War II). Finally, one must take a cue from Rothko's text and paintings themselves. He spends large portions of the book discussing the role of unconscious processes in the production of art, and fully a quarter of the book on the myth in art and society. It cannot be coincidental that these are precisely the subjects that came to the fore in his painting of the early 1940s. While rehearsals of *The Artist's Reality* may have begun earlier, Rothko's painting tells us that this book, more or less as we have it, was on the scene at the time his artistic transformations were beginning.

This was the progress of Rothko the artist and thinker. In the meantime Rothko the man had been struggling through the Depression era, barely able to support himself. He had sold almost no work, had few exhibitions, and had been employed the previous several years as a Works Progress Administration (WPA) artist. His first marriage, always stormy, was at its worst point. There was a prolonged separation in 1940 or 1941, a probable source of the depression that Breslin notes. Prior to these events his wife, Edith Sachar, who during this time was becoming successful as a jewelry designer, put him to work in her studio and reportedly discouraged him from any further painting. Their marriage would end in 1943.

I have sketched this background because it provides a context in which to understand the more polemical writings of *The Artist's Reality*. The tone of those chapters is angry, resentful, and sometimes whiny. You can taste the frustration of a man who feels like he has a great deal to say and desperately wants to be heard. Here is an artist who tries to capture his notion of reality, his idea of the truth, in every painting, but he can't get anyone to notice. It is with this in mind that we should read his repeated diatribes against Maxfield Parrish, his castigation of the cartoonist, his derision of the pseudo-primitives. Rothko had no patience for anything that did not aspire to the highest ideals. It was not merely that these "artists" were producing something derivative and soulless; they were doing so *and* capturing the public's attention. Meanwhile, Rothko sat upon his proverbial dung heap, cursing the fates that kept him there. "Popular" is therefore a doubly dubious word because it denotes both superficiality and the recognition from which Rothko was excluded.

This is not to deny that much of what Rothko dismisses is as vapid as he suggests. What I comment on primarily is his tone. His own feeling of deprivation adds an extra bite to his words. Were he successful, and were that deprived feeling less immediate for him, he might not even feel the need to comment on these lesser arts. One can take the same perspective on Rothko's discussion, in the chapter on indigenous art, of different methods for evaluating art. His analysis is sophisticated enough and ultimately rather convincing, even if it lacks the polish it would have had in subsequent revision. What strikes

one, however, is the vehemence with which he attacks the populists. This avowed socialist voices repeatedly a deep distrust of his fellow beings—especially when congregated—seeing them not as a force for social justice but as a dangerous mob. To Rothko, selecting great art by the numbers who endorse it is apparently a formula for enshrining the lowest common denominator.

This attitude toward the public carries through the book, from repeated citations of historic art defaced by the multitudes to pulled hair when he sees the paintings to which typical viewers flock. Rothko feels the sting of their neglect, and, perhaps doubting his own work, he lashes out.

There is, ultimately, a more charitable way to view the artist's stance toward the art public—and not simply to find that history has largely proved him right. To understand him more fully, it is important to remember that my father maintained this attitude of deep distrust and wariness toward the viewer long after he had become strikingly successful. Yet even as he feared the public, he desperately needed them to bring meaning to his paintings. This ambivalence is summarized in his well-known 1947 statement in *Tiger's Eye* magazine: "A painting lives by companionship, expanding and quickening in the eyes of the sensitive observer. It dies by the same token. It is therefore a risky and unfeeling act to send it out into the world." While this statement predates his rise to fame, it is typical of the comments he made privately later in his career, particularly in the context of exhibitions. Even after he had received significant adulation, he still feared, constantly, that his painting would be misunderstood and ultimately violated by an uncaring public.

Thus, while bitterness undoubtedly colored his writing of these chapters, his tone perhaps more clearly reflects how deeply personal an expression he makes in his works. He invests so much of himself in his work, and the notion of reality he expresses is so vital and internal, that it truly is a risky venture to send his paintings out into the world before the public eye. His anger therefore stems from a sense of vulnerability, one that is exacerbated by negativity from without, but which exists independent of any external reaction.

A related distinction, which Rothko makes repeatedly throughout, is between an artist's technical skill and his or her ability to communicate something profound in an immediate and moving way. He draws a clear line between illustration, or design, or decoration, and the production of fine art. While Rothko is hardly the only one to have made this distinction, and few would argue with him, one must again ask why he needs to emphasize this point so particularly. I believe that there are two primary reasons, one stemming from the nature of his art, and the other from his life.

The first reason that Rothko needs to be so dismissive of skill is because his own work from his realist period is, at first brush, so apparently lacking in it. The roughly

rendered, often clumsy-looking figures, the flattened perspectives offering little illusion of space, and the typical lack of detail all can give the impression of an artist incapable of producing convincing work (Plate 3). But as *The Artist's Reality* makes clear, Rothko's style at this time reflected his own philosophical and "plastic" preoccupations. He had no interest in making a likeness; he wanted instead to communicate to his pictures a sense of real substance and sensible weight. The pictures must have their own reality—they are not a mimicking of the visually perceptible world around us.

Like many modernists, however, Rothko was attacked because he failed to produce that likeness, and no matter how strong the philosophical underpinnings of his painting were, the attacks undoubtedly made him defensive. As one can see in some of his early line drawings and illustrations, Rothko was, in fact, a capable draughtsman. His surrealist work would soon demonstrate a real fluency with pen and brush (Plate 4), and he would go on to become a true virtuoso in the handling of color, space, luminosity, and reflectivity in his classic abstractions.

But in the early 1940s none of this mattered, and Rothko had to deal with the negative perception of his work at that time. Hence the counterattack we find in the "Art, Reality, and Sensuality" chapter and elsewhere, where those who brandish their skill are found wanting in substance, self-knowledge, and "true artistic motivation." And again, while his arguments are largely convincing, their tone reveals Rothko's bitterness from being unappreciated and misunderstood. At this stage he may have felt confident in his philosophies but he did not yet have the clarity in his painting that would allow him to brush off criticism of his style.

Rothko's bitterness also stemmed from sources much closer to home. I mentioned previously the unhappiness of his first marriage, a marriage whose discord was coming to a head at this time. Because Edith apparently did not support his painting, Rothko may have had a critic in his own house—hardly a firm foundation from which to operate. No less immediate, however, was Edith's increasingly rapid rise in the world of jewelry design. Her success, juxtaposed with his notable lack of it, must have galled him terribly, particularly when it became incumbent upon him to assist her. Hence the numerous slights made to those who practice illustration or design, and his general impatience with trappings and adornment. My father's angry tone is personal, and clearly some of it was directed at his wife.

In addition, there are a couple of ironies that attend my father's negative attitude toward the decorative arts. The first concerns his first wife's jewelry, which I have seen sported on some of the Sachar family women. It is quite spectacular, with a very fluid sense of line and a wonderfully organic feel to the pieces as a whole. My father was hardly enlight-

ened in the world of women's fashion and had in any case a rather dismissive attitude toward finery and ornament, but clearly his envy would have kept him from seeing its worth.

The second irony concerns my father's second wife, Mary Alice (Mell) Beistle, whom he was to meet and marry just a few years later. This was, largely, a much happier marriage, and my mother was far more supportive of his work, serving as the inspiration for his greatest painting prior to his classic abstractions, *Slow Swirl at the Edge of the Sea (Mell-ecstatic)* (Plate 5). She was, however, an accomplished illustrator. The psychological permutations of such a choice of partner on the part of my father are too complex to delve into here. What one can conclude, however, is that a significant portion of the slights he directs at the applied arts stems from the pain of his first marriage rather than from the dictates of his philosophy of art.

Rothko repeatedly expresses another notable feeling that gives us a glimpse of his life at that moment in time: the sense of nostalgia and longing that attends his discussions of classical times and the Renaissance. As he returns time and again to the "unity" of antiquity, to the order and wholeness of those people's worldview, there is a palpable yearning for the clarity and enlightenment of those times. He clearly wishes that he belonged to a world that had such a structure. And while the early Christian world does not lure him in quite the same way, he similarly envies the way in which the artists of that time could draw upon a cosmos ordered by its own internal logic.

Rothko, in fact, spends a good deal of time criticizing neoclassicists such as Jacques-Louis David, whose adoption of classical forms he dismisses as little but empty nostalgia. It is ironic, therefore, that we find this same nostalgia creeping into Rothko's philosophy. The crucial difference is that it does not manifest itself in his artwork. For even though Rothko is embracing classical myth in his surrealistic painting, it is a myth that has been transformed and broken down, and its dissolution can be witnessed on the canvas (Plate 6). It is antiquity referenced not out of nostalgia but for purely modernist purposes.

That nostalgia for unity may also express some of Rothko's existential concerns. A unified universe is particularly attractive in a world increasingly broken down by sciences —social and physical—into smaller and smaller constituent parts, and in a world that is being ravaged by a war whose destructiveness has never before been witnessed. His search for unity, and the society's as well, may be an attempt to fend off an incipient existential crisis—to find consistency and meaning in the face of increasing entropy.

Rothko also expresses a second type of longing: a yearning for the status that artists enjoyed in Renaissance times. For all of his reservations about the "advances" of the High Renaissance, Rothko still reveres many of the artists and marvels at their accomplishments. What astounds him, however, is the veneration many of those great figures received

in their own time. We encounter here, first, a type of envy from the unrecognized Rothko who, far from receiving commissions from popes and kings, had to rely on government handouts for much of the previous decade. Rothko clearly felt humiliated by that dependency, and his resentment at the government for its control over what he painted as a WPA artist is verbalized indirectly throughout the book. In this context he marvels at the freedom of the Renaissance master to move from one powerful patron to the next, across political and even military lines, although perhaps he does not recognize the degree of control those patrons maintained.

Envy centered on monetary success is not the primary sentiment here, however. It is, again, more in the realm of a wish that he, too, could live in such times. For what was clear to Rothko was the inherent rightness of that world order. What a dream to paint what one saw and felt, one's own sense of the truth, and to be lauded for it. For these artists, as Rothko relates, were toasted by the mighty and were venerated like football heroes by the masses. And this is what Rothko wished for: to paint the truth as one feels it and to win love and respect in one's own time. He, too, wanted, a world where the artist is king and his output a matter of great expectation and excitement.

These are the primary areas where we see Rothko unbuttoned, where we catch him out, expressing feelings beyond what he intended to communicate in the text. There is also something to be learned, however, from the stances he takes and the way he presents himself in his text. The first of these is as a teacher. While not a podium from which he consistently speaks in the book, this identification as a teacher of art infuses the text and appears at key places in his arguments. He presents himself as an expert on the art of children and holds up their work as keys to understanding the process of artistic creation. He is also keenly aware of the social responsibilities of the teacher, and thus when discussing cultural stances on art (as in the "Indigenous Art" chapter) he quickly moves to education as a prime area for consideration. It is interesting to note that the majority of Rothko's remaining papers that the family possesses concern the teaching of art. Clearly teaching was not something he did just to make a living, but something that he valued highly as well.

In contrast with these social concerns and his left-wing political affiliations, Rothko sets himself out as a keen individualist. He expresses this most directly in the chapter "Art as a Form of Action," in which he makes clear that the self-centered work of the artist —the expression of his or her personal truth—serves a more important social function than philanthropy. He still tips his cap to the idealism of the working classes, and sees the artist as working for the good of society, yet that social good is achieved by the satisfaction of the artist's individual needs. By this means—that is, by addressing the spiritual and

intellectual needs of the individual—progress will take place. This is the very antithesis of socialist art and collectivist dogma.

The book itself can be divided roughly into two parts: the polemical and the philosophical. As with all such artificial categorization, this division perhaps distorts as much as it reveals. I proceed nonetheless because I make a distinction based on tone rather than on content. The polemical Rothko is angry and argumentative, speaking out forcefully about what he sees as wrongheaded in the world of art. He is not shy in voicing his opinion about the largely unnamed institutions and individuals that he sees impeding the way of the artist both in the past and, especially, at that moment. This polemical style dominates the first and last parts of the book (as I have arranged it), although one sees occasional flashes of it elsewhere. Its manner is rhetorical, its arguments sweeping and not always well-supported, and, with few names given, his foes can seem like paper tigers. Rothko is impassioned and he intends to catch you up and gather you to his cause. He does not wish to obstruct his path with footnotes and qualifications; details would obscure the larger point.

For all the noise and excitement that the polemical portions generate, the majority of the book is taken up by the more philosophical chapters, beginning more or less in the middle of the chapter "Art as a Form of Action" and carrying through to "Modern Art." The tone here is quite serious, the manner more detached, the reasoning abstract, the writing consciously dense and academic. Rothko's choice of words is consistently marked by the desire to cast himself as an intellectual. "Prolix" and "pulchritude" are not the words of a downtown radical, and even when he uses more conventional language he often uses it in obscure and arcane ways that sent this editor researching fifth and sixth definitions.

This written style is not a matter of chance or a reflection of quirks. It is an index to the world of ideas that preoccupied the author. Although he read contemporary theory, philosophy, and literature, it was to antiquity and to the nineteenth century that Rothko turned (most notably at this time to Nietzsche's *Birth of Tragedy*). Similarly, he listened to Mozart, Schubert, and Brahms, not to Stravinsky or cutting-edge jazz. And, as the book illustrates, it was the art of the great masters of the past, rather than the art of the twentieth century, that most captivated Rothko's senses. His language, therefore, reflects his identification with those older traditions, especially the philosophical. His manner is somewhat Old World, outspoken but formal, not especially New York, hip, or brash. For all his identity as an American, Rothko, in both bearing and language, was a man of European roots.

His style is ultimately used as a deliberate means of positioning himself. He makes quite clear that he does not fit the popular notion of the artist as "inarticulate" and "moronic," which he describes with some humor in the chapter "The Artist's Dilemma."

He is of the artistic tradition, but he sets himself apart—he is an intellectual and to be taken quite seriously. This stance reflects a certain confidence in his ideas and, conversely, may indicate an insecurity that stems from his lack of recognition as an artist.

Most importantly, however, Rothko's intellectual and serious manner is necessitated by the rhetorical means he frequently employs to make his arguments. If we are to be swayed by what he has to say, Rothko must first set himself up as a person of authority. As he has no credentials (or had none at that time) he must generate them by means of the impression he creates. This lays the foundation from which he makes sweeping assertions about the course of art history, or the compromised methods of an established master. And while he is not always so convincing (especially when he tries to disavow his biases!) in this early draught of the book, he often is quite effective at drawing us into the argument.

Along with the tone he sets, it is actually the simple pronoun "we" that is perhaps most responsible for the success of his rhetoric. For by means of this negligible two-letter word he transforms his readers from audience to participants. The throwaway clause "As we have found," serves the vital function of personally involving the reader in the unfolding of the discourse. The audience is engaged in the same quest for truth as the author—the arguments are theirs as well as his—thus they are colleagues in the process. When it works, the trick is quite disarming because it short-circuits criticism. The reader is now on the inside fending off attack, rather than standing in judgment from the outside. And make no mistake, Rothko would have you on his side—he wants to persuade you of his truth.

The vehemence, rhetoric, and insistence that one finds in *The Artist's Reality* all point to Rothko's driving need to express something important and concrete. This book is not casual doodling but rather the product of a considered desire to communicate ideas, even if that desire was never fully realized on paper. And thus one runs headlong into the central questions raised by this volume: Why did Rothko write the book? and Why did he never finish it? Before I venture to answer these questions, I must make clear that all here is conjecture. We have no records, no statements, no material of any kind that gives substantive and substantiable answers to these crucial questions. Nonetheless, I have an answer that I will put forth with a good deal of confidence, in part because it is so simple: My father wrote the book because he could not, at that point, express the ideas it contained to his satisfaction in his own painting; and he abandoned the project because of a reawakening in his painting that allowed him to express those ideas more effectively through art than he could on paper.

My father was first and last a painter. Indeed, *The Artist's Reality* clearly demonstrates that he thought about painting constantly. It was therefore a very radical move for him to put down the brush after nearly twenty years and devote himself to writing. It is

not clear whether it was a bold move or one that reflected despair. In either case it was an active step, one that set him on a new journey or, perhaps, a different facet of the same journey. For the ideas in the book were not new for my father. His painting always was, and would remain, about ideas. The writing of the book was simply a different way to get them out into the world.

The very title of the book, *The Artist's Reality*, speaks to this desire. As Rothko emphasizes repeatedly, the essence of painting is, to him, the artist's unique perspective on the world and the communication of that perspective to the observer. To enter a painting is to enter the artist's reality, and although he would simply scribble that title in pencil on the folder containing the manuscript (see Plate 1), its message is writ large throughout the volume.

I cannot know for certain if the writing process—the rigorous wrestling with his philosophy of art—was responsible for launching my father forward in his artwork. One can see important breakthroughs in his work at this time—the move to surrealism around 1940 and the evolution of a far more abstract style of surrealism beginning around 1942. Because the book cannot be dated precisely the exact sequence remains obscure, but the rapid transformation that occurred in his art around this time is quite clear. As we know from both *The Artist's Reality* and other statements he made about his art in the 1940s, the changes in his paintings were philosophically driven. And the move to pure abstraction, which would occur in 1946–47, was just around the corner and certainly seems presaged by his discussion of abstraction in *The Artist's Reality*.

Those who love Rothko's work can thus be grateful for the frustration expressed in *The Artist's Reality*. Without that frustration there probably would have been no book, and without the book, perhaps, there would not have been the same developments in Rothko's artwork. Ultimately, without those artistic breakthroughs, few people, if any, would have read the book. Even if he had finished it, who would have published a book on the philosophy of art by an unknown artist who was a college dropout? Thus, *The Artist's Reality* —this unfinished book—can really be seen as a gift on many levels. And sometimes, the best gifts come strangely wrapped.

WRITER AND PAINTER

Rothko does not discuss his own artwork in the book—in fact, it is not mentioned even once. That rhetorical voice that speaks as "we" throughout the book never adopts the "I" of subjective experience, the "I" of the artist's eye. He discusses art as an observer, not as one actively engaged in the processes he describes.

And yet the book is all about his artwork. How could it not be? What he expresses in words is the thinking that informs his own painting. It is the philosophical foundation and also the aesthetic vision that necessarily underpin his work. Were this not logically the case, one would need only to note the impassioned tone with which he makes his arguments to see that this is no disinterested bystander, but someone constantly employed in the making of art, someone who lives that experience. The artist's afflictions and triumphs are his as well.

More specifically, however, one must ask what insights *The Artist's Reality* offers into Rothko's work. To begin, he offers us some perspective on his view of himself as an artist, albeit obliquely. And it is, I believe, something of a corrective. The book aside, it would be tempting to look at his classic abstractions as a revolutionary departure from the art that came before: the bold washes of saturated color, the striking reduction of form. And yet, as he makes clear repeatedly throughout the text, there can be no such thing as a revolution in art. The "plastic process," as he labels it—the development of art—is inherently evolutionary. An artist can react against it, but there is no way to be outside it; it is the fabric with which he or she weaves. Technique, ways of sensing, representing, and balancing, are all in a common pool from which the artist draws.

But it is not merely that artists cannot carry out a revolution in terms of the means they employ; there are also no intellectual revolutions emanating from the brush. In Rothko's view, artists' work must necessarily reflect the world of ideas active in their times. Artists use plastic means to express their own notion of reality, but that reality is ineluctably informed by the environment in which they function. While this idea was not unique to Rothko, it is striking that this artist, who by appearances broke so dramatically with prior tradition, sees himself not in the vanguard of the new, but as someone carrying forth the torch of the great (Western) artistic tradition.

With this in mind, it is fascinating to observe where Rothko places himself in the context of the then contemporary art scene. Despite the fact that the book dates from the early 1940s, when he had either recently adopted a surrealistic style or was shortly to do so, he is dismissive of surrealism as a school of art. He brands it as "skeptical" and "cynical," a movement that makes a mockery of ideational unities rather than seeking them. He offers some brief but compelling critiques of the surrealists' means and ends, but what is more essential is what the analysis reveals about Rothko.

Whatever the appearance of his style, he clearly does not see himself as a surrealist. His paintings from the first half of the 1940s may share surface elements with those of the well-known European surrealists, but clearly the aims and ideas are different. We know from some of his other writings, other parts of this book, and the paintings them-

selves that Rothko shared a number of their preoccupations—with primitive culture and the unconscious, for example. Ultimately the goals are very different, however, and Rothko has little patience with the Europeans' quest to dissect, when, for him, the role of art is to synthesize.

To him this cynicism is a tragic flaw, and we can learn from his philosophies that even paintings as disturbing as *Oedipus* are meant not as a sneering judgment, but as a genuinely concerned analysis of the human condition, with the end of mending, not dismembering (Plate 7). As he asserts repeatedly, all philosophy, all art, must address the human element. To speak to us, philosophy must be reduced to ethics, much as the myth brings the generalizations—that is, the worldview—of a society into the realm of man. And so must it be with art.

For Rothko, then, art aspires to a loftier goal than commentary, and it needs to speak to the essentially human in us if it is to succeed. In the chapter "Emotional and Dramatic Impressionism" he identifies the core of the content that the artist must address to make his art meaningful in the human realm. In short, that crucial content is the tragic. The chapter is a fascinating pre-echo of the famous statement he and Adolph Gottlieb were to make in the *New York Times* in 1943, but it goes much further in elucidating the role of the tragic in art. I give here a brief quote: "[Universal emotionalism] in relationship to the individual is found only in a tragic emotionality. . . . Pain, frustration, and the fear of death seem the most constant binder between human beings, and we know that a common enemy is a much better coalescer of energies and a much more efficient eraser of particularities than is a common positive end." Thus Rothko is already speaking here, as he will with Gottlieb a short time later, of art that is "timeless and tragic," of art that speaks to the human aspects common to all of us.

One must remember that Rothko wrote all these philosophical statements nearly a decade before he began to paint the classic abstractions for which he is best known. Nevertheless, his discussions of abstraction throughout the volume often seems strangely prescient of the changes that would ultimately come to his art. As Rothko makes clear, abstract painting *is* the painting of his time; the art that captures its *zeitgeist*. And it is clear that it is *his* painting. The questions he wrestles with here, both from within and without, are the questions he will face in the next three decades as he charts his course through the realm of pure abstraction. He will encounter the same bewildered responses to his art, and he will struggle to ensure that his apparently vacuous paintings are filled with meaning and content.

At the same time, it is important to step back and consider exactly what Rothko meant by abstraction and how this related to his own painting during this time. Although

he does discuss geometric abstraction in the book, this is not the only type of painting that falls under that rubric. When he speaks of abstraction, he apparently means a more general departure from representation—the distortion of the subject matter to conform to the artist's notion of reality rather than to that perceived through our vision. Thus, in this sense, at the time of the book he already is, and always has been, an abstractionist, because capturing visual reality had never served as an end for his painting. He has distorted figure and landscape, and forcefully manipulated form and space to expressive ends, from the very beginning of his career.

And yet there is clearly a further vision when Rothko discusses abstraction. We need only look at the changes in his artwork that immediately followed the writing of the book. Although, as I mentioned earlier, there is some question of exact sequence, it is clear that either he moves into his own brand of surrealism from his previous figurative style (compare Plate 8 and Plate 6) to witness a greater level of abstraction), or he moves from his early surrealist style to a markedly more abstract one in which the figures are little more than glyphs on their human or animal prototypes (compare Plate 6 and Plate 9).

But the broader sense of abstraction he presents extends well beyond the bounds of his then current painting. In fact, he seems almost to present a formula for the classic paintings of 1949 onward. For the vision he offers of the concepts of unity, generalization, ideas, and emotion as the essential elements of painting brings together precisely the constituent elements of those abstract works that have become synonymous with the name Rothko. It is a first glimpse of that as yet unknown world.

NOTES ON THE EDITORIAL PROCESS

Rothko was a man of draughts, many draughts. The family has copies of one-page letters that he reworked more than ten times. And I do not have the patience to count the number of draughts we have for the opening paragraph of his published essay, "The Romantics Were Prompted." Although Rothko did not make many written statements in his lifetime, the ones he did make were extremely eloquent, polished, and powerful. They clearly had been carefully considered and meticulously honed.

What a contrast with the state of things in this manuscript! Inside a sooty folder bearing the title were dozens of crumbling pages, crammed with text produced on a hiccoughing typewriter (see Plates 1, 2). Handwritten additions and crossed out letters and words crowded the landscape, and at this stage in the writing there had clearly been little regard for spelling and punctuation. Ultimately, I have tried to present the closest possible approximation of what my father would have published himself had he finished the book.

That is to say, I have presented it as a single work, not a collection of essays, preserved the book's structure as best it could be determined, kept the arguments in their original contexts, and changed as little in the way of chapter titles and terminology as clarity would allow. At the same time, I have not been shy about fixing grammar, polishing language, elucidating murky verbiage, and occasionally cutting text that wanders into unrelated or unfinished tangents. In sum, I have tried to produce a readable book, one that contains the maximum amount of my father's original text but which can be readily comprehended and holds together as a unified whole.

To some degree, that was a straightforward task, as Rothko left a sizable text that treats a limited number of subjects, albeit from different angles and with different emphases. There were two hundred and twenty-six typed manuscript pages—along with some loose sheets containing a paragraph or two of text—arranged into somewhere between twenty and thirty-six chapters, depending on how you divide and count subchapters. Fortunately, I never came away uncertain of what Rothko intended to say at any significant point in the manuscript.

From there matters rapidly became more complicated. It is necessary to understand that the manuscript was unfinished on several levels. Rothko mentions chapters that he ultimately never wrote, he leaves gaps in his charting of art history, and he provides no real sense of a summary or conclusion. Moreover, many of the chapters were themselves unfinished, breaking off before they reached the end of their argument or leaving a general sense of further territory to explore. And, most challenging, all of the chapters were in draught form, with numerous notes, appended pages, and language that had not been refined. Unlike his painting, which he pondered at great length but then generally produced rather quickly from a concrete idea, the thinking in Rothko's writing happened on the page, and he wrote the idea over and over until he got it right. I readily concluded, therefore, that in the case of *The Artist's Reality*, Rothko had left an early draught. Depending on the chapter, it is probably somewhere between draught one and draught three. A few of the chapters included multiple draughts or portions of new draughts and were a fascinating point of study that allowed me to examine my father's writing process in great detail. With each draught I could readily see how much had changed, but also how far he still had to go. In the end only a tiny percentage of the text came from my pen. The vast majority is Rothko's, tidied and rearranged for better comprehension and impact.

Probably the largest difficulty I encountered during editing was the lack of a clear chapter order. The sequence in which I found them was little more than arbitrary, but I attempted to piece together the numerous clues that Rothko left, such as the logical flow of related material that makes any text more cohesive, or references to previously discussed

material that occur throughout the text. The first chapter, "The Artist's Dilemma," certainly seemed intended to launch the book, but, after that, connections between the sequence of chapters I had found quickly dissolved. This disorder may have resulted from the journeys of the manuscript in the year or two following my father's death, but I think more likely it reflects not just the work's unfinished state, but also the lack of a conscious decision on my father's part to abandon the book. My guess is that he put the manuscript down, intending to return to it at some point, and life or depression or art intervened and he never found his way back. In the end I do not pretend to have duplicated my father's intended order for the book. First of all, there are chapters that were either lost or planned but never written. I have cut the allusions to these chapters, though I note here that he makes clear reference to chapters on technique, color, texture, line, and chiaroscuro that were not found with the manuscript. Secondly, because the work is unfinished, I do not believe that he ever wrote a concluding chapter or chapters. The chapter on indigenous art, which with its prophetic call for a new American art I have placed at the end, works quite well, but I do not believe that this was Rothko's preconceived finale.

Language was a second area of both abundance and concern. My father employs a wide vocabulary, and his writing is rich in metaphor and imagery. That said, he often draws on obscure, confusing meanings of words. Some of this was likely intended, perhaps as a way of creating variety and interest or of flexing intellectual muscle. Some of the obscurity no doubt stems from changes in usage over the last sixty-plus years, to which we may add a few decades given my father's somewhat archaic writing style. And finally, the terms can be unclear because my father uses them in their specifically philosophical sense, rather than in their more common usage. In some of those instances he addresses the different meanings of the terms, but in others he offers no comment and the meaning can be easily misjudged. I have made some clarifications where I felt there was too much potential for confusion, but in most cases I have preserved his language. The reader is cautioned to be careful with words like "materialism," "impressionism," and "plastic," all of which he uses in a more technical, rather than their more popular, sense.

One final specific area where I have chosen to let the book remain as my father wrote it concerns dated and biased language. *The Artist's Reality* is not a politically correct text. It displays consistent gender bias and Eurocentrism (and New York–centrism!), and it employs language that today would be considered racist and culturally insensitive. The cultural viewpoint and choice of language were the accepted norms at that time, however, and do not reflect any of my father's particular attitudes toward these issues (except as regards art, where he champions non-Western traditions even as his stance places them very much in the category of the "other"). There was no sufficiently compelling reason to

change the language of the book—it is of its times, as my father's philosophy says it must be. To do so would be to foist a political agenda on the book that has little to do with its contents. If the language occasionally jars, then it gives us a sense of just how far we have come in sixty years.

It is my hope that *The Artist's Reality* will give people refreshed insight into my father's work and refine their appreciation for what his painting can communicate. My sister and I will be placing the original manuscript into public archives, where it may be consulted for whatever additional nuances it may offer. I believe that this published volume, however, comes as close as possible to the spirit of what my father intended when he wrote the book. I expect that it will remain valuable to scholars and art lovers alike as long as my father's artwork continues to compel and challenge people to explore that in themselves which is most human.

PLATE 1 Cover of folder with Mark Rothko's handwritten notation, "Artists Reality"

The Artist's Dilemma

What is the popular conception of the Artist ? Gather a
thousand desriptions: the resulting composite is the portrait
of a moron. He is held to be childish, irresponsible, and
ignorant and stupid in everyday affairs.

The picture ~~generally~~, does not necessarily involve ~~censure~~ nor
unkindness. These deficiencies are attributed to the intensity
of the artist's preoccupation with his particular kind of
fantasy, and the unworldly nature of the fantasy itself.
The bantering tolerance granted to the absentminded professor
~~one~~ is extended to the artist. Biographers contrast the artlessness
of his judgments with the high attainments of his art, and while
his naivity or rascality are gossipped about, they are viewed
~~also~~ as signs of ~~the profound~~ Simplicity and Inspirationalism.
who are the Handmaidens of Art. And if the artist is inarticulate
and lacking in the usual diffusion of fact and information,
how fortunately, it is said, nature has contrived to divert from
him all worldly distractions, so he may be singleminded in
regards to his special office.

This myth, likeall myths, has many reasonable foundations.
First, it attests to the common belief in the laws of compensation:
that one sense will gain in sensitiveness by the deficiency in
another. Homer was blind, and Beethoven deaf. Too bad for them, but
fortunate for us in the increased vivdness of their art. But above
all, it attests to the persisting belief in the irrational quality
of inspiration, distributing between the innocence of childhood
and the derrangements of madness that true insight which is not
accorded to normal man. The world still adheres to Plato's view
when he says of the poet that " there is no invention in him
until he has been inspired, and is out of his senses, and the mind
is no longer within him". (no new paragraph. follow with next sentence here)

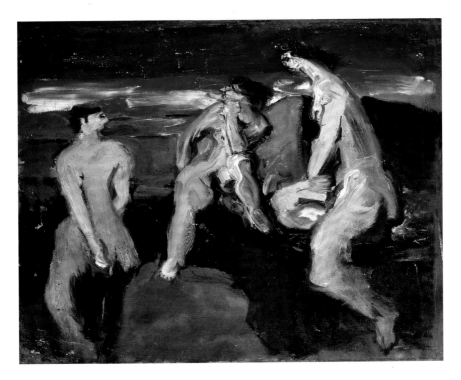

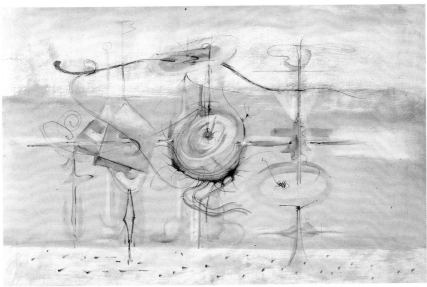

PLATE 3 Mark Rothko, *Bathers, or, Beach Scene*, 1933/34. Oil on canvas, 21 x 27 in. (53.3 x 68.6 cm). Collection of Christopher Rothko

PLATE 4 Mark Rothko, *Untitled*, 1945. Watercolor on paper, 27 x 40 ¹/₂ in. (68.6 x 102.9 cm). Collection of Christopher Rothko

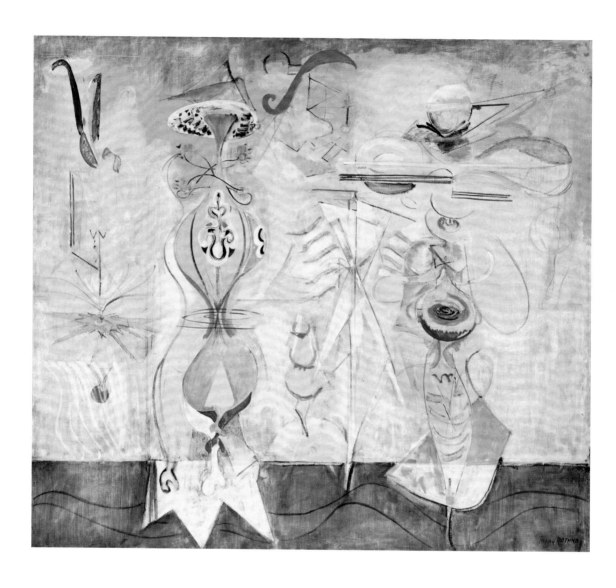

PLATE 5 Mark Rothko, *Slow Swirl at the Edge of the Sea,* 1944. Oil on canvas, 75 3/8 x 84 3/4 in. (191.4 x 215.2 cm).
Bequest of Mrs. Mark Rothko through The Mark Rothko Foundation, Inc., The Museum of Modern Art, New York, NY, U.S.A.

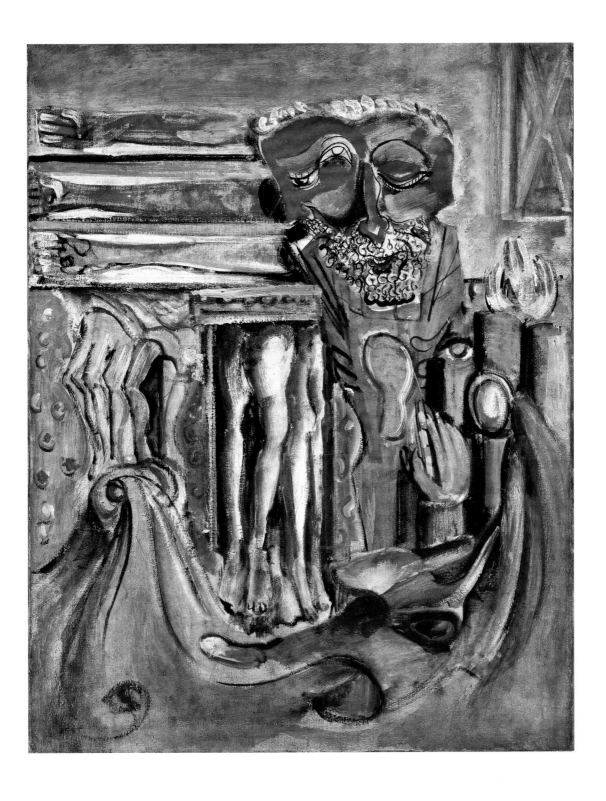

PLATE 6 Mark Rothko, *Untitled*, 1941/42. Oil on canvas, 36 x 28 in. (91.4 x 71.1 cm).
Collection of Kate Rothko Prizel

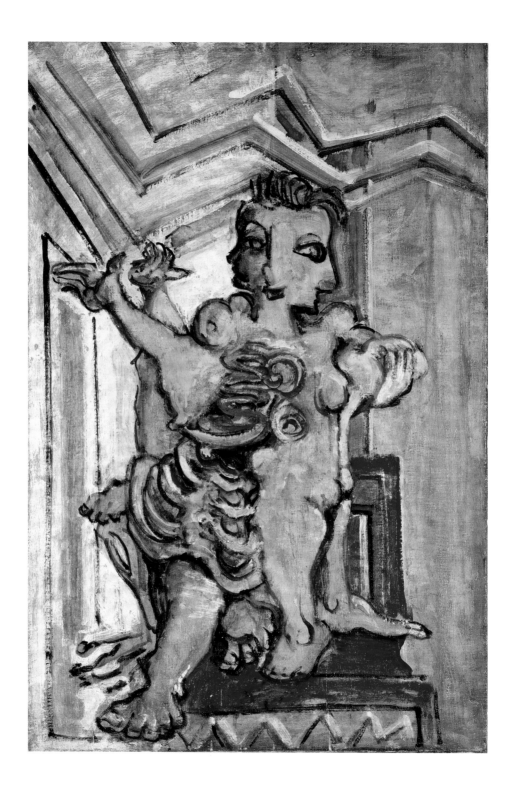

PLATE 7 Mark Rothko, *Oedipus*, 1940. Oil on canvas, 36 x 24 in. (91.4 x 61 cm).
Collection of Christopher Rothko

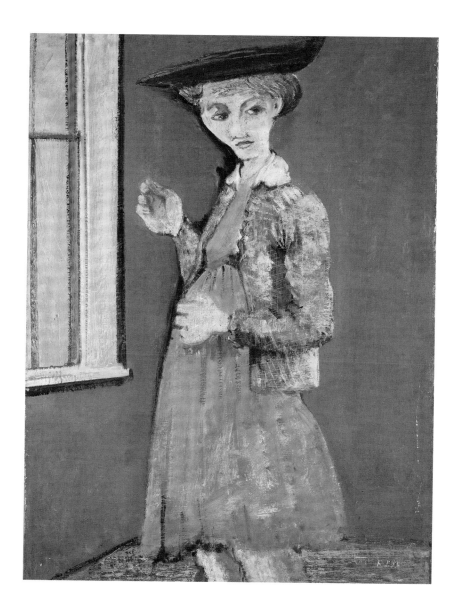

PLATE 8 Mark Rothko, *Portrait of Mary,* 1938/39. Oil on canvas, 36 x 28 1/8 in. (91.4 x 71.4 cm). Collection of Kate Rothko Prizel

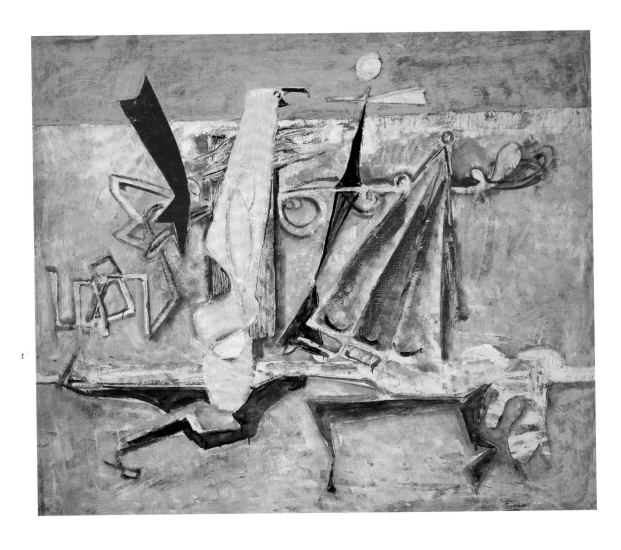

PLATE 9 Mark Rothko, *Untitled*, 1943. Oil on canvas, 30 x 35 7/8 in. (76.2 x 91.1 cm).
Collection of Kate Rothko Prizel

The Artist's Dilemma

What is the popular conception of the artist? Gather a thousand descriptions, and the resulting composite is the portrait of a moron: he is held to be childish, irresponsible, and ignorant or stupid in everyday affairs.

The picture does not necessarily involve censure or unkindness. These deficiencies are attributed to the intensity of the artist's preoccupation with his particular kind of fantasy and to the unworldly nature of the fantastic itself. The bantering tolerance granted to the absentminded professor is extended to the artist. Biographers contrast the artlessness of his judgments with the high attainment of his art, and while his naïveté or rascality are gossiped about, they are viewed as signs of Simplicity and Inspiration, which are the Handmaidens of Art. And if the artist is inarticulate and lacking in the usual repositories of fact and information, how fortunate, it is said, that nature has contrived to divert from him all worldly distractions so he may be single-minded in regards to his special office.

This myth, like all myths, has many reasonable foundations. First, it attests to the common belief in the laws of compensation: that one sense will gain in sensitivity by the deficiency in another. Homer was blind, and Beethoven deaf. Too bad for them, but fortunate for us in the increased vividness of their art. But more importantly it attests to the persistent belief in the irrational quality of inspiration, finding between the innocence of childhood and the derangements of madness that true insight which is not accorded to normal man. When thinking of the artist, the world still adheres to Plato's view, expressed in *Ion* in reference to the poet: "There is no invention in him until he has been inspired and is out of his senses, and the mind is no longer in him." Although science, with scales and yardstick, daily threatens to rend mystery from the imagination, the persistence of this myth is the inadvertent homage which man pays to the penetration of his inner being as it is differentiated from his reasonable experience.

Strange, but the artist has never made a fuss about being denied those estimable virtues other men would not do without: intellectuality, good judgment, a knowledge of

the world, and rational conduct. It may be charged that he has even fostered the myth. In his intimate journals Vollard tells us that Degas feigned deafness to escape disputations and harangues concerning things he considered false and distasteful. If the speaker or subject changed, his hearing immediately improved. We must marvel at his wisdom since he must have only surmised what we know definitely today: that the constant repetition of falsehood is more convincing than the demonstration of truth. It is understandable, then, how the artist might actually cultivate this moronic appearance, this deafness, this inarticulateness, in an effort to evade the million irrelevancies which daily accumulate concerning his work. For, while the authority of the doctor or plumber is never questioned, everyone deems himself a good judge and an adequate arbiter of what a work of art should be and how it should be done.

Let us not delude ourselves with visions of a golden age freed of this cacophony. This gilding is an artistic falsehood. We deal in fantasy ourselves and know how alive dreams can seem. And an age like ours, which demands so clear a facing of realities, will not allow us the pleasure of narcoticism. With the knowledge that man's tribulations, at least, are always with him, we can safely say that the artist of the past had good reason, too, to play the mad fool—so as to salvage those moments of peace when the demands of the demons could be quieted and art pursued. And if nature, in fact, contrived to give him the appearance of a fool, so much the better. For dissimulation is an exacting art.

> Ill hath he chosen his part who seeks to please
> The worthless world,—ill hath he chosen his part,
> For often must he wear the look of ease
> When grief is at his heart;
> And often in his hours of happier feeling
> With sorrow must his countenance be hung,
> And ever his own better thoughts concealing
> Must he in stupid Grandeur's praise be loud,
> And to the errors of the ignorant crowd
> Assent with lying tongue.

The lament is Michelangelo's (a translation of this madrigal can be found in *The Life of Michel Angelo Buonarroti* [1807]). Even this great man—who lived in an age when the rapport between the artist and the world seemed to have been ideal, and when fêtes and processions celebrated the completion of works by the artists of renown, for whose services dukes, popes, and kings fought—even he bore his full share of calumny and disapproval. The principles of his art were constantly assailed; and, after parrying those criticisms,

his morals were found wanting. Aretino attacked the nakedness of the nudes in the *Last Judgement* as inconsistent with Christian piety. The reasonableness of Aretino's point cannot be denied. Michelangelo's vision of the Celestial Court can be easily mistaken for an orgiastic bout. These doctors and moralists, they are always right! Like our own social moralists and critics, their facts are so neat, and their reasoning so pretty: but what disastrous falsity to the cause of truth!

Most societies of the past have insisted that their own particular evaluations of truth and morality be depicted by the artist. Accordingly, the Egyptian artist had to produce a definitely prescribed prototype; the Christian artist had to abide by the tenets of the Second Council of Nicea or be anathematized or, like the monk of the iconoclast age, work in danger and by stealth. We should note that Michelangelo's nudes were forced to wear, in the end, the appropriate panties and drapes. Authority formulated rules, and the artist complied. We shall not speak here of those whose daring periodically revitalized art, saving it from its narcissistic mimicry of itself. We can accurately say that, within these periods, the artist had to submit to these rules or simulate the appearance of submission, if he were to be permitted to practice his art.

It will be pointed out that the artist's lot is the same today, that the market, through its denial or affording of the means of sustenance, exerts the same compulsion. Yet there is this vital difference: the civilizations enumerated above had the temporal and spiritual power to summarily enforce their demands. The Fires of Hell, exile, and, in the background, the rack and stake, were correctives if persuasion failed. Today the compulsion is Hunger, and the experience of the last four hundred years has shown us that hunger is not nearly as compelling as the imminence of Hell and Death. Since the passing of the spiritual and temporal patron, the history of art is the history of men who, for the most part, have preferred hunger to compliance, and who have considered the choice worthwhile. And choice it is, for all the tragic disparity between the two alternatives.

The freedom to starve! Ironical indeed. Yet hold your laughter. Do not underestimate the privilege. It is seldom possessed, and dearly won. The denial of this right is no less ironical: think of the condemned criminal who will not eat and who is fed by force, if need be, until his day of execution. Concerning hunger, as concerning art, society has traditionally been dogmatic. One had to starve legitimately—through famine or blight, through unemployment or exploitation—or not at all. One could no more contrive his own starvation than he could take his own life; and for the artist to have said to society that he would sooner starve than traffic with her wares or tastes would have been heresy and dealt with summarily as such. Within the dogmas of the totalitarian states of today, you may be sure, the artist must starve correctly, just as he must paint by the dictates of the State.

But here, today, we still have the right to choose. It is precisely the possibility of exercising choice wherein our lot differs from that of the artists of the past. For choice implies responsibility to one's conscience, and, in the conscience of the artist, the Truth of Art is foremost. There may be other loyalties, but for the artist, unless he has been way-laid or distracted, they will be secondary and discarded in his creation of art. This artistic conscience, which is composed of present reason and memory, this morality intrinsic to the generic logic of art itself, is inescapable. Violate her promptings and she will ferret out the deepest recesses of thought and conjecture. Neither sophistries nor rationalizations can quiet her demands.

What did those artists of the past do about their conscience? The Law of Authority has this saving grace: it can be circumnavigated. One can pay lip service to the letter and with equanimity violate its spirit. One bows to necessity, then schemes to defeat it. We are told that there were times when the Truth of the Law coincided with the Truth of Art. Granted! But when the divergence became too great, what ingenuity the artist displayed in disguising one to have the appearance of the other. What guile and shrewdness in this seeming moron. One needs but recall the great Apollo. How easily this Hellenistic deity, with all his draperies and trappings, was slipped into the niches of the Christian saints. He had merely to change his name, and to look much sadder than he really felt.

What abetted the artist in his little game was the dogmatic unity of his civilization. For all dogmatic societies have this in common: they know what they want. Whatever the contentions behind the scenes, society is allowed only one Official Truth. The demands made upon the artist, therefore, issued from a single source, and the specifications for art were definite and unmistakable. That, at least, was something: whether submission or deceit were intended, one master is better than ten, and it is better to know the size and shape of the hand that holds the whip. In a master, definiteness and stability are preferable to caprice.

Today, instead of one voice, we have dozens issuing demands. There is no longer one truth, no single authority—instead there is a score of would-be masters who would usurp their place. All are full of histories, statistics, proofs, demonstrations, facts, and quotations. First they plead and exhort, and finally they resort to intimidation by threats and moral imprecations. Each pulls the artist this way and that, telling him what he must do if he is to fill his belly and save his soul.

For the artist, now, there can be neither compliance nor circumvention. It is the misfortune of free conscience that it cannot be neglectful of means in the pursuit of ends. Ironically enough, compliance would not help, for even if the artist should decide to subvert this conscience, where could he find peace in this Babel? To please one is to antagonize the others. And what security is there in any of these wrangling contenders?

4

The truths of India, Egypt, Greece spanned over centuries. In matters of art our society has substituted taste for truth, which she finds more amusing and less of a responsibility, and changes her tastes as frequently as she changes her hats and shoes. And here might the artist, placed between choice and diversity, raise his lamentations louder. Never did his afflictors have as many shapes or such a jabbering of voices, and never did they exude such a prolixity of matter.

Art as a Natural Biological Function

Why paint at all? A question well worth asking all those thousands who, in the catacombs or the garrets of Paris and New York, in the tombs of Egypt or the monasteries of the East, have throughout the ages covered millions of yards of surface with the panoramas of their imaginings. The hopes of immortality and reward, I dare say, might claim their share of motivation. Yet immortality is niggardly, and we know that in many ages the dispensers of official immortality have specifically withheld their gifts from the makers of images. No man of business would admit that the possibilities of gain are ever worth such risk.

Consider, too, the hardships which are endured. In our age starvation is the lot assigned to the devotee of this practice. Yet this is a happy situation when compared to the legal persecutions in Byzantium, or the promise of hellish fires by the Jews, Mohammedans, and the early Christians. These have been singly endured and cunningly circumvented. Surreptitiously, and in the face of dangers, the practice was continued and art has survived. Fortunate indeed have been those artists living in the golden age of Pericles, or patronized by the cultured merchants of the Renaissance or by the iconoclastic soldier-poets of the Trecento. Yet should we survey the fortunes and honors of the half dozen who have survived and traced the labors of the thousands who toiled anonymously on the vast extent of their work, and who dreamed that they might be as great as their masters, and, should we relive the lives of all of those whom fortune did not favor to even this extent, we should see that the glory and the rewards of even those opulent times were not as general as we like to believe. And think of those in the totalitarian regimes of our own day. How many of them have fled their native lands, living in poverty, in danger, uprooting their growth in their own soil, refusing to be strangled by either prescriptions or proscriptions based upon their art.

We may well say that all of these lived in the delusion of ultimate success. Men may be blind to some factors of their existence but not to all. They may have been well deluded as to their place in the eternal edifice of art, in the significance of their mortar, but they could not have been very well deluded as to their earthly rewards—examples to the

contrary are too convincing—and anyone who believes anything of this sort knows neither art nor the extent to which it involves conscious sacrifice.

The forgoing is not a plea for sympathy. The artist has accepted his fate with open eyes, and I do not believe that he wishes any charity in relation to his self-assumed sacrifice. He wants nothing but the understanding and the love of what he does. There can be no other rewards. The forgoing therefore is not in the spirit of asking for a charitable contribution, but rather the clearing of the way for what is really the motivating factor for this strange phenomenon: the creation of art.

If subscription to the duty of ensuring himself a place in the afterlife was the object, the artist could have found, at all times, more direct methods in his society for achieving that end. If by immortality we mean the one prophesied by the religionists, we can see that the artist could not have possibly considered himself the inheritor of such joys. Read the vituperations and the exhortations against the image makers of Isaiah and other prophets and marvel at the dire material tragedies which cursed both the makers of images and those who used them. The Mohammedans denied to those who even had the representations of the figure in their homes all the sensuous joys of the Mohammedan heaven. In Byzantium, for a period of one hundred and eighteen years, the exercise of plastic realizations was forbidden by Christian law, and the destruction of—that is, vandalism against—the great artistic productions of that era, as well as the destruction of the Hellenistic sculptures which previous emperors had revered and enshrined, was considered an act in the service of God. The Turks, from another quarter, whitewashed the beautiful frescoes and pulled down the mosaics in the great church of Sofia. In Egypt the artist worked for immortality but not his own, for the enduring of his monuments of stone continued and prolonged the existence of the man whom they represented, rather than the artist who executed them.

All in all, we can say that man has as often destroyed the work of artists in the hopes of achieving immortality as he has hoped to achieve immortality through the creation of such work. Even as late as the fifteenth century we have Savonarola decrying the making of pictures, inviting the populace to destroy them and, imparting his fervor to the artist themselves, convincing them to add their own works voluntarily to the flaming pyre in the hope of gaining immortality. Among those artists was Botticelli, who destroyed some of his best works, although he continued to paint. The Reformation, no doubt, accounts greatly for the turning of the Dutch to genre art, for they must have felt that Old Testament purism toward the representation of spiritual things. This change constituted its own type of vandalism, for it contributed greatly to the decline of great classical art.

Yet the idea of immortality cannot be altogether discarded. There is a different type of immortality, the kind that man has instinctively perpetuated throughout his existence and which has, in the last hundred years, explained a great deal with comparative clarity. This is the notion of biological immortality, which involves the process of procreation, the extension of oneself into the world of the perceptible environment, very much as Shakespeare expresses in his sonnets. This relates the artistic process to every other essential process; one that is biological and inevitable.

Art as a Form of Action

ESCAPISM

Art has often been described as a form of escape from action. It has been pointed out that the artist, finding the practical affairs of the world too unpleasant, withdraws from the world of true activity and ensconces himself in a world of the imagination in order to exempt himself from this unpleasantness. The world of true activity is usually considered that one which occupies man—either communally or individually—with the satisfaction of his bodily needs. The staving off of physical starvation or discomfort is considered the proper world of realistic action. With the rise of the standard of living the number of things which satisfy the physical needs of man have been greatly expanded. Originally these needs might have been called: food sufficient to satisfy hunger, shelter to protect him from meteorological inclemencies, and clothing to stave off pneumonia. Today a man cannot live, however, without a tile bathroom, without sanitary plumbing, without a vacuum cleaner, and without a well-appearing suit, nor can a woman without innumerable changes of costume within and without every season, and without innumerable gadgets and time saving devices. These time saving devices are to contribute to leisure, which is to be occupied with the satisfaction of the aesthetic impulses. Leisure requires its ornaments; it must first of all be attractive. Finally, the participation in the production and distribution of these innumerable gadgets has been gradually drawn into the sphere of man's realistic needs which originally had been satisfied by the most elementary provision of food and clothing and shelter. Any person who spends his life in the production or acquisition of these said embellishments pertaining to the physical needs is pursuing a life of action. And it may be pointed out that the life of our nation as a whole is a tale of triumph and tragedy and unremitting toil in the pursuit of this reality.

 This presupposes, of course, that the bodily needs are the core of existence and that other needs, if any, will be automatically satisfied. This assumption is contradicted by the fact that in those social classes where the possession of these goods is easy, one finds the greatest preponderance of ill health. No other class in the world is so beset by neurological disturbances, so-called imaginary disturbances, which science has recently found

often more destructive and less subject to cure than "real" ailments, which are considered legitimate. The subordinate class, which is willing to lay down its life presumably to make all those needed items more available to all of society, is a much healthier class. Why? Because these people, by the very fact of their idealism, are really fulfilling a need as great as that of the physical needs. Idealism here forms a kind of action which takes its place side by side with other self-expressive forms of action without which man cannot continue in good health.

Art is such an action. It is a kindred form of action to idealism. They are both expressions of the same drive, and the man who fails to fulfill this urge in one form or another is as guilty of escapism as the one who fails to occupy himself with the satisfaction of bodily needs. In fact, the man who spends his entire life turning the wheels of industry so that he has neither time nor energy to occupy himself with any other needs of his human organism is by far a greater escapist than the one who developed his art. For the man who develops his art does make adjustments to his physical needs. He understands that man must have bread to live, while the other cannot understand that you cannot live by bread alone.

Art is not only a form of action, it is a form of *social* action. For art is a type of communication, and when it enters the environment it produces its effects just as any other form of action does. It might be said that its use as a means of social action is dependent upon the numbers which it affects.

From that point of view, Maxfield Parrish is the most social of artists and therefore the artist who most deserves the esteem of society. Needless to say, this sort of a measure will lead one to the most absurd conclusions. When the artist produces something which is intelligible only to himself, then he has already contributed to himself as an individual, and with this effect has already contributed to the social world (just as we benefit ourselves, and therefore also society, when we eat). In other words, society benefits every time an individual improves his own adjustment in the world, for however we look at society, the empirical measure of society's welfare is the aggregate good of its constituents. How far a single impulse can extend in its effect is unpredictable. One minute stimulus can be more far-reaching, can affect the course of society more significantly in a single minute than a thousand other stimuli—whose effect is more obvious—might over a hundred years. The satisfaction of personal needs is therefore never an escapist form of action. In its effect, it is closer to natural action than a hundred acts of philanthropy and idealism which concern themselves with the needs of others. Who is to say which of the personal needs are more pertinent to society?

There is another way in which art is accused of escapism. In this case art would be included in the arena of proper activity if it performed a specialized function. This is a specialization of subject matter. Those who argue in this way will say that if art treats certain kinds of subject matter, it is a form of proper action, and if it treats other kinds of subject matter, it constitutes a form of escapism. Actually it is a violation of the essential nature of art as action for it to conform to the first requirement. For this argument conceives of art as excusable only if it performs a specialized function in relation to some extraneous objective, and insists that the intention to perform this function is present when the artwork is executed. If it does not meet these criteria the artwork is often repudiated as "decadent."

There are two ways in which the word *decadent* can be used. Certain kinds of art have been labeled decadent in relation to other kinds of art, and particularly in relation to works of art of the same tradition. The term is often applied to arts which are at the tail end of a tradition, when the possibilities of a development have been exhausted— for example, the Hellenistic art of the Greeks after the fourth century BCE, when artistic innovation had all but ceased. Thus, when the artists in a given society seem no longer able to develop the forms of the tradition and, as a result, fall into the exploitation of all sorts of devices which seem to be spurious to the plastic process, their artwork falls into this first decadent category.

Decadence has also been used to describe art which emphasizes sensual and sensuous attributes, such as the arts of the last days of Rome, types of Baroque art and the sensual arts of the French monarchy and French symbolists.

Therefore, in either usage, it may be applied simply as a descriptive term which might help us to place a work of art by the side of similar accomplishments from different places or times.

However, as used by the social critics with whom we are concerned here, the word does not concern itself with a description of plastic processes at all, but has a moral connotation instead. This is attested to by the fact that many of the painters of whom these people approve have employed decadent forms without the discrepancy having been noticed by their censoring advocates. As a matter of fact, since these people demand a more or less descriptive and dialectical art, the artists they approve have invariably gone to decadent art (as defined previously) for their plastic prototypes since it is decadent art which usually substitutes, or rather imposes, nonplastic objectives upon art, two of which are illustration and the creation of mystic illusions.

As a moral word, *decadence* has no use for us because it does not relate to paintings at all and makes no observations about their properties. This use of the word *decadent* simply indicates to us the moral predilections of those who use it and the habits of the society in which they lived. It shows us that these people disapprove of certain activities, viewing them as not good or ethical, and approve of others which they see as good. And their notion of decadence in painting applies merely to whether a painting praises or condemns a certain kind of human action. In this way the Communists in this country object to Thomas Hart Benton's portrayal of the Negro, because he does not present him in a sympathetic light. On the other hand they like Joe Jones's, because he makes of him a more likeable person. The difference between these artists is actually very small, as attested to by the fact that both have the same dealer, are liked by the same critics, and are bought by the same people.

This politically driven use of the word *decadence* can also be seen by observing the work which the German Library of Information is now putting forth as the finest manifestation of the current totalitarian virility. It is, for the most part, work of sentimental romantic painters that plays with half-mystical light and sentimentality, which a virile society devoted to such positive material ends could far more reasonably condemn as effeminate and decadent than the art which it banishes. Here, nondecadent art is considered that which will soothe the savage breast of the weary warrior in the same manner as women or beer. Still another example is Russia, which has attempted to reduce art to a function for the direct good of the state. Thus the ubiquitous smile so prevalent in our own toothpaste advertising seemed to be the distinguishing mark of their painting at our own world's fair, and the function of the painting there was to say that all is right with Russia. Another interesting illustration of these ironic contradictions is their literature, which describes the epic of the new state, surely enough the desired subject, but in the mannerisms of all the schools of Europe which they label decadent: romanticism, expressionism, surrealism, and symbolism. Obviously, this view of art looks only so far as its use as advertising, journalism, illustration, etc. It offers no basis for discussion, for it offers morality as a point of orientation, and this morality not only changes from place to place (note that the Germans hail romanticism as vital, and the Russians dismiss it as ivory tower) but also from minute to minute.

Even in the first definition of the word *decadent* that we described, which is really based upon plastic considerations, there is little worthwhile for our discussion. We can use the word in this more technical sense only if those who are involved in the discussion have similar prejudices for certain types of art. Otherwise the work can have no useful meaning. For instance, to an academician Byzantine art might be considered a

decadent use of the Hellenistic tradition, which to them is the height of achievement. To other critics, Hellenism is already a decadence of the real vitality of Greek art, which occurred in the fifth century BCE, and Byzantine art constitutes a rejuvenation of the art through the rediscovery of the original plastic principles. The same may be true in the consideration of the Renaissance, where some considered Giotto the apex of a great rejuvenation of classical principles and the Florentines a decline of a great tradition. For others, the Florentines are the rejuvenators who bring about the greater tradition of Renaissance paintings. Thus the word *decadence* is of value only if we use it to categorize traditions and the place of artists in it. Some of these we may call decadent and use them as a point of comparison for other artists in whom we discover similar attributes.

The confusion is even greater when the word is used in both senses at the same time; when people confuse its moral and plastic attributes and use them to mean either interchangeably. And it is this kind of confusion which is the most general; for our vernacular has become filled with words whose origins and meanings are of great complexity, but whose use popularly would indicate that they are as simple and clear as a noun like *chair*. As a result, completely meaningless generalizations such as the following occur: Byzantine art is a decadent derivative of the Greek tradition, and at the same time, early Christian art is a reaction to pagan decadence. Or, similarly, Dutch art is a revitalization of painting because it shows, on the part of the artist, an interest in his surroundings rather than in outworn supernatural myths, and on the other hand, the painting of still life is a decadent occupation because it shows that men can no longer say anything about human beings. Now where are we?

In view of all of this confusion we must realize that, on the whole, this word has no meaning which is definite in relation to art, and certainly cannot be used as a basis for the consideration of preferences for certain kinds of art over other kinds of art in the field of education.

The Integrity of the Plastic Process

We have seen that men insist upon producing art as a fulfillment of the biological necessity for self-expression. Art is one of the avenues which has afforded satisfactory means, which we may here call a language, for the successful fulfillment of this drive. Art, then, is a definite kind of thing, a species of nature, and like any species in the physical world it proceeds according to definite laws of its own. It has definite properties which will here be described as the plastic elements. By the constant rearrangement of these properties, art, like every other species, proceeds according to logic through stages of change that we can call growth. It grows logically, definitely, step by step from the exhibition of one set of characteristics to another, always related to its past equipment, and bearing at the same time the promise of the future.

A study of the history of art, then, is really the demonstration of the continuity of this plastic process—a demonstration of the inevitable logic of each step as art progresses on its way from point to point. The practice of art in the large, that is, the aggregate production of all artists, is identical to the evolution of these laws. And the work of each artist is a different facet of each stage and functions as an accretion that serves as a corollary to the preceding stage. It is in the terms of these plastic laws alone that art preserves a continuous, logical, and explicable picture. We thus see the artist performing a dual function: first, furthering the integrity of the process of self-expression in the language of art; and secondly, protecting the organic continuity of art in relation to its own laws. For like any organic substance, art must always be in a state of flux, the tempo being slow or fast. But it must move.

This point needs special emphasis today. Recent practice has tended to obscure this truth whose inevitability should be obvious upon any acquaintance with art. Our age seems to be in search for the greatest number of correlations it can find. Developments in psychology and in the social sciences have given rise to a body of information which has been quickly adopted to show its action in every activity. There has been a mad scramble to relate everything to everything else.

We have a ponderous mass of works relating art to all things and, for that matter, relating all things to one another. The economists have been showing that art is the result of economic conditions, the physical scientists that art is the result of climatic, geographic, atmospheric, and topographical conditions. Our books of art are therefore filled with the discussions of landscape or finance as the bases from which art can be understood. The ethnologists insist upon examining the expressions of racial traits in the artist, the genealogists consider a minute study of the artist's genealogical tree as essential to the understanding of his art. One very popular American critic has prefaced his studies of art in France and America with a minute description of the institution of prostitution in both countries, putting forth his comparative analysis of that institution as the basis for his judgments and preferences.

There is no doubt that the artist, being human, is both changed and influenced by his environment. The environmental factors that impress themselves upon him and his actions are infinite, and as time goes on and our investigations extend to more and more fields, we shall find many influences that we cannot trace as yet today. No doubt in their aggregate they will contribute much to our understanding of the artist, his motivations, and how they can be detected in his art. Art histories will discuss these influences in chapters dealing with the particular expressions of the artist within the plastic continuity of art. They will explain, for example, why Michelangelo, Botticelli, and Titian, whose plastic heritage is the same and whose environments were similar enough, produced works which are so different in their appearance and in the elements which they emphasize. They will do much to explain the subjective objectives of the picture and why the different artists said different things. They will explain the variable factors in this constant activity of the plastic process. For we may wish to know why John and Joe, two men contemporaneous with one another, possessing similar organs, and acted upon by similar environments, still look and act differently from each other. We will find factors that will explain the variations which the constant assumes under different conditions.

Unfortunately today, we have not as yet identified a sufficient number of these factors, nor have we worked out a system of causations that would contribute either a true or complete picture. Yet since the way has been pointed, it would be inhuman not to submit to the temptation of making assumptions from the possibilities that our current knowledge has presented. To understand John or Joe at all, however, we must first understand that they are men, and that at all times the environment influences them by means of the organs essential to their species, and by the particularities of these organs at a particular time and place; that these organs will receive only certain things and reject others, and that they will function only on their own terms and within their own potentialities if they are to function at all.

15

Therefore, the fact that a man was rich or poor, that he lived in a flat or hilly country, that he was shy or forward with women, or that his parents had inherited traits that are associated with temperate or torrid climates or with what are considered the attributes of the Anglo-Saxon or Latin race—these circumstances may explain why the artist's part in the plastic continuity showed this or that peculiarity. Yet in spite of any peculiarity, he nevertheless functions definitely and inexorably within the plastic process—nothing else is possible here. And to make any intelligent study of art as art means the allotment to the artist of his place in that process. This is the constant, the only constant which will provide intelligibility to his function as an artist. The other factors are of infinite variety, unpredictable, and largely still unanalyzable. They provide us with that endless variety of appearances, with those different aspects of a similar thing which dispel monotony and which make this examination of the plastic process one of esthetic appeal and endless interest. It is in much the same way that we would hardly enjoy new and different friends if they were all the exact duplicate of the same pattern. In other words, the environment provides us with the clue for the examination of differences. The laws of painting in themselves provide us with the inevitable constant, with the point of reference, with the measure that makes differences relate to each other and intelligible.

While we therefore welcome these correlations if our enjoyment of certain works of art makes us want to know something about the character of the author and the habitat in which he lived, we must voice, at the same time, the following misgiving: these correlators are often characterized by an excessive zeal for the establishment of immediate and direct causation, no matter what the cost. In fact, some of these researchers have reduced art to the position of a mere minion, obsequious to society's whim, badgered from corner to corner by a series of environmental concussions, changing its hues chameleonlike in the interests of adaptability.

This is a picture which cannot be substantiated. For the history of many artists is more often a defiance of the prescriptions and proscriptions of the environment than it is a resignation to them, as already indicated in our first chapter. And like a plant there are a million factors which daily would lead to the artist's destruction. The plant, as well as the artist, must overcome these environmental demands if they are to survive. To survive means the preservation of the identity, purpose, and function of one's properties. In this respect, the story of art is a story of ingenious circumventions and outsmarting of those who would thwart it. To survive, art may be temporarily deflected, to appear as something it is not. But more often it will disguise its true appearance, and at the first opportunity throw off this disguise and appear as it should in its rightful domain.

This struggle for the survival of identity is really a very adventurous one, where art often is in danger of complete annihilation, and the stories of its survival are as thrilling a series of miraculous escapes as can be found in the history of any human adventures. Sometimes the guile and cleverness with which it achieves its purpose are as clever as the ruses of some Oriental merchant.

When Christianity came to the fore and became the state religion, its leaders decreed that art henceforth must be ecclesiastical and demanded a unity of art and dogma. Did the great artist discard the accumulations of centuries of beautiful growth in Greece, in Alexandria, in Antioch, and in Mesopotamia? What did he do but rearrange his inheritance? It is interesting to see how the Christian artist's treatment of folds in garments is the continuation of the same folds found in the statues and pictures of the past which he loved. The postures of his figures are a carrying forth of the classical symmetry that is the soul of Greek art. And the attitudes of those figures are a transplantation of the peaceful and benign expressions so common in Greek tombstone monuments. So, too, the decorative arts of Assyria and the Egyptian attitudes of the Coptics all find their incorporation in the Christian artists' new art. Christian art can no more be called new than Christian thought itself, for that simply is the consummation of the meeting of East and West in Asia Minor, where Greek Platonism is combined with the mysticism of the East and the puritanical legalism of the Oriental Jew. Christianity in art is therefore no more an invented species than Christian thought, for art, like thought, has its own life and laws, whose integrity is again as inviolable as the integrity of the laws of any other phenomenon.

Similarly, when the iconoclast emperors forbade the representation of ecclesiastical themes, artists channeled their efforts in the production of lay art, where the folds now adorned the shepherd rather than the saint, and the beasts were no longer apocryphal demons but rather paraded beneath the Oriental tree of life in sweet, idyllic poses. The monks themselves, flouting legal proscription, continued secretly to develop their types of art in their monastic retreats, producing the prototypes for an art which was to constitute the basis of the great Christian art of Italy for ten centuries to come.

Another example will make this process even clearer. The Mohammedan conquest of Persia caused a forceful suppression of its art. Yet secretly the practice of art continued, and its continuity is preserved hundreds of years later in the miniatures that we so admire today and that in their turn have contributed much inspiration to modern art.

One explanation or reservation must be made here, however. In art, as in biology, there is a phenomenon that can be described as mutation, in which appearances radically change at a tempo much more rapid than that at which they normally proceed. As in the case of biology, we have no means to determine the process by which this radical change

occurs. Yet we do know that it is a reaction to a form of congestion. It is a desperate change due to the arrival at a point where the corollaries to a situation are exhausted, when the stimulus to additional growth is sluggish and a rapid rejuvenation is needed so that art, through disuse, does not atrophy in much the same way as an unused human organ. Here art must attain a new start if it is to survive. Then, assiduously, it renews its traditions by marriage with alien traditions, by the reexamination of its own processes, and by those means reestablishes contact again with its own roots. It is in this way that new plastic worlds are born. For art, like a race, cannot inbreed very long without losing its incentives to continue; it needs the rejuvenation of new experiences and new blood. These mutations, it must be clear, however, do not constitute a change in properties, or mean that art has discarded its past. On the contrary, mutation involves a more conscious evaluation of art's inheritance and the redirection of that inheritance into channels where it can be continued with greater force.

Art, Reality, and Sensuality

Artists' pigments, like printers' inks, have many uses apart from the creation of art. The advertising artist, the illustrator, the portraitist, the stylist, and the decorator all employ the plastic and pictorial devices of the artist. Yet their chief preoccupation, the purpose and function of their effort, is other than the creation of art. It is the commercial artist's job to enhance the desirability of marketable goods. The illustrator vies with the written word in the description of places or facts and the reporting of events. The portraitist must flatter his patron, while the stylist and decorator adorn his figure, streamline his gadgets, and embellish his property. There may be a resemblance to the outward appearance of art. But the intrinsic relationship is no closer here than that which exists between the composition of birthday greetings, recipes, or advertising copy and the creations of the poet, though the identical phrase and syntax may be used in both.

No doubt, the confusion between art and that which merely resembles it is as eternal as the effort to distinguish between the two. The painter and poet have always suffered its untoward effects. Yet, in the case of the painter, there is an element which aggravates this confusion, from which the poet is comparatively free. This element is the ambiguous character of the word *art* itself, which is legitimately applied to any kind of skill. We have therefore the Art of Love, the Art of War, as well as the Art of Cooking. But in common usage it describes, particularly, the skill of manipulating plastic materials to pictorial and decorative ends. Hence, while the reporter is seldom confounded with the poet, the illustrator, the decorator, and innumerable others—named or unnamed above—all are properly alluded to as artists. The housepainter and hat-trimmer, too, whose fee is sufficiently high, share this appellation.

This common participation in the Trinity of Line, Form, and Color has founded a promiscuous fellowship which, while promoting the respect for skill, promotes to a far greater degree the misunderstanding of art. For skill in itself is but a sleight of hand. In a work of art one does not measure its extent but counts himself happiest when he is unaware of its existence in the contemplation of the result. Among those who dec-

orate our banks and hotels you will find many who can imitate the manner of any master, living or dead, far better than the master could imitate himself. But they have no more knowledge of his soul than they have knowledge of their own. We all know how little skill avails, how ineffective are its artifices in filling the lack of true artistic motivation. His "less is more," is Robert Browning's famous evaluation of this problem in comparing the imperfections of Raphael's art to the impeccability of Del Sarto's. "I should rather say that it will be more difficult to improve the mind of the master who makes such mistakes than to repair the work he has spoilt," Leonardo wrote. Neither Giotto nor Goya exhibited half the skill of Correggio or Sargent, either in the complexity of their undertakings or the apparent virtuosity of execution. The artist must have the particular skill to achieve his particular ends. If he has more, we are fortunate not to know it, for the exhibition of this excess would only mar his art. You may be sure that the artist whose method is muddled betrays less his technical inadequacy than the incoherence of his own intentions.

This brief statement by no means exhausts the discussion of skill. The whole question of what constitutes skill and what does not, the difference between surface and expressive skill, and the fascinating relationship between method and concept will be fully discussed in another place. These can be better resolved when we have further explained the purpose of the art with which its method is inextricably allied. Our intention here is to show how short is the reach of skill, and to what lengths one can be misled by apprehending art through this common similarity.

To understand either art or commercial art, we must penetrate the mind of their creators. Any parallels or classifications which can be useful in understanding these forms must discard this kinship of material and method and seek instead the motivations and objectives in their creation. The vernacular, too, hints vaguely at this distinction by drawing the jagged line of differentiation between the "fine" and "applied" arts.

From the viewpoint of mind and purpose, no one resembles the artist less than those others who share his devices. The art of the advertising artist can be understood only by the study of the mind of the salesman. The aim of each is to sell his respective product by exaggerating its virtues and suppressing its defects. The illustrator will find his soul mate in the news reporter or the tabloid photographer. The verisimilitude of his descriptions will depend upon what appears real to his employer. The fashionable portrait painter is closest to those courtly flatterers whose hypocrisy is the ladder to material success. While the man who contrived his pictures so they look well above a sofa, as well as the decorator and stylist, shares the intentions of the confectioner, whose function it is to season luxury with the pleasures of the senses.

We are here neither to moralize nor to segregate art into levels of value. Each to his own work and may he do it well, and derive the rewards which he prizes most.

But we must look elsewhere if we are to find the analogies in human action to enlighten us concerning the activities of the artist. It is the poet and philosopher who provide the community of objectives in which the artist participates. Their chief preoccupation, like the artist, is the expression in concrete form of their notions of reality. Like him, they deal with the verities of time and space, life and death, and the heights of exaltation as well as the depths of despair. The preoccupation with these eternal problems creates a common ground which transcends the disparity in the means used to achieve them. And it is in the language of the philosopher and poet or, for that matter, of other arts which share the same objective that we must speak if we are to establish some verbal equivalent of the significance of art.

Let us not for a moment conceive that the language of one is interchangeable with that of the other: that one can duplicate the sense of a picture by the sense of words or sounds, or that one can translate the truth of words by means of pictorial delineations. Not all the odes of Pindar, framed and embroidered, could duplicate the portrayal by Apelles' brush of the *Hero of the Palaestra*. The Pandemonium of Milton or Dante's Inferno can never replace the vision of the Last Judgment by either Michelangelo or Signorelli. No more so than the Pastoral Symphony of Beethoven can be apprehended through the reading of idyllic poems, augmented by descriptions of woodland and fields, of torrents and streams, the study of ornithological sounds, and the laws of harmonics. Neither books on jurisprudence, nor costume plates, can possibly reconstruct Raphael's *School of Athens*. And the man who knows a book or a picture through its critics, whatever his experience, has no experience of the art itself. The truth, the reality of each, is confined within its own boundaries and must be perceived in terms of the means generic to itself.

In speaking of art here, there is no thought of recreating the experience of the picture. If we compare one art to another, it is not with the intention of contrasting their actuality, but to speak rather of the motivations and properties such as are admissible to the world of verbal ideas. And if in the analogies to follow we are partial to the philosopher at the expense of those others who share with the artist his common objectives, it is not because we divine in his effort a greater sympathy to that of the artist, but because philosophy shares with art its preoccupation with ideas in the terms of logic.

Particularization and Generalization

A painting is a statement of the artist's notions of reality in the terms of plastic speech. In that sense the painter must be likened to the philosopher rather than to the scientist. For science is a statement of the laws that govern a specific phenomenon or category of matter or energy within the specified limits and conditions of its operations; philosophy, however, must combine all these specialized truths within a single system. It is because of this broad scope that Aristotle gives preeminence to the philosopher in the introduction to his *Metaphysica*, for he tells us that every man except the philosopher is an authority within his specific field, whereas the philosopher must have the acute knowledge that each man has in his own field plus the ability to relate all these fields to the operations of universality and eternity.

Therefore art, like philosophy, is of its own age; for the partial truths of each age differ from those of other ages, and the artist, like the philosopher, must constantly adjust eternity, as it were, to all the specifications of the moment. Art, too, creates at different times the notions of reality that the artist, as a man of the age, must inherit and develop and consider real along with the other intellectually conscious men of his time. His language, which is his plastic means, will also adjust itself to the possibility of making those notions manifest in their most coherent possibilities. The reality of the artist, therefore, reflects the understandings of his times, even as his creations shape those understandings. We posit this without wishing to attempt to untangle here the series of causes and effects, a process which would probably obscure more than it clarified.

As for the plastic means themselves, their discovery and the emphasis with which the artist employs them are also functions of the notions of reality of the age. One interacts upon the other in a succession in which the order of priority is unimportant. They work together to constitute the statements of the notions of reality of any age, whether they simply corroborate the notion that already existed or point the path in new directions, either as development, protest, or reactions.

These reactions themselves are made possible through new means which are themselves properly evolved due to the introduction of new notions of reality. For example, the development of linear perspective was the result of the new notion of physical laws that were discovered during the Renaissance. The painting of appearances was also the result of new understanding of these physical laws. The use of these laws in Renaissance painting demonstrates the simultaneousness of the impulse—that is, the new understanding—and its statement in every contemporaneous intellectual field. This immediate incorporation, as in the use of linear perspective, is therefore not necessarily due to any organic relevance of these new laws to the artist's notions of reality.

Different plastic languages are used for all sorts of purposes, but they serve art only when they *generalize* beyond the particular. The plastic elements of art may find many employments in our society quite outside of their being the manifestation of that generalization of reality. They are used for the purpose of embellishment; of flattery or of record, in the case of portraiture commissioned by specific individuals; as illustrations of all sorts, including both scientific events and scientific description; for the decoration of rooms and show windows; and thousands of other diverse purposes, just as language might be employed for the purposes of verbal description or for conveying directions, recipes, road signs, and military commands—quite outside its function in establishing ultimate generalizations. The same is true of mathematics, which can be used for the settlement of accounts, for puzzles, for computing the results of mechanical operations; or of science, which can be employed for the purposes of designing vacuum cleaners, or toys, or orange squeezers, or the transmission of radio messages, or untold other uses that might range under the general heading of the applied arts.

Yet the function of the artist or the mathematician or the scientist is not to produce the wherewithal for gadgeteering or, for that matter, even more important functional developments. This does not mean that he may not hope for or even envision such developments. Yet these cannot be his point of orientation. It is his function to evolve generalizations, and the scientist cannot be deterred by their ultimate application. (That said, for centuries the laws of mechanics have had hovering about them the picture of the uncontrolled or morally misapplied use of the machine. The specter of the Golem or of self-annihilation from the vast energies which the scientists are unleashing is too compelling a truism for them not to have been aware of it.)

Yet science must continue with its generalizations not in relation to function but in relation to the organic integrity of the science itself, which may be likened to a self-contained organism which proceeds according to the laws of biological growth peculiar

to its own organism. According to those laws it must proceed, ever building from the materials of its own past and imbibing from its environment the food for its growth.

The same is true of art. But this environmental food must pass through the fine selective sieve of the organism itself, which is generic to its development. The function of art is therefore to make a generalization within the limits of its category. Every generalization must reflect an understanding of the limitations of the category (categories which Aristotle places in an order proportional to comprehensiveness). That the limits of these categories are forever being extended does not alter the necessity, at each point, for the artist to set the definite limitations wherein he must function.

The sciences all work within their specific scopes: mathematics deals with generalization of quantity, geometry with generalization of positional shapes, physics with the mechanical properties of matter, chemistry with the composition and the interaction of substances, psychology with the mechanics of the sensual apparatus, etc. And we must remember that ancient philosophy included all these sciences.

Now, we have stated that the function of the artist is similar to that of the philosopher, and that the kind of generalization each makes is alike because of its comprehensiveness or synthetic quality—in contrast to the specialized generalization of the scientist. Yet in what manner do their generalizations differ? Why are they not a duplication of each other, and why are they not interchangeable, one into the terms of the other?

An essential characteristic of both of these types of generalizations is that they must combine all the sensible factors, both subjective and objective. Stated in another fashion, they must show the relevance of all knowledge, intuition, experience, and whatever else is admissible as reality at any particular time. Magic and superstition were in that realm in primitive times, and so they are today in the forms of occultism and psychiatric demonology. Art and philosophy must therefore show the relevance of these phenomena to men.

Now, the philosopher reduces all of these phenomena by means of verbal or numerical logic to the end of human conduct or, more precisely, to ethics. For unless he does so, his philosophy simply functions in a higher category of science. In other words, he must array and marshal all available knowledge and experience to the objective that man shall know how to behave in a relationship of harmony to all of these factors. He must reduce into a generalization all of the external things perceptible to man, the apparatus for perception itself, as well as the actual product of concrete sensation, with the end of improving man's conduct.

The artist's hand must reduce all of these experiences for man as well. His objective is different, however, for he must reduce all of the subjective and objective with

the end of informing human sensuality. He tries to give human beings direct contact with eternal verities through reduction of those verities to the realm of sensuality, which is the basic language for the human experience of all things.

Sensuality stands outside of both the objective and subjective. It is the ultimate instrument to which we must first refer all our notions, whether they be abstract, the result of direct experience or of some circuitous reference to such experience. Sensuality is our index to reality. The proponents of both points of view—the objective and the subjective—must ultimately appeal to our sensuality, our notions of the validly existing. They must make contact with our sense of the tactile that is the textural quality of ideas or substances.

We must say here that this purpose is correct and fundamental. We use the word *sensuality* instead of *sensation* because we know now that sensation itself is divisible. Through our study of the apparatus of sensation we know that man's final sensation is a synthesis of atomic particles of separate sensations. But the sum result, the final index to reality that is the synthesized result, can be understood only through sensuality. For sensuality applies ultimately to our sense of touch, to the tactile, which, whether we want it to be or not, is still the final justification of our notions of reality. Our eyes, our ears—all of our senses—are simply the indications of the existence of a veritable reality that will ultimately resolve itself to our sense of touch. That the sensual is so closely interlaced with the entire mechanics of procreation is further evidence that man in his most profound biological functions is impelled by his sense of touch.

We must also note that our notions of reality are now known to be simply the registration of comparative degrees of pain and pleasure. Here, then, is further corroboration of the centrality of touch, for we have within sensuality the apprehension both of objective and subjective reality.

Therefore we can posit this generalization: That a painting is the representation of the artist's notion of reality in the terms of the plastic elements. The creation of a plastic unit reduces all the phenomena of the time to a unity of sensuality and thereby relates the subjective and objective in its relevance to man. Art therefore is a generalization. The use of the plastic elements to any other ends, which are most usually particularizations and descriptions of appearances, or which serve the stimulation of separate senses, are not in the category of art and must be classified in the category of applied arts.

The term *applied art* is really a misnomer and contributes preponderantly to the confusion of applied arts with the art of generalization. It would be far better to call this offshoot, or use of the plastic elements, *applied plasticity* or any other name that would distinguish it from the essential category of that activity we would call art.

If we were speaking from the point of view of the historian, and if we desired to know as concretely as possible how those peoples of the past or present conceived of their world, we should have to turn to their philosophy to find how they thought about their world, and to their sciences to analyze the atomic factors that contributed to those thoughts, and then to their applied arts for the understanding of how this notion appeared when necessarily vulgarized to the common denominator of intelligence. But we would have to turn to their art to understand how they "felt about their world," to know how their notions of reality found expression in their sensual perception of the world. And we know, of course, how those expressions can differ by simply examining medieval Christian art, which consciously discarded the reality of its predecessor, Greek Hellenistic art.

It is significant to note that there were no philosophers during antiquity. There were sciences in the sense that men had, through experience, noted the relationship of mechanical cause and effect concerning phenomena, and the same kind of cause and effect was also imparted to rational phenomena, since ancient man did not differentiate clearly between the two. In fact, the philosophers of antiquity were her poets, who symbolized the ultimate unity of all that was considered reality in the created myths, which were the products of poetry. These myths were not only the science; they also constituted the basis of religion as well.

Aristotle, who was the first notable differentiator, or specialist, lived at a time in Greek history when the classical Greek unity was no longer actual but remained from habit and traditionalism. In fact, he could no longer be content with the traditional theogony of Hesiod, but needed to posit a sort of ultimate unity above the old gods, a unity that he called perfection, a complete abstraction denoting merely the ultimate harmony of all the factors visible in reality. The old Greeks had a symbol to coordinate their diverse hierarchy, but they dismissed it by calling it chaos. This was a very profound invention and it attests to the solidity of the basis of their notions of reality and at the same time the precarious balance and insecurity of their rational symbols. It was a sort of atonement for the pride they felt in their reasonableness, and also a recording of the atavistic terror of the unknown, an insecurity from which they had heroically begun extricating themselves.

The function of the old philosopher, namely the poet, was then no different from that of the artist, for like the artist he reduced all of his perceptions of actuality to the most basic level to which humans relate: sensuality. Subsequently these identical notions of reality reduced to sensuality were used by the church in symbolic form with the end of shaping human conduct. The church sought the participation of all in the established unity

through the agency of ritual, which was in itself the sensual combination of all these sensualisms into the vernacular of human action.

Even with the ascendancy of reasonable, objective categorization, the resulting specialization of philosophy, and the philosopher's separation from the poet, the philosopher still needed to synthesize an ultimate unity in which the reduction of all phenomena to the relevance of human conduct was essential. Therefore we may say that the philosopher today produces this unified worldview by making ethics the objective of all his researches, and instead of making sensuality his end he must now make it conform to the harmony of all of the other factors. Otherwise he remains simply a scientist in a higher category. In that sense the rational man, the one to whom rational logic is still the only key to reality, can find guidance for his conduct in philosophy.

The artist, however—that is, the poet and the painter—has never lost his original function and establishes the unity of the ultimate by reducing all phenomena to the terms of the sensual. For sensuality is the one basic human quality necessary for the appreciation of all truth.

Today, therefore, when there is no unity, when the separation between the objective and subjective has not yet been bridged except perhaps through the attempts of pragmatism, we can no longer see the full face of a unified reality, but rather we must look at each profile separately: art or sensuality is one of these profiles, and philosophy or objectivity is the other. The church remains as a symbol of the need and the desire for that ultimate unity. Viewing the church in this light, we may explain the genuine feeling of those who believe that only religion, as the instigator of the arts, can produce a truly ultimate art. What they really mean is that religion is the manifestation of that ultimate unity.

The duality of the subjective and objective realms which we face today is not as disruptive as it might be because each classification believes in the ultimate finality of its own orientation. Actually, the objectivist tries and succeeds daily to draw more and more of what is commonly called the subjective into the orbit of his order, whereas the subjectivist succeeds more and more daily to show that, by the very dismissions of the objectivists, the subjective is given greater credence. What constitutes the real unity of our age, then, is the reality of an abstraction of faith that all phenomena can submit to generalization. In other words, we are really recapturing the profundity of the Greeks, who accepted the unknown as a positive element of reality.

Man knows that he can express himself fully in the two terms of the duality. Those terms are fast approaching the position of implied complementariness rather than opposition. Perhaps man will soon realize in definite form the differentiation of what he can know and what he can speak about. Indeed this is perhaps a return to the Platonic ideas

of visible shapes and their ideals, but in an inverted significance. Man will know the difference between reality and his apperception that is his symbolic statement of it. Therefore both the philosophic and the artistic expression are essential for man to comprehend the world, and we should note for our work here that it is art which provides one of these two constituents of the whole.

In that sense modern thinking, which is the sum total of this duality, is a form of the enforced equilibrium between rationality and pragmatism. Our ultimate truth is atomic, it proceeds toward the dissolution of the world into smaller and smaller units, and every step in this process of division is, in fact, a further corroboration of the ultimate and closer interrelationship of every difference. Side by side we develop and impart our confidence to a series of pragmatic ideals in the social sciences, medicine, and a host of other occupations that are definitely pragmatic sciences and which cannot be substantiated in the terms of rationality. Rationality, however, serves as the ideal of those who carry out these researches, although they know that there can never be a thorough integration of the two.

There are dogmatists even today who seek to destroy rationalism by branding it as escapist and degenerate. We might say that amongst these are the more rabid of the functionalists. They cannot conceive of any truth except that which is verified by statistics of action, that is, of materialistically perceptible action, for we have already established that art is an essential form of action. While these views do not yet hold full sway today, they are perhaps the portents of man's weariness of the functions of his mind and indicate that perhaps he shall soon voluntarily impose upon himself a dogmatism which will remove the burden of seeking this form of corroboration.

But today our notions of reality are still rationalistic, and even the equilibrium which we are attempting to establish between pragmatism and rationality is a rational recognition of the essential duality of truth, the essential categorization of phenomena into the world of Platonic ideals and the difference in their manifestations in appearances.

Therefore the art of today, which can in fact portray our notions of reality, must be the exemplification of this principle of Plato's ideals, and the compromises inherent in the world of appearances can in fact demonstrate the abstractness of those appearances. That is why, in the significant paintings of today, the subject matter is constituted either of ideological abstraction or appearances abstracted into the world of ideals by being frankly employed as a foil or vehicle for demonstration of these ideals.

Here, says the artist, I can use anything, what does it matter, it will dissolve itself into the generalization of atomicism. By contrast, those artists of today whose paintings deal with the particularities of appearances for their own sake cannot speak to us for they do not make the generalization to which they give credence. For pragmatism today lives

by sufferance only. It is gaining ground to be sure, but as yet, at least, mankind is not weary enough to substitute the comforts of dogmatism for the rigors of rational thought. We perceive pragmatism as a department of reality, in the rational sense, indicating a type of tolerance we have today for the validity of certain dogmas in their own times. Thus, while the Renaissance abandoned the unities of the Christian and primitive worlds as mere superstition, we now recognize the value of their symbolic systems as manifestation of certain types of reality.

Actually, the equilibrium between pragmatism and rationality issues from our acceptance of relativity, in which the alternations of the rational and the dogmatic constitute a pattern in which we can recognize the rhythms of the life of the mind. Yet the reestablishment of a complete dogmatism must be an irrational act and in today's world cannot be accomplished. And the proponents of dogmatism who seek to unseat rationality must sell their opiate in misrepresented rationalistic coverings and must attempt to sell their irrational wares in the guise of rationality. This is not so difficult to do, because the field of mental operations is so wide, and therefore so little generally apprehended, that the substitution rests upon the exploitation of vulgarizations and the confusions already existing in the vernacular.

Generalization Since the Renaissance

The Renaissance artist did not see his path at once. Mindful of the Greek unity that was the prototype of his activities, he dreamed that, like the Greek, he too could be all in one: priest, scientist, and artist. He did not realize that he was embarking on a course which would inevitably lead him to specialization and, subsequently, to the separation of functions, wherein the essential relationship between the developments of these functions would become obscured. Hence he began his career encompassing all endeavors within himself. The painter of Florence was thus also her scientist.

Logically, every scientific development in relation to the Renaissance artist's plastic elements should have been fully incorporable into his art. Therefore the formulation of the laws of linear perspective should have been employed entirely and without reservations in his paintings. Yet we know that this was not so. One needs but read Vasari's chapter on the investigations of Uccello to see that the Florentines realized at once the validity of the laws in their own rights and at the same time saw that they were not incorporable as a whole into the unity of a picture. In view of the fact that Michelangelo was Vasari's teacher, and because of the importance of Michelangelo's influence, Vasari's treatise is a compelling indication that this duality was recognized generally at that time. This is rather a curious commentary upon our own perspective zealots, whose dogmatism on this point is greatly at variance with the position of those who discovered the principle—and in whom such dogmatism could be much better excused.

It is not difficult to see why the Florentine artist must have sensed very deeply the inadequacy of pictorial representation with the use of linear perspective alone. It left him without the presence of the sensual element, which he knew from his experience was a sine qua non for artistic achievement. Whether through knowledge or instinct he understood that in demonstrating a physical law alone he had failed in the ultimate end of art, which is to reduce this law to the terms of profound human sensuality. This was his first step in conceding the duality of the qualities of science and art, and the first indication of the separation between the two. Here was the first statement that science could deal with sep-

arate truths and establish insulated units within fragments of the universe. The artist, however, like the philosopher, cannot create partial unities but must always resolve his fragments in man's subjectivity.

Michelangelo himself could not solve the problem and had to substitute the illusion of sensuality for the immediate plastic equivalent of sensuality. By creating the visual likenesses of sensuality, that is, the appearance of muscular and cavorting strength and animality, he effected a substitution that perhaps contented him. We say "perhaps" because the very excess and strain of these illustrations are an indication of how titanic the struggle was to gain that profundity which he did not otherwise know how to achieve.

Leonardo was the first to hint successfully at the solution for the reduction of art again to the subjective, a solution that was accepted by the great painters in Venice and which served as the basis of a unity between the subjective and objective until the turn of this century. This solution survives to this day and functions side by side with methods rediscovered by artists from our contemporary painting scene. Leonardo, in contrast with Michelangelo, was perhaps more artist than scientist, although, like the other Florentines, he practiced both. Yet even his scientific work is characterized by the unrestrained flights of the imagination for the achievement of the then impossible, reflecting in that work a truly mystical preoccupation.

This hint that Leonardo discovered is the subjective quality of light. In short, by means of this method, which he employed in so fragmentary a form, he introduced a plastic element that was to constitute the basis of plastic romanticism. That plastic device was to serve for the next five centuries as the basis of the expression of the subjective quality.

Plastically, light impressionism made it possible to push space back further and give tactility to the intervening atmosphere. We must note here that the development of this device was really the product of a new technical advance. Leonardo alone among the great Florentines began to experiment with oil paints, and it was this new medium that made it possible to render the infinite nuances of forms passing from light into darkness, to give tactility to atmosphere, and to introduce a sort of haze or smoke whereby atmosphere could be achieved.

To clarify, we should make note of the technique of chiaroscuro, which was at that time already in common use. Chiaroscuro is also a method derived from the observation of the action of light on objects. What additions did Leonardo make to these methods? Michelangelo, as well as Signorelli before him and many other Florentine artists, employed this method for indicating the action of light.

Now chiaroscuro was a method which gave relief to individual objects. For instance, by representing the action and interplay of light and shadow on a figure it was

possible to obtain a heightened illusion of relief around the figure, as well as in relation to the individual parts of the figure such as legs or muscles. It was developed because the early Renaissance artist did not fully realize the differences between the nature of painting and sculpture. Since his inspiration originated with examples of Greek sculpture, and since this was his most cogent plastic clue to the Greek unity (and such clues must be given to the artist plastically), he sought to emulate in his paintings the effects of sculpture. Hence relief, as Vasari states in his preamble to the life of Michelangelo, was one of the gifts which God sent to man in his new status.

But Leonardo's discovery, which was fully developed a half century later in Venice, made it possible to unify the picture tactilely through having all the objects partake of a common enveloping atmosphere, as well as to provide a tactile means for the representation of sensuality. Heretofore chiaroscuro called attention to each particular object and every part of the object with an insistent force which divided rather than unified the composition. But Leonardo's method created a permeating tactile medium in whose essence all objects participated. It must be noted here that the Venetians, who so successfully employed light in their paintings, made a complete exploitation of the oil medium.

To make this matter still clearer let us look at it from yet another angle. Starting with the Renaissance, we find an emphasis on the illusory type of art. In fact, we may say that the shared common objective of the Renaissance artists was to give credence to the world of appearances. This was the first preoccupation of the reborn rationality. And it was a logical step if we consider that the Renaissance was not only a reversion to Greek classicism but also a reaction to Christianity, which was in itself a development of Plato's rejection of the world of appearances because it obscured fundamental essences. And as we have said, it was Plato's inevitable corollary to place the artist in a very undesirable position in his scheme because the painter had to objectify reality through appearances. He could not foresee the development of the twentieth-century method for the representation of the essence of appearances through the abstraction of both shapes and senses.

The Renaissance masters, therefore, began to study the fundamentals of appearances and the laws of vision. Chiaroscuro and perspective were the first to be developed. These enabled the masters to formulate methods for giving the particulars of their paintings the illusion of existence. But they could not include within these methods their own sensuality toward these particulars. It was sensuality that they knew would be the ultimate bond for the separate illusions of appearance that they used in their compositions, and it was this that the Venetians developed. Their method allowed them to relate, sensuously, objects which had no ideological unity to bind them together. Once they consciously attained this method, the use of the ancient myths began to die, for the myth never really

expressed their unity. Rather, it expressed their desire and nostalgia for Greek unity, or for a unity comparable to it. This had the value of all referents to a myth of the past, for in the expression of the admiration for this myth its essence and existence was reaffirmed. We might say, then, that Leonardo and the Venetians developed a method whereby the picture as a whole retained its unity, and made it possible for the artist to make representations of not only illusions of objects, but illusions of tactility itself.

Light, then, is the instrument of the new unity. It is indeed a wonderful instrument and was wonderfully suited to the inevitable interests of the next four centuries. During that time men were occupied with the investigation of the world of appearances, and the study of appearances manifests itself in attention to the particulars. Through this instrument the artist could elevate the particular to the plane of generalization through the subjective feelings that light can symbolize.

Emotional and Dramatic Impressionism

We can call this new unity, enabled by the plastic use of light, *impressionism.** And the word is applicable from this time on not only to the plastic means of art, but to its subject and subject matter, too. For the world of appearances is the world of particulars, and in that sense those arts which have not occupied themselves with some nostalgic myth since the Renaissance are occupied with particulars. That is, the artist tries to impart the character of the general from the particular things that he must now employ as the embodiment of his plastic notions. He must enlarge the implications of his impression in the world of appearance. He must enlarge them until they enter the relevance of the human world of sensuality.

And in this endeavor light is the binder, for by its means he can not only make the appearances that stimulate him to participate in a general category of visual observation, but he can find within that category the means to symbolize his feelings about these appearances. For light makes it possible to substitute for the directness of the mythologist's sensuality a new factor that we can call *emotionality.*

In essence, it is emotionality which replaced the myth. The common designation for emotionality is mood. And it is the evocation of human mood that frequently served as the anecdote of European painting since the Renaissance. This forms an anecdotal adjunct to the sensuality which the impressionistic plastic method achieves through the participation of all objects in the solidity and sensualism of their textures generated by their participation in a common light. The quality of this mood is based upon the association of certain specific emotions with the effects of light. In theater productions today this association finds a clear illustration in the use of different lighting to stimulate the associations of sorrow or joy or other shades of emotion. The dramatic and emotional potential of different colored light, degrees of light and dark and the contrast between highlight and deep shadow, evoke a mood before even a word is spoken or any action is introduced. Of

* Rothko here is defining the word *impressionism* for his own purposes, unrelated to the well-known movement, which is discussed in the next chapter.

course, we must understand that it is quite possible to impart mood to the scene without the use of light, and we cannot but be certain that the plays of Shakespeare, for instance, produced this mood effectively enough without access to this device.

Mood was present, needless to say, in all the great paintings of any age. But the mood that these impressionists achieved was of a different type than those represented by other painters. Mood, generally, was the effect resulting from the implications of the anecdote, from human action, and from the rhythms produced by the disposition and tempo of moving masses. The mood here, on the other hand, is a specialized form of sentiment. In a sense, sentiment is closely related to sentimentality. By way of definition, sentiment might truly be called the illusory representation of mood, and sentimentality may simply be called an excessive and therefore banal representation of sentiment.

Ultimately mood was the subjective factor that, allied with the objective participation in the world of light, produced the new unity of subjective and objective. And when this unity provided a generalization large enough to give a comprehensive expression of the artist's notion of reality—that is, when the objective mechanics of the picture produced a sense of infinity that referred the mechanics to ultimate mechanical order, and when the mood sentiment reached the proportion of universality, of symbolism rather than sentimental illustration—then we had a generalization whose equivalence at least approached the domains of mythical reality.

Mood or sentiment might be called, too, the introduction of the factor of humanity into the picture, an attempt to relate the representation of the individual emotionality in the terms of universal emotions. Therefore, the person who in the popular sense alludes to the humanity of a picture is undoubtedly thinking of the type of emotionality Rembrandt achieves. For Rembrandt did succeed in doing just that: the enlargement of human emotionality to the plane of a universal emotionalism. And he did so by means of the methods of impressionism.

It is significant that such emotionality in relationship to the individual is found only in a tragic emotionality. In comic situations this quality is achieved only in an ironical presentation whose end again is the enhancement of the tragic element through the medium of contrast with the tragic doom. This is an intricate subject that will not bring us much further in our study. Let us just briefly state that pain, frustration, and the fear of death seem the most constant binder between human beings, and we know that a common enemy is a much better coalescer of energies and a much more efficient eraser of particularities than is a common positive end.

Perhaps this focus on the tragic is also a vestige of Christian myth, wherein suffering was an instrument of salvation. Yet it is more likely that Christian suffering was

given that position because it helped to bring this fear and insecurity to a logical place in ultimate unity. Nietzsche's analysis of Greek tragedy offers a fine hypothesis of how Greek tragedy itself solved the problem of pain and evil. Nietzsche found that life would have been unendurable for the Greeks—as it would have been for anyone—unless a heroic attribute was imported to suffering by means of art. To him, in fact, the entire function of art is to produce an intelligible basis for the endurability of man's insecurity. We need not decide which of these is the correct answer. Suffice it to say that this is a truism: that it is through the tragic element that we seem to achieve the generalization of human emotionality.

Throughout the era of emotional impressionism it must be noted that no society was capable of inventing a myth which could allow the representation of this emotionality in the interaction of human beings. The artist was generally successful only in his representation of a single figure, the projection of the tragic onto groupings of inanimate objects or onto a group of figures whose tragedy was implied by their lack of interaction, that is, by the fact that they gathered not for any interaction but because of some superficial pretext. Whenever he wishes to represent interaction between humans he must necessarily revert to the nostalgia of the old myths. And so we find that Rembrandt, when he is not painting *The Night Watch*, where the figures are grouped through the sheer excuse of function, he reverts to the myths of the Bible or of mythology.

Here we come to the consideration of another exploitation of emotionality to which impressionism was adapted. This is the representation of the dramatic, the emotionality of excitement. Much like the tragic in emotionality, the emotionality of the dramatic is most applicable to the dramatization of individual tragedy in action, or action which embodies strife. Strife in itself is always a heroic element, for it is a struggle against the forces of evil, whether instigated by nature, the gods, or men. In that sense it implicitly embodies the notion of the tragic, especially since the failure in the struggle has death as its reward. So here we have again the heroic notion of the tragic. And men are therefore gathered together in a common action not through some human interaction but rather in the abstract symbolization of the heroic quality of man's response to insecurity and the impending specter of death.

It is to this threat, in proportion to risk, that we experience genuine excitement. We can readily see the difference in the sort of excitement we experience in the suspense of a game of sport and that of a struggle wherein catastrophe is the alternative to failure. Hence the dramatic representation of a ball game is not a subject for ultimate generalization in the terms of the dramatic, and it would suffer the same lack of profundity and conviction that attends the dramatic portrayal of any genre excitement.

We see human drama and tragedy in the paintings of El Greco and, later, of Delacroix, both of whom are able to evoke plastically the emotionality of excitement through the imposition of color mood upon exciting plastic rhythms and subject matter. In the case of the dramatic portrayal of human interaction they are effective by means of the manifestation of strife in relation to ultimate alternatives. Actually, both artists express the emotionally tragic through the agency of light mood. They both suffer limitations in representing real human interaction because they lack a myth to give a symbolic place to that interaction within the framework of an ultimate unity contemporaneous with the artwork.

The need for the myth, the yearning for it, is periodically revived by those who reappropriate it for nostalgic reasons. And as we have said, the search for a myth represents the dissatisfaction with partial and specialized truths and the desire to immerse ourselves within the felicity of an all-inclusive unity. This search goes on to this very minute.

Objective Impressionism

The impressionism which is connected, in the vernacular, with art such as that of Monet, Sisley, and Pissarro, is really the continuation of the integrity of the light factor in a picture, and from that point of view is no departure from the interests of painting since the end of the myth. These artists, like their predecessors, continued to use light as the chief sensual coordinator—the common denominator which bound all the elements of the picture—and maintained the use of the resultant mood as the emotional source of the picture. Their chief contribution was the discovery of the possibility of achieving these effects without reliance on tone, and they showed the possibilities of reducing the extended spectrum palette into the domain of impressionism.

Now the use of color for its own sensual ends as well as for its structural ends had greatly deteriorated since the time of Giotto. Perspective displaced the use of the organic quality of colors, which had previously, in and of themselves, produced the tactile effect of recession and advancement. Painters who wished to push distance further and further into the canvas, away from the frontal plane, and who were interested in the illustration of the illusion of space, had found perspective a more suitable demonstration of these desires. Also, the development of atmospheric perspective had emphasized the tonal values of color as they appeared at various distances from the frontal plane, and abstracted color from its sensual effects to the functional ends it served. A painter was not interested in giving the sensation of colorfulness but rather the sensation of the recession of color, that is, in its various intervals of gray as it receded. Also, instead of affecting the emotions sensually by the interaction of colors the artist affected mood through the pervasion of the entire surface by a single color mood in much the same way we described the use of color mood in the modern theater.

For these reasons, the colorfulness of painting since the Renaissance had been greatly reduced. Colors might have been used with a certain amount of brilliance to portray a specific local material, but they always had to participate in the general grayness of tonality. We know, in contrast, that as the last step in painting a canvas some of the old

masters would sometimes cover the entire canvas with a glaze of a single color in order to achieve the one color tonality. To achieve a similar effect, the Venetians worked on colored backgrounds wherein the basic color was allowed to function everywhere through the other colors superimposed upon it. And we of course are all familiar with the general brownness and grayness of the Dutch and English and French pictures. Even Delacroix, who had a passion for the sensual qualities of color, never really understood the problem. He succeeded simply in producing more sensual and more dramatic tonality. That is, instead of browns he used red tonalities, which gave his pictures more dramatic moods than those of his immediate predecessors and contemporaries. The use of fatty oils and varnishes also gave the pictures a more unified tonality, for the reflection of the shiny surfaces made them all participate in the mysterious depths which these materials created.

Now French impressionism did not alter the objectives of the painters in relation to this tonality, but set out rather to render this tonality, this ultimate grayness, by means of a greatly extended palette. In other words, while this technique made it possible for the artist to actually have a greater number of pure or brighter colors on his canvas, the quality of grayness as the ultimate effect could still be preserved. This approach was sparked by the discovery that the optical apparatus actually synthesized. That is, the fundamental or basic materials received by the eye were really different bits of color, which the eye proceeded to combine into the various tonal relationships characteristic of the laws of color perspective. These researches and laws are well known to everyone by now, and we need not go into their explanation here.

The important thing for us to consider at present is: what relationship to the general sense of reality did these new preoccupations mirror? Why did art preoccupy itself with this particular type of analysis after centuries of being satisfied with the representation of light as it gave form and emotion to particulars? Why this new fascination with how these actually appeared to man's visual intelligence?

Our answers will be found in the examination of all the scientific and philosophical preoccupations of that age. Until this time, man's investigation was chiefly centered upon the study of the objects of sensation, of the things man saw, touched, heard, and smelled in the world we call the objective—external to the senses themselves. But now the analysis extended to the examination of the apparatus of those organs by which man received those sensations. Man here differentiated between his intelligible perception and the methods by which he received sensations and finally perceived them. In other words, the senses themselves were removed from the body, turned about, and examined.

Up to this point man and his organs were an inviolable whole, but now specialization was viewed as beginning within the organism itself, and man himself was no

longer an indivisible unit, but the compound of many interacting separate elements, which in their turn produce a new unity. Psychology was born, but it was a mechanistic psychology and it was reserved for a later time to make further divisions that produced still new notions of reality and new unities which in turn needed to be addressed.

Fifteen hundred years earlier Plato had proclaimed that things were not what they seemed. However, he had never conceived of the physical or mechanistic basis that served as an intermediary between seeming and being. We know today that impressionistic synthesizing is merely one of a great number of intermediaries whose properties or scope we have hardly begun to know. Plato's differentiation was of course moralistic as well as scientific and hence found more pertinence in art. Christianity accepted Plato's differentiation and embodied it in a mystical human myth. The Renaissance, of course, rejected Platonism, along with the Christian notion of reality, and committed the Christian sin of considering appearance as reality.

Here, then, with French impressionism we find a swing back toward Plato, and in fact, many later artistic developments bridge the gap between the world of appearances and that of ideas. Actually, these developments gave a physical embodiment to his notion of pure forms and even constructed new systems, which, through the employment of abstract symbols divorced from particular appearances, referenced the experience of ideal prototypes.

We have noted that in this sense, the impressionism of the last quarter of the nineteenth century began the movement away from the acceptance of particular appearances as the notions of reality. Here Cézanne came on the scene, and in the world of plastic philosophy he played an important part.

We might say that Cézanne was a reaction to Monet. We may say, too, that he played the same part toward the laws of impressionism that those Renaissance artists who discarded the demonstration of the laws of perspective as the objective of art played during those times. Essentially Cézanne was a pragmatist. He saw clearly that with the pursuit of Monet's preoccupations, all visual phenomena would be disintegrated into a series of equally material color blobs; that it would be the dissolution of all reality, for the result would be an ultimate monotony wherein the similar would annihilate all differences; a situation which is not consistent with our conscious awareness. For he knew that man was sensitive to limitations, to differences of weight or sharply differentiated forms, and to a variety of intrinsic properties. He knew that a cornerstone of mental life was the apperception of distinctions based upon reference to similarities and that emphasis of sameness leads to the death of consciousness of contrasts. Thus, to heighten awareness of distinctions would be a tool to further emphasize the reality of our sensible perceptions; that it is to this end we should employ our plastic means rather than use them toward the dissolution of differences.

Since Cézanne's preoccupation was particularly one of giving augmented tangibility to the physical existence of objects, in particular the demonstration of that existence through weight, we find that the process developed a series of other manifestations that point to the developments of art which were to follow. Cézanne was not interested in the appearance of particulars of objects. His painting was a demonstration of our sensation or apperception of the abstraction of the real existence of the weight of objects as units. This was a reaction to the dissolution of the unity of particular shapes found in Monet's impressionism. Hence one might say that his painting was the demonstration of the abstraction of weight differences, for it was only through the picturing of comparative solidities that he could give an embodiment of that kind of form to particulars. As a result, his demonstration reduced his particular forms to abstractions, as it was in this manner that he could best impart the clear picture of structural relief. And so, unwontedly, he indicated the direction in which later art developed: toward a plastic equivalent to Plato's notion of abstract ideas. Since he, too, used color structurally to enhance his apperception of the existence of color, he needed to discover the structural function of color.

Cézanne was not blind to the corollaries which came as a result of his preoccupations. For as they developed, one by one he changed the factors in his demonstration to use these new developments. He began by attempting to give a sense of relief by the method of a sculptor, producing an actual sculptural relief by the use of impasto. He augmented the sense of relief by having these accrued protruding masses turning into the space by the means of color. Then he abandoned this method because he realized that color within itself had a tactile function and hence this sort of actual relief was unnecessary. He discovered that the sensation was most directly affected by the color quality itself. He also realized the nature of what he was demonstrating, and spoke of his employment of shapes as abstractions for the purposes of those demonstrations. In this sense he understood and stated the symbolic function of all of his elements in the pictures, and later we find him abandoning his romanticism—that is, the representation of human emotionality— for tactile, plastic sensuality.

In other words, his was a reaction to the notion of the flux and a reaffirmation of the principle of stability. The corollary task was the restatement of the importance of the stability of the ultimate equilibrium of the whole picture, and of all those devices of distortion and abstraction. It also resulted in a general immobility that he imparted even to his presentation of live organisms.

Yet he always remained an impressionist. For like the others, he was interested in the reaffirmation of reality through the agency of light, which is the conveyer of visual reality to man, the agency by which man knows reality through the world of appearances.

Thus, while he abstracted the shapes of the appearances, he still retained their particularities, for he never lost sight of his original and constant objective: the reaffirmation of the visual reality of the world, of the reality of the things that we accept as real in our visual experience. All his use of the abstract factors were for the purpose of the augmentation of the sense of the world of appearances. This is the direct opposite of those who developed his methods for the demonstration of the participation of experience in the generalizations of the world of ideas.

Cézanne also accomplished the structural reconstruction of painting. As we have said, it was his purpose to reaffirm the reality of the world of appearances. This reality wasn't one simply of the individual objects, but had to be applied to those objects' interrelationships as well because the generalization of the validity of appearance meant the extension of that validity to the perception of the solidity of all their interrelationships. He therefore imparted this solidity to every square inch of the picture. This again was a reaction to those who dissolved the concreteness of both space and the objects within it into the uncertainties of romanticism. Painters, in their overemphasis upon mood, became slipshod in depicting the reality of those elements to which their mood was applied. The portions that were not as important as the central object of their romantic illustrations fell more and more into neglect. Painting had become the extension of mood to perceptible objects when there were no longer any objects to receive these extensions. In that sense, Cézanne's art was a protest in two directions against the dissolution of the world of matter; it argued against the sacrifice of the tactile for romantic emotion, even as it countered the dissolution of tactile appearance, that is, he moved away from the manner in which Monet and others had divided tactile appearance by its division through the representation of the mechanics of vision.

In that sense he was the exact opposite of the painters who came after him. For he was mindful of the world of appearances and spent his life in the reaffirmation of that world's existence. His followers, however, while imbibing and continuing his predilection for structural integrity, abandoned the direct world of appearances and sought to affirm that structural integrity through references to the generalizations of forms.

Plasticity

DIFFERENT KINDS

This book is devoted mainly to the description of the plastic elements. It is necessary at this point to define what we mean by plasticity. There is no common agreement as to the exact limits of the meaning of this word. Different groups at different times have employed this word to describe desirable attributes in a painting, and they have also described the shortcomings of a work by noting the absence of its plastic qualities. Never has the word been used as an indicator of undesirable qualities. That is, a painting has never been considered bad because it was plastic. On the other hand, it is clear that some painters will praise a painting specifically for possessing plastic qualities, while another group will say that this same painting is lacking in plastic qualities. Obviously, plasticity is a virtue which is considered desirable in every painting, and it would be true to say that a painting will not be considered excellent unless it contains plastic qualities.

Modern painters will generally deny that Dutch genre pictures are plastic. They will say that, in these paintings, the picture as a whole has no weight, the space is not real and is treated as a vacuum rather than as a substance, and that both textures and space are illusory rather than real and tangible. Academic painters, on the whole, will deny that modern paintings achieve any sense of plasticity in their use of space. They will deny that things move in space at all and that the textures give them any sensations of actual existence. We will find that the discrepancy between these two positions stems basically from how each views the nature of reality.

Both groups of painters are interested in the sense of existence which a painting achieves. They want to feel that the painter has given his picture a conviction that makes it convincing as defined within their own conceptions of reality. The notion of plasticity therefore implies that the artist has convincingly imparted the feeling of existence to the picture.

It would be interesting here to quote Mr. Bernhard Berenson on this subject in his discussion of the work of the great Florentine, Giotto, in *The Florentine Painters of the Renaissance* (1896). He says:

Psychology has ascertained that sight alone gives us no accurate sense of the third dimension. In our infancy, long before we are conscious of the process, the sense of touch, helped on by muscular sensations of movement, teaches us to appreciate depth, the third dimension, both in objects and in space.

In the same unconscious years we learn to make of touch, of the third dimension, the test of reality. The child is still dimly aware of the intimate connection between touch and the third dimension. He cannot persuade himself of the unreality of Looking-Glass Land until he has touched the back of the mirror. Later we entirely forget the connection, although it remains true, that every time our eyes recognise reality, we are, as a matter of fact, giving tactile values to retinal impressions.

Now, painting is an art which aims at giving an abiding impression of artistic reality with only two dimensions. The painter must, therefore, do consciously what we all do unconsciously,—construct his third dimension. And he can accomplish his task only as we accomplish ours, by giving tactile values to retinal impressions. His first business, therefore, is to rouse the tactile sense, for I must have the illusion of being able to touch a figure, I must have the illusion of varying muscular sensations inside my palm and fingers corresponding to the various projections of this figure, before I shall take it for granted as real, and let it affect me lastingly.

And he sums up: "It was of the power to stimulate the tactile consciousness—of the essential, as I have ventured to call it, in the art of painting—that Giotto was supreme master."

Actually Mr. Berenson is only hinting at an idea which is the foundation of plasticity in modern painting carried to its logical conclusion. It is this same notion of tactile reality as championed by modern painters which allows us now to better accept the space of the Egyptians or Chinese.

Edwin Blashfield, on the other hand, does not share Mr. Berenson's notion of the supreme reality of Giotto's work. In fact, he finds it quite inadequate in a number of ways:

Speaking of Giotto's figures in *Italian Cities* (1900) he says that they "are but little modelled, and this slight modelling happens to be admirably suited to the kind of decoration which he was doing, but it was slight because he did not know how to carry it further."

Of his draperies he says, "Giotto had not yet learned to paint drapery realistically, but he had the sentiment of noble composition, and he arranged his folds simply and grandly, and painted them as well as he knew how, pushing them as far as he could."

And he finds fault with his treatment of grass, noting, "The drapery was one piece, and he could arrange it in a few folds, but the blades of grass were all there, and

44

he thought he must draw every one. Ruskin and Rio and Lord Lindsay all regard this incapacity as a special virtue based upon a spiritual interpretation of the relative importance of things in nature and art. They account as truth in Giotto what was really the reverse of truth. In looking at such a scene as that represented in the fresco, no human being could see every blade of grass separately defined. A general effect of mass would be truth, and Giotto would have grasped it if he could have done so, but he was not yet a master of generalization."

In the quotations of these two men we see a hint of the diversity of what they consider pictorial reality. The picture would be yet more confusing if we added the opinions of still others who have written on the subject of Giotto. But the opinions of these two men point out a basic difference. One seeks a reality which is commensurate with his sense of touch; the other seeks a reality which is commensurate with the idea of sight divorced from every other sense. It will be shown later that these are the basic differences into which all of the other differences might be grouped. While in the case of Giotto there is this basic difference (and specifically because Giotto's painting violates so deeply Blashfield's photographic sense), in later painters there will be sufficient agreement between Messrs. Berenson and Blashfield as to make our problem somewhat easier and provide a common denominator for what the artist wishes to attain.

It is not our purpose to justify one school of thought at the expense of the other. Both point to a bulk of artistic achievement whose worth cannot be easily cast aside. Their preference for one or the other is the result of particular prejudices that are dependent upon their own particular interests in art and in criticism. These prejudices are not reprehensible; in fact, they are essential to both artist and critics. For were they not thoroughly convinced that reality is precisely as they conceive it, they could not convince us of that reality in their own work and we should have nothing at all. Each age, and each artist within that epoch, assumes certain truths or variations of it, and his devotion to it is the sum of his gifts to the rest of us.

In making a definition of plasticity, therefore, we must evolve one which will serve to explain the nature of the means that we consider pivotal in our investigation. It must be equally applicable to either of these cases we have just set forth. Thus it must operate successfully in the fulfillment of both of these aims which, on the surface, seem so divergent and antagonistic.

It must be said at this point that the author's own prejudice would lead him to contest the validity of Mr. Blashfield's ideas. Yet there is a school of modern artists who, while they would perhaps not accept Mr. Blashfield's work as a manifestation of their own principles, might still employ aspects of his theories in a modern sense.

Here, then, is a definition that we shall offer for the term *plasticity* in this work. Its validity is dependent on how closely it fulfils the analysis given here.

The word *plastic* is generally applied to such materials that are malleable. Similarly, in the arts it is usually applied to techniques that use materials which are malleable. Sculpture in clay, soft wax, putty, or any pliable material receives the most immediate application of this word. Similar work in metal or stone in which we can make dents by means of tools can also be readily seen as answerable to this description.

If we apply this same notion to painting, our most immediate association would be with paint so thick that it could be modeled to give the effect of relief or the incision of drawing in fresco. As a matter of fact, there are many painters who have accepted this literal association and will insist that theirs is the most elementary and natural method of achieving plasticity with paint, and ascribe to such work, therefore, first place. Even a great painter such as Cézanne, who, as we have seen, was interested in regaining the structural power lost by impressionism, seems to have been addicted to this notion in his early work. Later his opinion changed on this subject and he felt that this method was a misappropriation of the medium. How, then, can we transfer the use of the word *plasticity* to the realm of painting, where most of its practitioners have not attempted any type of modeling effects?

To answer this question let us first examine the purpose of indenting either stone or clay. Obviously, it gives the sense of things going back and coming forward in space. Let us say a head is being modeled. The nose protrudes, the eyes sink in. The eyebrows overarch the cheeks, the hair frames and comes forward from the brow. The lips are two protrusions, and the sinking in-between is the mouth. The chin comes forward, the neck recedes, etc. The character of the figure, or the excitement of the symbols it contains, is conveyed to us by a series of advancements and recessions. The reality of the artist's intention in relationship to the material is communicated by means of these aggressions and recessions.

Let us consider a piece of decorative metalwork to make the argument clearer—for example, a metal flower. How is its flowerness communicated to us in the metal? The metal is hammered up so that it forms protuberances. At the edges it slopes inward to give us a sense of its concavity. A deeper incision produces the sense of space that separates each petal from the next. In the center a still further depression receives the protruding stamens and pistil. The flower is achieved by a series of back-and-forth pushes in relation to the original plane of the metal. These depressions and protrusions render not only the similitude of the flower, they also produce a series of rhythmic movements which cause our eye to follow their course up and down, in and out, under and above, contriving for us a spatial journey.

Plasticity in painting points to a similar effect. It is the process in which reality is achieved by causing forms to progress and recede, and that is why the word *plastic* is applied to both painting and sculpture. Forms and space are realized by making the foremost parts come forward and the parts further removed from the frontal plane recede into the distance. In a painting, just as in a sculpture, these movements must be organized so they make sense in relation to each other. This is achieved again by certain rhythmic intervals of progression and recession.

The plastic elements are therefore the means and the devices which painters employ to produce these effects of movement in space. They are, in fact, the only means known by which the representation of our ideas in the materials described can be achieved. Plasticity, then, is the sensation of reality imparted to us by means of the sensation of things moving back and forth in space. The plastic elements are numerous. In fact, all of the devices and elements we will discuss contribute to this effect. Not all of them may be used or need be used. In fact, the differences between artists or their styles is, to a great extent, determined by the means they choose to produce this sensation.

Now, these elements are used also to produce many other sensations, but ultimately the whole purpose of art is to produce something which is inward and quite apart from these elements. In other words, these plastic elements are simply a means to an end, not ends in themselves. These ends are not in the scope of this book, for here we shall deal only with those things that are constant in all works of art. The sum total of the artist's ideas, his environment—both psychic and physical—his own peculiar intellectual digestion, all of these arbitrate the ends to which these elements will be used.

In painting, plasticity is achieved by a sensation of movement both into the canvas and out from the space anterior to the surface of the canvas. Actually, the artist invites the spectator to take a journey within the realm of the canvas. The spectator must move with the artist's shapes in and out, under and above, diagonally and horizontally; he must curve around spheres, pass through tunnels, glide down inclines, at times perform an aerial feat of flying from point to point, attracted by some irresistible magnet across space, entering into mysterious recesses—and, if the painting is felicitous, do so at varying and related intervals. This journey is the skeleton, the framework of the idea. In itself it must be sufficiently interesting, robust, and invigorating. That the artist will have the spectator pause at certain points and will regale him with especial seductions at others is an additional factor helping to maintain interest. In fact, the journey might not be undertaken at all were it not for the promise of these especial favors. But, as we have said, it is these movements that constitute the special essentialness of the plastic experience. Without taking the journey, the spectator has really missed the essential experience of the picture.

While we do not wish to convey the idea that the languages of painting and music are interchangeable, an analogy here may clarify what we mean. An auditor can lie back in his chair and be overcome by the sensuous waves of tone which are aphrodisiac or narcotic. He may even find the pleasure of beating with his foot, enjoying each momentary change of interval. Yet if this be the sum total of his reaction, then he has not experienced the piece of music. Unless he has traveled with the composer up and down the scales and through the corridors of polyphony, and has sensibly observed the relationship of the elements in this journey to one another, he has simply experienced a sensual pleasantness not far removed from the kind induced by the spilling of a bottle of perfume.

In the case of the flower, the plastic journey is up and down the crags of petals, down its curving sides, passing through the crevice between the petals, and climbing up the curved inclines of the next. The sum total of that journey is the metal flower, yet it cannot be perceived without having taken that journey. One has gained knowledge of the flower by taking a topographical tour.

To this end, any of the plastic elements can serve. The fundamental unity of conception lies in the kind of space the artist employs, and the kind of space he uses will determine how color, line, texture, chiaroscuro, and every other item contributes to this movement. For all of these elements intrinsically have the potential to produce that motion. Color advances and recedes. Line gives the direction, the attitude, and the tilt of shapes. The functions of each of these elements in the plastic scheme are unique, additive, and essential, but before these can be dealt with we must discuss the world of space, for it determines how the others will function in the picture.

PLASTICITY AND SPACE

The examination of any plastic work will show that it knows no other way in which it can make the statements particular to its medium. Movement in relation to the picture plane—away from it, toward it, and simultaneously across it—is the means by which the pictorial experience is achieved. It is much the same as music, where it would be impossible for us to think of a musical statement in any other fashion than movement in time, up and down the scale, or progression through beats of rhythm. It is true that recent experiments have tried to give music a spatial feeling through vertical harmonies, and that painting has tried to produce a sense of time through rhythmic intervals. That is understandable, of course, since our own notions of time and space today are prone to be combined in a single formula called *timespace*. Yet this conception, which is popularly alluded to as "the fourth dimension," must remain an abstraction for, to our senses still, space

and time are measured by two different standards, and the relation needs an intellectual process for its combination.

In other words, these experiments attempt to shift the ends of the plastic process and do not involve the use of new elements. For we still conceive of paintings in terms of a space in which the element of time can receive special emphasis, for it has always been there; and music must be conceived of primarily in terms of time for the purpose of simultaneously receiving a sense of space which again was always there, for modern science has shown us that it is impossible to separate the two, and that to do so is simply a convention. Yet the fact that this is a convention can be explained by the limitations of certain media to express a particular view of things in which the unexpressed elements are symbolized. Such is the nature of all human forms of communication, and this is why the particular expressions of a definite medium are not interchangeable with that of another. Thus we cannot duplicate the statement of a painting in words. We can only hope to arouse with our words a train of similar associations, but these are subjective to the spectator and in no way duplicate the original statement. Therefore, such an attempt might be criticized as an extension of the plastic language beyond its proper domain to perform a function which is not within its power. This is a problem about which, fortunately, we need not draw conclusions here.

To return to our original problem, what is the difference between Mr. Berenson and Mr. Blashfield? They both want a picture to have a convincing sense of existence. Yet their kinds of existence are not the same. Giotto, let us say, gives Berenson pleasure because he imparts a sense of reality in a more intense form than he is capable of rendering himself. Giotto's greatness lies in his ability to communicate a sense of reality in his pictures that is more palpable than most are capable of creating. Mr. Blashfield, on the other hand, admires certain decorative felicities, yet from the point of view of his kind of reality Giotto falls short on many counts. The draperies and the flowers are not good, for example, because that is not the way they would appear to the eye. Here we can arrive at the basic difference: Mr. Berenson seeks the reality of *tactility*, while Mr. Blashfield seeks the reality of *appearance*.

This difference is really fundamental. It provides two categories for us which, one might say, are the basic ones of which all other differences are corollaries. As a matter of fact, in most art which is controversial, the controversy is due to the demand on the part of the disputants that the one or the other point of view is the proper representation of reality. This is an antagonism that has persisted to this very day, even within the ranks of those factions which seem united and opposed to other factions, for example, among the modernists or among the academicians. And the description of these differences will lead

us to a definition of plasticity which we hope will be able to include both these points of view within its scope.

Mr. Berenson is not conscious of the shortcomings that Mr. Blashfield must point out. He feels that Giotto has given a supreme sense of reality. He does not observe that the flower and the garment do not correspond to how these things actually look. He finds Giotto convincing because he can actually touch, can sense the tactility of Giotto's forms. He demands that his eye does not only see it but that it feels the physical matter of the things represented. He wants a totality of sensation, which, from infancy, is attributable to his eye.

It is interesting at this point to find a corroboration of Mr. Berenson's position in recent psychological experiments. The newspapers have reported the experiences of a young man who had been blind from infancy and whose sight was restored by a surgical miracle. This man actually had to learn how to see. At first he could not get any sense of reality from sight alone and had to corroborate what his eyes showed him by touch before he could satisfy himself as to the existence of an object. For example, a nearby dog and a horse three blocks away seemed to be the same size. He had to learn that things diminish in size at a distance, and that colors are grayed. In other words, he had to learn how things looked in space in relationship to others, just as we must learn through touching that a shadow represents volume.

In Mr. Blashfield's position it is interesting to note that he is not concerned with the reality of any particular object. Instead he is concerned with how it looks, which implies, of course, how it looks under a variety of specific conditions such as light or grouping. He is dissatisfied with Giotto's flowers because they are all painted in detail. This is not how they would look, he says. Let us repeat here: "In looking at such a scene as represented in the fresco no human being could see every blade of grass, separately defined. A general effect of the mass would be the truth, and Giotto would have grasped it if he could."

Mr. Blashfield's position, then, is that reality in a painting is a duplication of how things look in relation to the mechanics of sight itself. He denies that the picturing of every blade of grass is truth because the eye does not see all of them. And if someone would object that even if we do not see each blade of grass we know that it is there and therefore we are justified in picturing it if we like, Mr. Blashfield would undoubtedly object that painting owes its allegiance to the sense of sight only, and therefore any additions through any other sense would be a denial of essential truth and inadequate in a completely satisfying picture.

We are ready now to make a generalized statement of these differences. Mr. Berenson apparently demands that a picture be reality in itself, that its textures and the movements satisfy directly a physical sense of touch. When he can actually touch forms and

textures he knows that the picture exists. Mr. Blashfield demands that a picture remind him of how things look. If grass or any other object is painted he must corroborate them through his experience of seeing. In other words, for him, reality is always corroborated by reference to his sense of sight. He wants the picture to create an illusion that will be identical, insofar as possible, with what he observes through his sense of sight.

To make this point somewhat clearer, we need but to travel on two sides of the example we have used up to now. Giotto has been a very good example because he is more or less acceptable to all schools of thought. Blashfield, while denying Giotto's attainment of ultimate pictorial truth, nevertheless concedes his stature as an artist, and considers him unsurpassed in the dramatic aspects of his work as well as in the decorative. It is just the limits of his use of these words we do not know. But whatever they be, they indicate his proper respect. Yet, should we go somewhat back in time and examine Giotto's forbears, the Byzantine painters, we shall find the notion of tactility carries further and can therefore illustrate our point. I doubt whether Berenson himself would have conceded the logical con-clusions to follow. He wrote, however, before modern art had brought these painters back into repute.

These Byzantine painters were in the habit of embellishing their works with actual precious stones, and the halos which encircled the heads of their saints were of real gold. These stones, this gold, and the brilliant colors which were really an extension of the same idea and would have not been used if additional materials of great intrinsic and sensuous value were available, were not employed to convey a picture of the garments of the dignitaries pictured, but rather, in themselves, in their own costliness, to give a sense of the power and the sumptuousness of the church. Obviously this sensuousness could have been conveyed by illusory means, as witnessed in the representation of jewelry in either our portraiture or in the painting of the sumptuous costumes of the eighteenth century. To say that these Byzantine artists had not the skill would not be true, for they had the Coptic examples to learn from, where such skill is readily displayed. The only explanation was that they did not seek to create illusions but instead to directly convey their meanings.

It is exactly the same sort of motive that has caused some modern painters to paste pieces of material onto their pictures. There is the conscious distinction between illu-sion and the fact itself. It may be argued that here the painter is encroaching upon the domain of the sculptor. But not so, for we do not expect from the sculptor that he tint his statues in natural colors nor that he reproduce the texture of skin and pores, but rather we allow him to exploit his materials for the beauty inherent in them. This example brings us to another characteristic of painting. As in the case of sculpture, where the sculptor is not asked to produce the visual illustration of life, so may the painter feel it unnecessary to pro-

duce such an illusion. The picture is a thing of paint on a flat surface, and there is no need to make it appear as anything else, no more than it is necessary for the sculptor to make his stone look like anything but marble or stone, something which he could very well do (if you do not believe sculptors possess such skill, examine the manikins in our store windows and observe the sometimes breathless wonder of the crowd, watching for a single betrayal by movement of the fact that this is only a person disciplined to be immoderately still).

The fulfillment of Mr. Blashfield's ideal of pictorial truth does not take place until some hundred years after Giotto lived. Consequently, pictorial truth does not exist for Blashfield until that time except as accidentally stumbled upon by some artist, who could only hint at it but had not the knowledge of the laws which would make possible their consistent exploitation. Giotto himself used the foreshortening of buildings, and the diminution in size, but not always in accordance with visual laws, and sometimes he would have figures ridiculously small where they should have, by the laws of perspective, appeared larger. The whole notion of a purely visual sensation was developed into a system during the fifteenth century by Squarcione and Mantegna who, it is believed, codified linear perspective, along with Masaccio and Leonardo, who added the visual laws of chiaroscuro. Chiaroscuro is the representation of light and shadows in relation to the source of light, replacing the older notion wherein the darkening of edges simply served arbitrarily to round shapes, and differences in value were used for the ends of decorative contrasts and dramatic effects. In other words, not until these visual laws were in place as the basis of picture composition could Mr. Blashfield's notion of truth be attained. With the knowledge of these laws, the appearance of situations could be duplicated. "How natural" this picture appears is therefore popularly the statement of how well the picture conforms to the laws of seeing. That these are but man-made laws has been amply demonstrated by the case of the young man who regained his sight and who then actually had to learn them.

To demonstrate this further we need only turn to the scenic designs of the fifteenth century, where, by means of these visual laws, long vistas were simulated on a flat background. No one, of course, is fooled into imagining this background really as space. But this background reminds us of how space actually looks, and therefore we are willing to accept it as such. The structural theater is, of course, a rebellion against this type of illusion and employs actual constructions on stage to eliminate this reliance on illusion. We need not argue the merits of this. Suffice it to say that the painters of the fifteenth century produced paintings, one of whose chief aims was the demonstration of the proficiency possible in achieving the illusion of actual vision. This sort of painting, therefore, is frankly illusion, and depends upon its resemblance to things seen, or remembered as being seen, as the corroboration of their validity. Blashfield was working from this perspective when

he criticized Giotto's flowers, which were inadequate because Giotto did not paint them as they would appear.

The same duality applies to form. Now, form is the validation of a shape for us through the recognition of its weight. Weight, in turn, can be perceived in a picture in two ways. First we shall take the illusory. Let us say a piece of iron is pictured so that we can tell from its appearance that it is iron. We know from having handled iron that it is heavier, let us say, than an equal volume of feathers. Now, if a painting showed a metal bedstead with pillows on it, and the pillows were also recognizably painted, we would realize that the iron is heavier than the pillows. It will be seen here that the sense of form can be achieved only by the comparison of the density of objects to each other in the picture. Here we have, then, a sense of comparative densities which is based on the comparison of two appearances of substances, and that through our knowledge of the comparative densities of the two substances represented we have some sensation of comparative form.

The tactile way of representing form, however, again makes reference to the abstract quality of density directly. We know that some things actually give the sensation of being more dense than others. Things which have absorptive textures, for instance, seem heavier than those which have translucent substance. Cubes, for instance, look heavier than spheres of the same material. Here, through the agency of textures and shapes, we can impart actually a sensation of comparative weights which does not depend upon our recognizing a specific material.

In this discussion of form and weight we must also consider the confusion between plastic force and the illusion of power. A good example of the difference between the two can be seen by a comparison between Michelangelo's and Giotto's achievement of force of form. The thing which we consciously feel in Giotto is the massiveness of his forms. His figures give us a physical sense of weight; when they lean we feel their potentiality of falling with a crash in response to the force of gravitation. In Michelangelo, too, we have a sensation of power but of a different type altogether. Michelangelo's figures look powerful. By the representation of bulging biceps, thighs, abdominal muscles, and the extension of the shoulder and neck muscles the idea is communicated that the man is very strong, and we know that if this man should fall there would be a terrific crash. There is a great difference between these two representations, because in the case of Giotto we perceive the feeling of weight and massive movement from the tactility of the form, divorced from our experience of a human being, while in the case of Michelangelo we simply know that a man with such a powerful and tortured expression must be powerful and must feel very badly. Again, we can make the comparison to the abstraction of

music where we can feel gay, sad, heavy, or light, not by any human association but through the relationship of rhythms and the textural quality of the sound.

The foregoing discussion makes clear that a picture can be realized by completely different methods. First let us name the two different schools for the sake of convenience. Let us name one the *tactile* type of plasticity and the other the *visual*, or *illusory*. The word *illusory* is not used here in a critical sense. It is used simply because it seems to us the most vivid description of the type of sensation which it evokes.

It should be pointed out that in the early races of men, primitives in aboriginal races today, the insane—who, according to psychiatrists, simply travel back on their road of development toward childhood—and peoples such as the Chinese, who have retained the characteristic artistic traditions of antiquity, we constantly find the employment of the tactile type of plasticity. To this end it is important to note, too, that children, at the beginning of their painting career—let us say to the age of ten, when they are not inter-fered with—have also invariably employed this type of painting. In this case it is obviously used altogether instinctively. It will no doubt be pointed out that our theory is at odds with the facts, for certainly in the case of primitive races, whose life is full of supernatural beings and forces, and in that of children, whose fancy takes them so entirely into the realm of the imagination, the illusory type of painting would be dominant. But while it may appear untrue on the surface, our theory still holds. For the gods and demons of antiq-uity, and the reveries and vagaries of childhood, are far more concrete to them than many of the things we consider as part of reality today. These gods and demons and these imag-ined fantasies are ever with these people. They live in their houses and can be addressed, entreated, cajoled—even bargained with —and they constitute as tangible a part of their existence as a tree or a stone.

Examine, on the other hand, those things we speak about with certainty, let us say the atom, or force, or environment, or many other nouns, and let us examine how well we can visualize or describe them. Hence, in any representation, children and primi-tives give the most concrete sense of reality to the symbols which to them are a concrete part of the world and which the plastic arts can reflect as real. Here, obviously, they must create reality, for there are no visual prototypes. In fact, they achieve a sense of reality so compelling that to the African, his images are real gods, and to the ancient Egyptian, those figures on the wall will be boon companies to banish the loneliness in the long solitude of the tomb, while the sarcophagi of the Christian saints are actual embodiments of them, possessing the power to heal the sick and give new courage to the soul.

It is reasonable, therefore, that modern art, in its objective reanalysis of the plastic processes, found that these tactile methods were the most basic and employed them

54

and have, in many cases, made it a prerequisite of legitimate painting. For undoubtedly it is the natural, basic method for plastic expression.

The apparent naturalism of objective painting will not constitute grounds in this book for the rejection of the illusory type of painting. It is not for us to say that only the natural must survive. If man can excite and move us by sophisticated variants and developments, we shall accept them.

We are now ready to produce our definition of plasticity: Plasticity is the quality of the presentation of a sense of movement in a painting. This movement may be produced either by the inducement of an actual physically tangible sensation of recession and advancement, or by the reference to our memories of how things look when they go back and move forward.

This is the problem stated in the simplest way. And it is through this way of looking at it that we shall be able to examine the plastic elements in their widest sense and in their function of producing this movement. Here, therefore, with this definition we need not be partisan to either of these methods. Moreover, we may as well recognize that these two methods rarely occur in painting without the other. In every work, to some extent, both are employed. It is simply a matter of emphasis. Largely, whether a painting fulfils its dictates in relationship to one idea or the other is determined by what representation of space it employs. Space is the philosophical basis of a painting, and its kind usually determines how the plastic elements are to function within the picture. It is to space, therefore, that we must turn our attention next.

Space

DIFFERENT KINDS

Now what is the essential difference between the sort of space which is characteristic of tactile painting and that which is characteristic of illusory plasticity? And why do we designate one as tactile and the other as illusory? That is, why does one kind of space actually give us the sensation of things that can be felt by touch while the other can be perceived only by the eye, this latter type of perception apparently a specialized or departmentalized function of sight?

Tactile space, or, for the sake of simplicity, let us call it air, which exists between objects or shapes in the picture, is painted so that it gives the sensation of a solid. That is, air in a tactile painting is represented as an actual substance rather than as an emptiness. We might more readily conceive it if we picture a plate of jelly or, perhaps, soft putty, into which a series of objects are impressed at various depths.

The artist who creates illusory space, on the other hand, is interested in conveying the illusion of appearance. In his very attempt to be faithful to appearances, however, he cannot give air any appearance of actual existence, for a gas cannot be seen. Hence we have an appearance of weight for objects themselves and none for the air that surrounds them. In other words, there is no way to represent the appearance of this all-pervasive substance which we know has a pressure of fifteen pounds per square inch. As a result, the appearance the illusory artist achieves is of things moving about in an emptiness. The only way in which the air can even be hinted at as a solid is by the introduction of certain apparent gasses into the picture. As a result, we have the introduction of such things as clouds, smoke, or mist and haze as the only means by which the appearance of existence can be imparted to the atmosphere. Another method is the knowledge of atmospheric perspective. By this science we know that objects of a certain color become grayer in color as they recede in space. So if we paint objects at various spatial intervals into the canvas, we can imply the existence of air through the visible effects upon these objects by the intervening air.

This is why a certain fuzziness occurs in some masters' work, particularly the impressionists, and by those we mean all painters who tried to give a sensation of atmos-

phere through illusory methods. They were aware that the picture lacked atmospheric solidity if air was not represented. Hence the introduction of a haze, but one which had to involve the representation of the object as well as the surrounding air, since to have imparted the haze to the air without imparting it to the figure would have necessarily involved a discrepancy. Hence the paintings of these artists obscure the outlines of their shapes, and we obtain what can be described as a fuzziness of effect.

In order to best demonstrate two divergent spatial philosophies with the greatest possible clarity, we must choose examples of each in which are found the least number of contradictory or compromising attributes of the other. For art does not proceed in the identical tracks with science, although at most times they seemingly walk arm in arm, particularly if we do not look upon science as the quantitative formulation of all phenomena, but rather if we view it in its more comprehensive state wherein it is only a collective designation of the sum of those things which man can definitely say he knows. At times the poet or the painter stumbles upon a metaphor that prognosticates by a thousand years the future births of truth. However, since he cannot formulate this prophecy or chance coincidence, we shall call it only a lyrical ebullience. Perhaps he has, through some dim agency, suspected how hearts would flutter at the nostalgic power of illusion and has allowed it to creep into his work, although completely foreign to his purpose. On the whole, however, we can say that Egyptian wall painting is an undiluted example of plastic spatiality and that the paintings of Perugino have as their aim the creation of a completely illusory spatiality.

In the case of the Egyptians we find no division of space into the vertical and horizontal planes, which are the most elementary manifestations of illusionary space in painting. All the figures exist on a single horizontal line, which, by the way, is the instinctive beginnings of a child's achievement of portraying space. Every child begins by placing one line on the very bottom of his paper to represent ground, and another at the top to represent sky. This apparently is a completely instinctive symbol, for it is not, as far as we know, taught to him. This convention appears immediately after the child comes to have representative tendencies, that is, when he considers his paintings as the expression of the story. This stage usually takes place after he has achieved manipulative control at about the age of five. The only variation is a complete unconcern with the representation of space in which the desired objects simply float anywhere on the paper.

As in the case of children, there is no effort in Egyptian wall painting to indicate spatial recession. Things in front of one another are represented through the means of interference or are simply placed one above the other. Yet in looking at these paintings we feel the existence of these figures in space. The color that surrounds these monochromatic

mythic figures has the quality of air—or of colored air, rather—in which these figures are bathed. In fact, it can best be described as a sort of mucous or jelly substance in which these figures are imbedded. In other words, space is here pictured not as a quality of something behind the figures but as a substance having tangible volume that approaches the frontal plane of the wall, together with the figures.

We have here in Egyptian painting, then, a form of space that relies on two factors. The first of these is the slight turning of the upper part of the figure, achieved by means of the silhouette. The second stems from the interference of the legs of one figure with the other, which results in a slight recession of movement into the third dimension, while the main movement proceeds across the wall. Space, then, is achieved through the drawing of the figures so that they turn into space, the sensation of recession produced again by drawing the legs of one figure intersecting those of the one beside it, and by the choice of the contrasting color between the silhouette and the background so that they both come to the frontal plane. There is no effort to produce the illusion of distance whatsoever. Yet we can feel that these figures exist, breathe, and function, in the atmosphere in which they are immersed.

The type of tactility here is not of the type of Giotto. We are not aware of the existence of a particular object in the picture. We are aware of the tactile existence of the panorama as a whole. To repeat, here the picture itself has existence. In the case of Giotto the problem is more complex. His picture too is tactile as a whole. But in his case, as in the case of all the Byzantines, you find a certain reliance already on certain illusory devices. He employs the division of space into horizontal and vertical planes, although that is employed by the Egyptians, too, in the representation of seated figures. In order to violate as little as possible the frontal plane of his picture, however, his vertical background plane is never very far from the surface, as if he knew (as he must have) that every additional foot of space represented by his picture diminished its tactility. Therefore, if it was an interior, the wall enclosing it never seemed more than a foot or two away from the front of the canvas. If it was an exterior scene, a hill, a wall, a group of trees, or a mass of figures limited the space into which the eye could traverse. Therefore, his movement was always confined within a short space within the canvas. This accounts for the extraordinarily strong feeling of movement that Giotto's pictures convey. Obviously a man who covers only a foot when he has a mile to go has traveled hardly at all toward his objective, whereas a man who has traveled a foot when his objective was only eighteen inches away has almost completed his journey. We might say he is already there. That is why the tactile movement of the figure in paintings where the illusory method depicts long distances is necessarily very weak.

It is Giotto's color, however, that produced the great effect of his tactility. All the tactile painters have used color with a knowledge of its tactile qualities. This is in contrast with the illusory painters whose illusion of recession is achieved by the graying of color as it recedes into the distance. The tactile painters, in other words, achieve their tactile quality by means of color value. Color, however, intrinsically possesses the power of giving the sensation of recession and advancement. The bluntest statement of this property is that cold colors recede while warm colors advance. It is this property that both Giotto and the Egyptians exploited. Colors which made no attempt to resemble atmosphere at a distance actually gave the sensation of coming forward and going back. Again, this use of color made it possible for them to give to space that tangibly mucous character, that of atmosphere containing objects. This, of course, strengthened again the tactile sensation, for every motion in any direction is always resisted by a sensed mass or solid space. How much more powerful this is than the movements walking about in a vacuum, where there is no resistance to make the figure exert any force.

PHILOSOPHICAL BASIS

If one understands, or if one has the sensibility to live in, the particular kind of space to which a painting is committed, then he has obtained the most comprehensive statement of the artist's attitude toward reality. Space, therefore, is the chief plastic manifestation of the artist's conception of reality. It is the most inclusive category of the artist's statement and can very well be called the key to the meaning of the picture. It constitutes a statement of faith, an a priori unity, to which all of the plastic elements are in a state of subservience.

As has been pointed out in the case of primitive races, there is no particular differentiation between the so-called world of reality and the world of fancy. As a result, their space is the kind that objectifies and attempts to create a sensible existence for all their imaginings. In that sense they are the possessors of the only real synthesis, that is, the only identity between sensibility and truth that we know of through intellectual experience. Christianity, to the extent that it was able to bring its serrated demonology into the everyday sensible existence of the society it controlled, is also a synthesis. Greece, too, in its primitive state had that synthesis (for it worshipped its statues), but only until it began to question the tangibility of its apparent sensibilities and, with that, the tangibility of its gods. Then its painting and sculpture began to perform those miracles that belie the wall on which it was painted and stone from which it was carved.

From the Renaissance onward, such a synthesis has no longer existed. Men began to discover the discrepancies between the world of sensation and the world of objectivity

from which these sensations derived their stimuli. In short, the scientific method, the beginnings of inquiry into the nature of things, had forever disrupted the unity that had existed between the objective world and the imaginative; that is, it demonstrated the distinction between sensations derived from tangible objects themselves and those receiving concreteness from the creations of the mind.

It is not incomprehensible, therefore, that art from this point on has never held the unity of *space philosophy*, let us name it, which is characteristic of the primitive, the archaic Greek, and the Christian devotee. For the discoveries of science always result in partial, segregated truths and require a super science to correlate them again lest they wander off into a mythical, abstract philosophy. And even to this day, when the mechanics and the processes of science seem to verge on the very edge of the ultimate, we still do not possess the knowledge to make a statement of faith as to reality. We have not found a formula for the formulation of the unity of the subjective and objective.

It is not strange, therefore, that the art of the Western world, if we are to name the European painting from the Renaissance onward as such, always manifests a mixture of spatial faiths. To put this into words commensurate with the plastic world, Western art is always a manifestation of a combination of spatial attributes. That great art has been achieved during those times is a symbol of man's faith in ultimate unity, that the lifeless components are integrated finally by man's sense, if not by his intellect. Every age must somehow form its own unity in the light of what it knows, otherwise life would not go on.

This explains why different art lovers go to different artists to satisfy themselves. Some prefer Raphael, some castigate him. The same is true of Giotto and Titian and the thousands of other masters who were so plentifully produced in those great times. In the case of none of these masters are the opponents unaware of their great qualities. These castigations are simply the result of differences of spatial faith.

Modern art has manifested again this lack of unity as it would appear when carried to its logical conclusion. It has produced in Dadaism and surrealism a philosophy of skepticism—chiefly a plastic skepticism. Is not the investigation toward ultimate unity in itself worthless, these modern artists ask? Is it not a delusion commensurate with the thousand other illusory faiths that have futilely entertained mankind throughout its history? Hence we have an art evolved, which ironically, and with sadistic and masochistic whimsicality, goes about combining discrepant and antagonistic faiths. These are an expressed mockery of ultimate unity, and are the bitter fruits of skepticism.

Again, we shall not moralize about these paintings. We speak about them only to make more concrete the basis of the spatial divergences of which we shall speak. Those who feel that man must believe in an ultimate unity in order to carry on at all as a social

individual will of course reject this art as antisocial. Those who will deny that man can seek comfort in self-made delusions will defend it.

In short, this representation of plasticity is a contemporary, plastic Book of Job. And we must accept it as a valid manifestation of our environment. Its enjoyment is comparable to the enjoyment of the Book of Job or any other pessimistic philosophy. Those who, from an abstract notion of tolerance, will consent to its validity for existence, and who are really repelled by its implications, will argue that deepest pessimism will spur man to the discoveries of a synthesis which in the end will refute those pessimistic philosophies.

Our dealing, therefore, with the space compositions of the several hundred years since the Renaissance will be much more complex and will occupy more space than our treatment of the usages of space in the thousands of years prior to that time. Giotto himself we might call the beginnings of these rumblings of the disintegration of this unity. That is why nearly all schools are partisan to him. For those who wish for the objective statement will find the synthesis of Christianity still comparatively intact in him. Those who wish for the illusory will find the seeds of integration already apparent here and there, and will therefore hail him as the harbinger of the new, his work comparable indeed to the synthesis achieved by Thomas Aquinas, who succeeded at least for a moment to bolster the church in the terms of the newly rising world, staving off momentarily the onslaught which was to follow.

On the whole, however, modern art is not a denial but an affirmation. Like most of our scientists, the process of disintegration or analysis is not a wanton act of destruction but part of a process for the evolving of more comprehensive synthesis. And therefore modern artists have not left us merely with the members of the body of art strewn about, but they have reassembled them and revivified that body with their own breath of life. In short, they have attempted to regain a synthesis as complete as that of the primitive, based, of course, upon contemporary considerations and point of view.

Beauty

This discussion of the two types of plasticity—illusory and tactile—brings us to the consideration of beauty. For lack of a better noun to describe the total aim of the painting process, we shall have to use this one in spite of all the variations and the display of particular prejudices which the word involves. From the point of view of materialism, such a word is suspect because its traditional usage makes of it an abstraction in which its functional unity can be difficult to discuss. On the other hand, the meaning of beauty can be difficult to grasp because the word is used with all sorts of esoteric connotations. Our problem, then, is to redefine our use of the word so that it will be applicable to both types of plasticity, as we have already granted validity to each of these.

This is indeed a difficult definition to essay because the perception of beauty is definitely an emotional experience. That does not mean exclusively the human emotionalism of sentiment or sensuousness (as has already been shown), but instead that the process involves an exaltation which is communicated to us through the emotional system. This exaltation is usually composed of sentiment, sensation, and, in its highest state, intellectual approbation. We shall not argue here the relative quantities or the proper proportions in which these three, or any additional factors, should be compounded, or even if all of them need be present, in order for a person to experience beauty. At the risk of being esoteric, let us describe the experience as a reaction to rightness, reflected in an ideal of proportions, and as an apperception of harmoniousness, whose recognition produces an exaltation. To reaffirm its indefinable character we might say that beauty conforms to the demands of the spirit. The experience of beauty may also be a sign of the reception of the creative impulse.

As soon as we begin to speak of art qualitatively we immediately imply a category for the existence of beauty. We say that one work of art is greater than another. Certainly this judgment is not based on the skill manifested in the work, for we shall find repeatedly that the artist to whom we have granted the laurel may have displayed his skills less aptly than the person to whom we have denied it. I do not believe that there is a single commen-

tator on art in whose criticism you will not find something comparable to the following: that a particular artist had superlative skill, perhaps above that of any other man living, yet his works were far below that of so-and-so. The poem by Robert Browning on Andrea del Sarto (called "The Faultless Painter") is a well-known illustration of this: as Browning makes clear, his more was less. Therefore skill itself is not an index to beauty. Of course, the artist must have sufficient means at his command to achieve his objective so that his work becomes convincingly communicative. But clearly it is something else which the art must communicate more than this before its author is seated among the immortals.

The fact that one or more of us can receive this communication originating in another person—the artist—attests to the existence of an abstract quality; one that the artist strives to achieve and that we may recognize. That we have disagreements or that we find this satisfaction in different places does not alter the conditions of this truth. We might say that all natural laws have always existed, and the universe has operated accordingly; man's failure to apprehend them, or his denial of them when they are first apprehended, does not undermine the universality of their existence in relation to both space and time. (Thus the fact that not everyone can understand relativity does not refute its existence.)

Since we can apply the designation of beauty at once to a piece of music, a painting, a human being, an animal, a building, a stone—or to an infinite variety of objects or sensations—we know that this particular type of exaltation can be generated by altogether differing stimuli. Therefore beauty is the description of a particular kind of reaction but one which can be derived from different stimuli. Here our reaction, the way we feel about such things, is the constant, and the stimuli are the variables. In our discussion, beauty is the constant, and the stimuli are the common factors in different paintings which cause us to think them beautiful.

Our definition of beauty, then, is a certain type of emotional exaltation which is the result of stimulation by certain qualities common to all great works of art. To apply this definition to our notions of plasticity, we may say that the sum total of all plasticity in a painting must be the potentiality for the evocation of a sense of beauty.

We have a variety of explanations for the origin and the nature of this abstraction. Psychologists say that beauty evokes a feeling of pleasure. This pleasure is closely connected with our infantile desire for security. Those forms or shapes which we associate with the satisfaction of this desire for security will forever give us that sense of complete satisfaction. In so far as the child's original notions of security are connected with the form of his mother, the curves and tactile planes in the human body are the origin of this satisfaction. The artist draws on these areas of security when he depicts the human body. The love for these human shapes is then transferred to similar shapes in the world at large.

The idea of functional, or ordered, beauty is not far removed from this. It posits the satisfaction of human needs as the basis for our sense of beauty, the completeness of this satisfaction limited only by what we consider human need. Humans are inclined to resolve their needs materially, yet this limitation, which we have already shown to be unwarranted, should not restrict a properly conceived notion of functionalism. For it is not accurate to say that man's passion for order was given to him in order to survive, but rather that man, having developed this passion, has found it useful for survival. Another point of view which is open to question in the theory of functionalism is the economy which supposedly is characteristic of nature. This economy may exist as an ideal which in the end makes function possible, but in actual experience it might be said that nature is, on the whole, prodigal and wasteful, and it is only through the miracle of Greek unity that order is achieved at all.

Plato, too, has a definition of beauty which will make the matter clearer for us. He states that somewhere in nature there exists an actual prototype, an abstract absolute of beauty, of which all the manifestations are simply different facets. And although the two preceding theories (the psychological and the functional) will deny the Platonic notion simply because there is no empirical corroboration, the concepts are not contradictory. Nonetheless, both of these viewpoints must deal with the Platonic model, and the fact that they contend with it can very well be considered a negative affirmation of its reality. At any rate, we need not choose one theory here; we state them simply because they might help in our discussion.

Recently there has been an attempt to define, more scientifically, the parameters and mechanisms of this abstraction by applying dynamic symmetry, which is the mathematical study of spatial placement in works of art. Here it has been demonstrated that the satisfaction—which we call *balance*—in a picture conforms in all works of art to a proportion of arrangement based upon geometric progression of masses. Of course, this method examines only to a part of the process, as color and other elements are omitted. In fact, further studies in relation to the other elements have been conducted, but these studies are essentially useless. They help demonstrate only the existence of an abstraction of relationships whose achievement can produce the exaltation of beauty. They are useless because neither the world of mathematics nor the world of words and sounds is interchangeable with the plastic elements through which beauty is achieved.

Like the old ideal of God, the abstraction itself in its nakedness is never directly apprehensible to us. As in the case of God, we can know its manifestations only through works, which, while never completely revealing the total abstraction in the round, symbolize it by the manifestation of different faces of itself in works of art. Therefore, to feel beauty is to participate in the abstraction through a particular agency. In a sense, this is a reflection

of the infiniteness of reality. For should we know the appearance of the abstraction itself, we would constantly reproduce only its image. As it is, we have the exhibition of the infinite variety of its inexhaustible facets, for which we should be thankful.

Let us consider the case of our relationship to our friends. We love them with a common love because we all participate in the common prototype of humanity, but because each human being is a new and different manifestation of this prototype we want to know more about each one. Yet we should not be able to enjoy our friends at all if they could not be referred to the common prototype, for through the recognition of this identity with the prototype are we able to make sensible observations of differences.

BEAUTY: PLASTIC AND ILLUSORY

Now what kind of stimulus is afforded us by each of the two types of plasticity, illusory and tactile? We have already said that each is devoted to the manifestation of an ideal through a related movement within the canvas. This ideal we have now is called *beauty*. We must then ask how to receive the sense of beauty from the illusory painting and from the tactile painting, and in what way they differ.

Let us first take the case of the illusory painting. This, as we have already stated, is committed to the reproduction of appearances. Even imaginary situations must appear to us as they would visually if they were actually in existence. Our whole reference here is to the sense of vision alone. Therefore the artist must either have the model before him or imagine the visual model for his painting so concretely that the painting itself is a reproduction of what is seen either in nature or in the mind.

For the sake of illustration let us assume that a portrait is being painted. Our sense of beauty in relationship to the portrait must come from the thing described in the painting, rather than from the likeness of the model. Of course, we can derive certain pleasure from the excellence of execution and the facility of technique, but we have already concluded that beauty does not depend upon this and that it demands only that the technique be adequate for presentation. To state this more pertinently, we might say that the less we are conscious, particularly in the case of illusory painting, of the necessarily artificial methods of achieving the illusion of this visual reality, the greater the conviction we will have in this reality.

Now if this painting is, let us say, of a woman, our sense of beauty would be satisfied if the woman in the picture were beautiful. In other words, what we enjoy in the picture is the notion of a beautiful woman. The picture here participates with us in our ideal of feminine beauty and our reference is the ideal that we have in common with the

artist of what makes a woman beautiful. For corroboration of the existence of that ideal, we have moving pictures and theaters, both of which present a pretty good notion of the common denominator of visual beauty in women, which is attested to by their box office returns. There are women on the stage, of course, who are not beautiful but who are there because they are good actresses. The distinction between these two types of actresses, however, is very clearly made.

Of course, not only this idea of pulchritude exists. Certain features give a sense of refinement of character. This, of course, the sensitive illusory artist would also try to include in his presentation, his object being to portray the visual attributes of these qualities. "Naught but the fair can dwell in such a temple" (to paraphrase the bard), is the basis of his representation. If he were to portray an ugly person, however, the picture, except in its execution, could not be beautiful, unless he tried to substitute for the irregularity of features the representation of qualities of character which would offset this shortcoming and therefore produce a representation of beauty of character as can be reflected in the outward features: bearing, posture, and other attributes as make visible such qualities.

In other words, the beauty of the picture is dependent upon the beauty of what it represents. The beauty of the picture depends on whether the picture reminds us of a person whose features or character we like. Should that fail, the objective of the picture has not been achieved. Ultimately, the character in the portrait must evoke the same response which the visual experience of the model itself would, and, failing that, the portrait must evoke the same response that the memory of a similar visual experience would. The point of reference here, then, is outside of the picture itself.

The tactile plasticist, however, wants the picture in itself to be beautiful. In other words, the picture in itself is his object—that is where beauty resides—whereas the object of the other artist is to paint a picture of something that is beautiful. To this end, the tactile artist's plastic components must so interact with one another that the manifest relationship will in itself provide that exaltation. How that is possible can be demonstrated by an incident related by the French artist Amedée Ozenfant. While amongst a group of friends on a beach he proposed that they all collect beautiful pebbles. He recorded that invariably the many hands found themselves groping for the same pebbles. Obviously the shapes, the indentations, the particular curvatures, the surfaces and their textures, the tinting—all contributed to an ensemble which gave them a sensation of beauty.

It is in the same sense that the artist wants his picture to be desirable for itself. Of course, in the case of the pebbles, there are only the decorative, and none of the expressive, elements that a painting would possess. In the painting the decorative and the expressive have to be so organically intertwined that the two simultaneously contribute to the

effect of beauty, so that neither be perceived without the other. Therefore, the tactile painter, in painting a portrait, would want you to be moved by the actuality, the tactile sensation of the image. The sensation here is one of actual life—not to be confused at all with real life. In other words, a new being has been created in the terms of plastic invention.

The person depicted in a tactile painting may well resemble an actual person rather than a demon of the primitives, but this person or the artist may want his picture to have the actual existence and emotional impact which the demon possessed. And not only the person, but the space around him and all the accessories must make complete this tactile manifestation.

The texture of his garment may remind you of some that you know, but that is unimportant. They must be of a stuff that you can feel is drapable over the objects depicted, whether you have the knowledge of that texture or not. This does not mean that the artist here denies himself associations from life. On the contrary, here, too, in the tactile painting that is essential. Just as in the case of beauty, the knowledge of a familiar thing will enhance the effect of the familiar depicted object to which it may be compared; for without the recognition of the prototype there could not be the apperception of differences. But here the associations are used for their emotional effects rather than for illusory ends. Therefore, carried to its logical conclusion, this form of painting in our modern times has allowed itself to distort the object, relying upon our memory to relate it to the familiar in our experience, while making it more valid for plastic beauty by changing the shape to fit the ensemble. Again, in abstractions, which do not use recognizable shapes at all, you will find some hint of visual reality to connect the picture with everyday existence.

To summarize, in the first instance—that is, in the illusory painting—all the elements in the picture contribute to the beauty of the model. The surroundings and everything else give us the reality of the model augmented by the visual reality of the surroundings. In the second, the tactile painting, the model as well as the other accessories contribute to the beauty of the picture, which is the unit, or objective. Here the elements of memory and sensation and proportion are referable directly to an abstract notion of beauty.

When you see the features of an illusionistic portrait you are reminded of people whom you know. When you see a plastic one, you seek amongst those that you know something like it, for it is a new creation.

BEAUTY AND ITS CREATION

Our notions of beauty today are essentially Platonic. That is not strange, of course, since we have already observed that our most manifest and comprehensive reality

is Platonic. In fact, it is difficult to escape the Platonic notion of beauty in any period. The Renaissance artist, who was definitely interested in appearances and who was preponderantly pragmatic in his attitude toward nature, could never quite work—even pragmatically—without the notion of an abstract ideal of beauty. Both Leonardo and Dürer in their writings attested to a definite duality which they never quite manage to resolve. They both speak of painting being simply a mirror by implying that the mirror can not only mirror appearances, but that it mirrors the most profound aspects of appearances. They must study the organic construction of all the objects which they portray in order to mirror them properly. This approach displays the ultimate faith in appearances. It implies that the artist, in addition to portraying external appearances, can, depending on his skills, also portray internal truths by noting and depicting the profound subtleties of those external appearances. So far so good.

Yet we find that they are not interested in all of the aspects of the particularities of an object. That is, they do not consider it their function to portray appearance. They must paint those appearances which imply a sense of perfection. Therefore both Leonardo and Dürer write that to compose a proper figure they must examine numerous figures and select those limbs and organs from each which seem to be the most perfect and then combine them into a synthetic figure which would be a symbol of perfection. Therefore they make the definite statement that in nature itself, perfection does not exist in separate appearances, but that the artist must select and synthesize various attributes to create an appearance of perfection.

Being essentially pragmatists, they introduce a statistical factor into their notions of perfection, for they say that perfect separate limbs would be those which are considered perfect by general consent. This qualification is made by both artists. The obvious implication here is that all individuals can participate in the evaluation of the perfect. In other words, according to them, most men possess the faculty of sensing ideal perfection. Their statistical notion does not in any way dilute, therefore, the pertinence of the Platonic ideal.

What appears before the mirror in this process is, of course, a question, and Leonardo sometimes attempts to answer it indirectly in some of his recipes for the creation of imaginary organisms, such as a synthesized beast. He will tell you that you can import reality or credibility to this beast by composing him of the veritable appearances of the different organs of different beasts. For example, the eyes must be specifically the eyes, let us say, of a tiger, the tail recognizable as that of a lion, the nose that of a camel, etc. This recipe is really significant, for in a way it is simply a restatement of his recipe for perfection in a figure.

The implication of both of these recipes is that the prototypes of the parts selected from nature must each bear, in their specific parts, the verities of appearance. But perfection is a synthetic act which appearance does not encompass, but which is left to man. The extension of the notion of perfection to common consent does not alter that notion in any way. For even if one argues that the general notions of beauty or perfection change at different times, we can simply say that all of them contribute, or are the specific manifestation in its manifold nature, of the genre of perfection, just as the individual confirms the genre of man even through his manifold and disparate appearances.

In that sense, too, all of our present academic painters who believe that they are holding a mirror up to nature are really deceiving themselves. For if the perfection of a picture was based upon its exact imaging of the object, no one could really participate in the understanding of that perfection unless he could compare the picture to the exact object depicted in precisely the same conditions in which it was created. Otherwise, how could anyone fully corroborate its perfection?

Leonardo and Dürer's position on what is generally considered beautiful contains the germs of the statistical method, the notion of averages that is characteristic of our own pragmatic ideas. It is safe to say, however, that their faith lay not in the general notion of what was beautiful, but rather in their own certainty as to the abstract proportion of abstract beauty. We can be sure that they never canvased their contemporaries for their notions of the beautiful.

So in spite of their faith in appearances as reality, these artists made their own transformations, or let us say their own distortions—for distortion was precisely what it was—to attain perfection. Cézanne, in our own time, has of course come up against the identical problem. Wishing to reaffirm the reality of appearances, he had to distort their particularities to do this. Hence he paints the apple-ness of an apple and not a particular apple, and distortion is the necessary corollary of that preoccupation with appearances.

This entire notion of distortion is closely allied to the notion of beauty today, especially where the expressionists have introduced a kind of distortion which is more extreme, and which perhaps could not garner an imaginary statistical sanction for the por-trayal of beauty. Actually, these distortions are simply a variation of the sort practiced by both Dürer and Leonardo, and more violently by Signorelli and Michelangelo, as well as by nearly all of their contemporaries and no less by the Venetians, who went to extremes in the distortion of sensuality.

The distortions practiced today by the expressionists are contrived to achieve the emotionality of the emotional, actuated by the consciousness of terror as reality, and there-fore relate to the distortions of the Gothic as well as the very primitive animistic realities.

Added to that, they are obsessed by the notion of atomic flux and therefore push the emotionalism of the impressionists to their final conclusion. They depict distorted forms flowing one into the other, losing their boundaries and participating in undefined generalizations of terror, delving into the primeval mucosity of substance, which is conceivably the beginnings of consciousness itself. Yet since the expressionists are eventually lost in the final incommunicability which is inexorably their conclusion, it is perhaps more fruitful to consider the distortions of the cubists.

It is interesting that Dürer himself names the five shape principles of Plato and emphasizes their essentialness to the conscious understanding of perfection. Cézanne did the same, and showed a similar preoccupation to that of Dürer, as both focused upon the derivation of the essence of perfection in appearances. It is not surprising, therefore, that Vasari discusses a drawing by Piero della Francesca wherein he had composed, most wonderfully, the six aspects of a vase simultaneously. Likely, if we had the records, we would find this type of focus on abstract notions, these prophesies of the preoccupation of the cubists and their developments, throughout the history of the Renaissance.

What is therefore obvious is that the Renaissance artist, in his objective attitude toward appearances, had to take account of the world of abstractions which he thought must underlie them, but which he used for the affirmation of appearances. The abstractionists of our age are also our objectivists, and they use appearances for the purposes of demonstrating the reality of the world of ideas. Both types of artists are objectivists. Both are occupied with the objective world of appearances, but one subverts ideas to appearance, and the other appearance to the world of ideas.

The expressionists, however, do not find a prototype in the Renaissance because they are mainly interested in the world of emotionality. Therefore they stem from the world of Romanticism wherein the mood of light is the point of orientation. And for their prototypes they must therefore go to the animistic sources which the Renaissance had discarded as unworthy of man's preoccupation, for they constituted the unreal and despicable worlds of chimera and superstition.

BEAUTY AND ITS APPERCEPTION

We have already suggested that the sensual is the common denominator to which the artist must point his expression. We have also shown that sensuality is not conceivable without the attributes of pain and pleasure. Now, pain and pleasure are the opposite poles between which range the variety of feelings which we designate by the name sensual. We might say that, as in a graph, the pleasure is the positive radius and the pain is the negative. Now,

that type of exaltation which we associate with complete satisfaction might be denoted as the point of equilibrium between those positive and negative poles. That sort of a definition will allow us to understand that beauty is also composed of pain, that rightness must include evil, etc.

This explanation does not necessarily have to be accepted, and, in fact, the whole notion of the beautiful is so complicated that its disentanglement is futile and would not advance our study. Our own reactions to things as beautiful are dependent upon so many associations and so many conditions extraneous to those things which we call beautiful that it is futile to isolate the notion. For instance, an upset stomach will spoil the beauty of the object or, on the other hand, a general sense of exhilaration will impart a tolerance which, under other conditions, would not be extended. The whole business is too subjective to be analyzed effectively. The author himself has often rebelled unreasonably at the acceptance of things which, for some reason or another, did not please him. This has occurred because of certain prejudices and personal preoccupations which the beauties of the rejected items contradicted.

Therefore, to attempt to understand these things we must study what the artist thought would contribute to their final beauty and how he sought to construct it. In that way we can attain a notion of what the whole business of beauty is about.

Now, the apperception of beauty in a work of art—that is, the recognition of this ideal of perfection by the spectator, independent of the recognition of its achievement by the artist—is a very complex problem. This involves the entire communicability of art. There are two primary ways in which this apperception of beauty in art can occur: 1) That there is imparted to the observer—that is, the ideal observer who can divorce his cognitive senses from irrelevant associations—a state of equilibrium between the pain and pleasure of the sensual communications resulting in the sense of exhilaration which we find in art. And it may be pertinent that the one expression which antique art tries to represent is this state of exaltation. 2) That a common reference to a common prototype of perfection in the abstract has been achieved by the artist and shared by the observer. This second type of communication involves the Platonic notion of an abstract form of beauty.

Actually, even in the case of accepting the first explanation, it is still difficult not to fall back on the abstract forms as a point of reference. For one can claim that this state of sensorial equilibrium is made manifest in the observer only by the representation of beauty in a form which subscribes to abstract ideals of perfection.

Insofar as we suggest that communicability is possible at all, we must accept some abstraction as a point of reference. In that sense, art really differs in no way from demonstrations in fields which appear based on greater certainty. For they all depend upon

taught or imposed abstractions of quantity and quality. Hence we can demand the same communicability for pictures as for anything else. Actually, one cannot understand anything except by performing these demonstrations of truth himself. The acceptance of principles or generalizations as such depends upon faith in a certain abstraction of demonstration. So we accept relativity not because we can demonstrate it but because we have accepted the abstraction of its demonstration into our notions of credibility. But we have that faith because, in our training and environment, the proper relationship between the concept of relativity and sensorial reality, or sensualism in the terms of pain and pleasure, has been established.

Due to our reliance on Platonic forms, we have the same difficulty in appraising the apperception of beauty in terms of the sensual apparatus that Dürer and Leonardo encountered when trying to reflect faithfully the mirror of appearance. They had to posit the notion of comparative general consent in order to establish prototypes of perfection. This is simply the extension to greater numbers of their need to refer to the general ideal of the prototype.

To return to the case of the sensorial explanation, it may be objected that, to many, complete equilibrium is death—the absence of reality. We believe that this is true yet there must be provision for the adjustment of tension between pleasure and pain for the experience of beauty. The predilection for the excessiveness of tension may be compared to the masochistic or sadistic state, where pleasure, at its highest, is achieved by an emphatic lack of equilibrium. These are deviations from the normal in the sense that here the excitement from tension is greater than that from the fulfillment itself. The excitement of the process can not exist but for the promise of fulfillment, and in that sense the participation in the tension itself without the promise of the final equilibrium is a substitution of emphases which are not normal.

It is not necessary for us to make a decision as to where the emphases must lie. We must simply recognize that there must be either fulfillment or its promise, which inevitably returns us to the acceptance of an ideal prototype.

Naturalism

The whole notion of naturalness in art has been grievously misconstrued. There has been promulgated a view, which is now popular, that the unnatural appearance of the art of ancient civilizations is due to their ignorance of the manner by which to make the appearance of the depicted objects conform more clearly to the appearance and movement of life.

Those who profess this view forget that there are so many instances known to us wherein the ability of artists to reproduce appearances far outstrips the general status of human knowledge in their society. It is difficult to see how these critics can persist in their tenacity for these views. They forget that the prehistoric cavemen who left the tracings and animal drawings on their walls had reached a perfection in their depictions of animals and in the accuracy with which they portrayed the human figure in action. Seeking artistic parallels to these achievements in civilizations such as those of the Greeks, Egyptians, and the Hindus would reveal a comparative state of savagery, with artistic accomplishment far beneath these crude civilizations. For the immobility and the stylization of the human figure in the arts of those advanced cultures would be construed as an inability for particularization that would attest to the rudeness of their science and powers of observation.

These critics also seem to be ignorant of the fact that these immobile works of art from these classical civilizations were not the only pictorial expressions these peoples created. There is a whole mass of work—available from the same period as those works that they consider marred by the imperfections of ignorance—that would rapidly disprove their assertions. For the Egyptians, even while they created their huge monoliths, produced a plethora of popular works which exhibited the ability to produce just the type of representation these people ask for. The little statuettes, comparable to the Tanagra statuettes of the Greeks, are consummate examples of their ability to represent the familiar motions and appearances of human beings in attitudes and in forms of animation that impart a reality both to the appearance and the spirit of those things they are designed to illustrate. The Egyptians, too, practiced the custom of producing a likeness of the deceased subject,

which they pasted to the head of the burial shroud. This form of representation was in fact common to all these old civilizations. How successful they were in achieving their objective may be seen everywhere we can find these shroud paintings. They might well have been done by any member of the Dutch school.

We know that when the Christian artist began his representations, his unnatural forms were due not to ignorance but to a deliberate choice. As a matter of fact, the choice appeared again in Italy, where the first Christian paintings were in the naturalistic pagan style known to us in the paintings of Pompeii. We see the same choice made in France, where, before the advent of the influence of the early Italian Renaissance painters, the manuscript illustrations, which were the primary form of painting, were far more naturalistic than were the "easel" paintings. The German peoples and the Flemish had a repertoire of naturalism that the Renaissance ideal could never displace, even partly, for they apparently had a sympathy simply for the abstract form rather than for the subjects of the Renaissance.

If we examine, in fact, the history of painting anywhere at any time, we shall find a heroic art and a popular art. In the popular arts we always find a tendency to illustrate the local, and these popular arts, in their fulfillment of this tendency, always exhibit an uncanny dexterity at the imitation of appearances, an ability one might not suspect they possessed from knowledge of only the heroic art. We can see, therefore, that the unnatural representations found in the heroic art are the product of choice, not limited ability. Even the Renaissance painter, to whom science and the study of nature were the ideal by which he functioned, also made a definite distinction between the function of appearances in the execution of the great works of art and the popular.

It is reputed that the art, that is, the great art of the Renaissance, was a popular art beloved and understood by all. Unfortunately, that is true of only a small fraction. For we know that the public loved their popular illustrators, as happened everywhere else, but that the statues of Michelangelo, especially the one of David, had to be guarded because it was stoned on route to its pedestal. We know that at the times of Titian and Tintoretto there was a plethora of popular genre art, which was widely loved and sold. These popular works bear some of the marks, of course, of the heroic art but describe far less exalted pleasures than the canvasses of the masters.

Vasari, who was a Florentine, a younger contemporary of the great Venetians, and the pupil of Michelangelo, may be a gossip and a liar in his reports of the conversations of these great men about whom he wrote. Yet we can be sure that if the phrases which he put into the mouths of the great were never uttered by them, these words did inescapably represent his own ideas. And we can be sure that his ideas were by and large representa-

tive of the views of the artists of the Italian Renaissance. In *Lives of Seventy of the Most Eminent Painters, Sculptors and Architects* (1896) he says: "One cannot but marvel . . . how stone which was just before without form or shape, should all at once display such perfection as Nature can but rarely produce in the flesh." This he says of the *Pietà* of Michelangelo, and he adds in his treatment of *The Last Judgement*: "The attention of Michelangelo was constantly directed at the highest perfection of art, as we have said elsewhere; we are therefore not here to look for landscapes, trees, buildings, or any other variety of attraction, for these he never regarded; perhaps he would not abase his great genius to such matters."

Vasari speaks here of what constitutes the idealized perfection of nature, and yet makes clear that nature does not often reveal these perfections in its particular creations. He reinforces this notion with the exclusion of the trappings, which the growing naturalism had brought into paintings because they were accessories of the naturalistic scene. He excludes them because they did not really contribute to the comprehensive generalization that is the end of art.

Thus Vasari, like Michelangelo, and like the great artists of all periods, understood that it is to produce a plastic equivalent of the greatest truth that art is created, not to produce and reproduce the specific characteristics of any particular object. Such works, in their insistence on any given particularization, simply diminish the view of the ultimate.

Subject and Subject Matter

SUBJECT

At the very outset of this discussion we must make a series of distinctions which will enable us to speak clearly on this all-important matter. In its actual use in our vernacular, the word *subject* has an ambiguous connotation. It may refer to the recognizable elements in a picture, such as objects that we know, an anecdote we can recognize, a mood that is familiar to us, or even some more remote association with our experience. The use of the word in that sense implies the recognition of these elements and quite generally the order in which they have been named; that is, most people will first recognize objects, secondly their relation in an anecdote of either situation or action, next the subjective qualities, either in their reading of expression or the general mood of the picture, and finally the more abstract experience to which the picture refers, such as the establishment of mood without recognizable objects or anecdotes, for example, gaiety, sadness, nobility, squalor, etc. The further we proceed through the chain of subject matter, the fewer the number of people who will actually recognize the depicted element.

The second use of the word *subject* seeks to describe the objective of the picture. What is the picture trying to say or express? What does it mean? In this sense the word *design*, when used in its original and more comprehensive sense, is really the better clue to this use of the word *subject*. In its original sense the word *design* means plan or intent. To put it more plainly: the subject or design is what the artist intends in the picture. And his intention in a painting has a point of view to which his subject matter, that is, the elements of the painting, will contribute as an integral part of the whole. The subject or design of a painting is, therefore, the painting itself, and all of the statements which it makes simultaneously.

Obviously, the two meanings of *subject* are not synonymous, and for the sake of clarity let us call the first, popular meaning of subject *subject matter*. The word *subject* itself will denote the design or the intent of the painting as a whole.

Now let us examine our definition of *subject* in relation to the popular notion of the subject (that is, the subject matter). It is logical that some representation of the

subject and the associations it entails is the object of the picture. In our definition, the subject may simply be the most natural and convenient manifestation of the plastic message. Now, the plastic message or philosophy must be embodied in some sort of actual manifestation. Therefore the marriage of the plastic elements with some objectively representable shapes is necessary for its final fruition. The natural parallel is the soul and body; neither can be manifest to us without the coexistence of the other. One might say, as those in the Christian era did, that the body is simply the dwelling place of the soul; or, in our own age, we might put it that the soul is simply a form of energy and that the body fulfills its functions and needs. We know that for us one is inconceivable without the other and that we can only think of their simultaneous existence.

Therefore, in all works of art we find that the marriage between the two—that is, the plastic message and the subject—is absolute. We do not think of the plastic elements as the means by which the reality of the painted objects is achieved, except for those who are interested in the physical use of materials for the achievement of such—in other words, those interested in technique. Nor is the apperception of a work of art the recognition of the existence of the various shapes in addition to the various delights of movement, rhythm, texture, colors, etc. Nor, on the other hand, is the apperception of a work of art the detection of the plastic intents, followed by the additional recognition that in the course of the relationships between these intents there has been created a particular kind of shape or emotion. The proper apperception is the recognition of the existence of the whole situation as one.

When we perceive a painting properly we become aware of the life of the picture as a whole, and that the sum total effect of our recognitions and emotions—that is, our associations and what they have made us feel—is the result of the plastic journey we have enjoyed. This journey, in other words, is not merely for exercise, nor merely for the seeking of scenery or the people we may meet on the way. What is essential is that the entire journey is a delight and that that delight is contributed to by all of these factors at once. We can make the analogy to going for a walk. If a man's leg is sore, or if he limps or is hot, he still may enjoy the scenery but he will not enjoy the walk.

We have already indicated that the plastic philosophy is the constant which underlies all works of art. By the plastic philosophy, we shall repeat here, we mean the evolution in any artist of the plastic continuity. In considering, therefore, the subject of a painting, we can say that the plastic philosophy is at least as important a part of a picture as any other factor. We can see this particularly in the examination of the style of any painter's work.

Style is those uniform characteristics which a painter exhibits in all his work. It is arrived at by his selection and emphasis in the use of certain plastic elements. No matter what the represented or recognizable elements are, style remains constant in a painter's

77

work. It holds whether we are considering objects or psychological representations, or any of the other factors into which we subdivide the picture in order to be able to speak about it.

Suffice it to observe that style is the similarity of treatment that runs through any painter's work. Obviously, a still life by Chardin does not look like a still life by Cézanne, and a portrait by Chardin does not look like a portrait by Cimabue. But rather, both the portrait and the still life by Chardin look as if they were done by the same person, just as a still life and a portrait by Cézanne look as if they were done by the same person.

By this we mean to show that the subject matter is not the constant, but rather it is the artist's view of looking at things that remains the same. This explanation makes clear that an artist's plastic existence is not subservient to subject matter. Or further, that it is not subservient to the representation of recognizable objects, mood, or atmosphere. To state this in another way, the plasticity of a picture does not have as its sole objective the representation of the elements that are commonly or popularly called *the subject* (that is, *the subject matter*) of the picture.

When we say subservient, perhaps we have chosen the incorrect word, for it implies a lesser importance. This is not what we wish to imply. We simply imply the relationship of the constant factor to the variable. For example, we may say that all the individual forms in life are the manifestation of the life principle. That is, that trees, men, beasts, flowers, fish, etc., are the manifestation of a certain structural biological principle. Yet it would be fallacious to consider their importance as only a demonstration of that principle and that they themselves have no inherent importance, just as their consideration without reference to the principle of life would relegate them to an absence of consciousness and therefore an absence of life.

We might say then, that the picture itself is the vehicle for the manifestation of the plastic continuity. The objects or separations that we are able to identify in discussing a picture are the various members of this organism through whose functions the manifestation is able to portray the life principle.

It might be closer to the truth to say that the subject matter is but a manifestation of the plasticity. But this would be begging the question, for we well know that the plastic idea could never become manifest except through the agency of some representation that makes some connection with the experience of man. This may be by the representation of recognizable objects in recognizable environments, or abstract elements which we can refer to our experience, not necessarily in a logical manner, but through some form of association.

It may be objected here that man would not be able to begin making the plastic statement if he were not moved by some experience in his environment. It may be answered that man would never make a statement about this experience—in fact, could not be

consciously aware of it—if he did not perceive a series of relationships concerning this experience. We know that our experience is infinite in scope, and that at the same time we are aware of only an infinitesimal part of it. We also know that we can be aware of only those things in our environment concerning which we have a series of relationships established on the basis of similarities and differences, either in the comparative strength which they exert upon our senses, or by the reference to some abstract form of measure in quality or quantity. Therefore the idea of priority is of no help to us. Priority can be established only in reference to a particular instance; divide this instance into smaller components, or place its continuity into a category which includes it, and what comes first becomes a senseless question (e.g., the egg or the hen).

To apply all of this to subject matter, it will not help us to say that this or that artist would not have painted a certain picture if a certain situation did not appear to him as beautiful. We might answer that it would be equally true that a certain situation would not be beautiful to him unless his particular orientation toward reality found its expression in that situation. We have no way of determining which comes first. And, in fact, it would not add to our picture if it did. Apparently the entire process is of as great a variety as there are painters. The question of whether a certain substantiated truth has achieved its status by beginning with a generalization and then finding its corroboration in fact, or has been suggested through a particular experience which pointed toward a generalization which was then corroborated by the examination of analogous instances, is unimportant. Both demonstrate a faith in experience submitting to generalization, and both strive to achieve an identical quality of statement concerning experience.

Therefore, we may posit this definition of subject: the subject of a painting is the painting itself, which is a corporeal manifestation of the artist's notion of reality, made manifest through the production on the canvas of objects, or qualities, or both, recognizable or created, which are referable to our experience, either directly or through reasoning.

SUBJECT MATTER
SUBJECT MATTER AND THE ARTIST'S REALITY

Those people who underrate the importance of the subject matter are no less guilty of dismembering the body of art than those who place the plastic elements in a position subsidiary to that of the subject matter. Our whole effort in this chapter to this point was to establish the importance of both interactively contributing to the final objective of the painting. It is true that we can speak intelligibly of art only in the terms of the plastic continuity because this constitutes the constant. We are able to realize the whole of art by relating it to

this continuity, whereas if we should speak of the subject matter we should know nothing about art, for it is only the manifestation of the particular instances of art. But let us not underrate these individual manifestations, for it is only by examination of the smaller element that we become aware of the larger categories. In other words, let us not condemn the flesh, for without it we should never know the spirit.

To think that any art can exist without subject matter would be to substantiate a hocus pocus spiritualism that is inadmissible to our experience. We could never know art or speak of it if that were so. To say, therefore, that abstract painting does not possess a subject matter, which, as we have already said, is some kind of reference to our experience, would be the statement of an impossibility. It is just as impossible for art to exist without subject matter as it would be for subject matter not to reflect some aspect of our environment, as we have already discussed in a previous chapter. It may be that abstract art does not employ subject matter that is as obvious as either the anecdote or familiar objects, yet it must appeal to our experience in some way. Instead of appealing to our sense of the familiar, it simply functions in another category. It appeals to our abstract experience pertaining to the familiar relationships between space and shapes. And it has its own anecdote, for every relationship implies an anecdote, not in the sense of a story, which is simply an anecdote of human action, but in the sense of a philosophical narration of bringing all the related elements together to some unified end.

That it is possible to appeal to our experience through references to abstract qualities is clearly seen in our own use of abstract language. What do we understand when we read that an atom is bombarded by electricity of a certain voltage, or when we say the attraction of masses to one another is inversely proportional to their distance from each other. The picture is a pure abstraction. Yet we construct systems in which these abstractions, such as the atom or gravitation, assume definite parts of our experience, and these systems can, in turn, produce new unities that are incomprehensible to us.

In the same sense, abstract artworks use abstracted notions of shapes and emotions in plastic terms to establish unity in a superior category. This can be more clearly explained when we say that a ball is a sphere or that autumn is sad. Here, a specific object is reduced to a geometric category of abstraction, and the physical appearance of a season is reduced to an emotional abstraction, yet both of these abstractions can be used to new ends to establish further ideas. It is in this way that abstraction functions.

The only time an abstraction can be said not to have employed subject matter is when it had nothing to say about anything at all. In that case we can say that both subject and subject matter are absent, as is the case with ineffectual art. Yet the more frequent case is that the abstraction has subject matter but no subject: that is, the artist was unable

to produce a unified objective for his subject matter. In other words, he was unable to make a generalization of conclusion of the various ingredients in his picture. We can say here, too, that the artist had nothing to say.

Now, apparently any subject matter would corroborate the artist's notion of reality since, if the artist is really convinced of that particular notion, it should be applicable to any part of his environment. This, however, cannot be true. For we find that in relation to any such notion shared by most artists at a particular time, there is always a similarity of subject matter. Now why this similarity of subject matter? If we can find the answer to this question we shall do a great deal to answer those who find fault with the artist for producing representations of the environment which they do not find interesting, or those who feel that the artist is evading his environment by painting certain things instead of others.

I think we can get a clue to the reasons artists use certain kinds of subject matter rather than others as the embodiments of their notions of reality by examining the following examples in chemical analysis. If a man wants to prove that gasses expand in certain ratios, he will, of course, choose first those gasses which have the largest coefficient of expansion, for they would allow the most accurate perception by our senses as well as by our measuring apparatus. Or if he wants to prove that sunlight consists of all colors, he will, of course, refer to the spectrum of colors that is within the range of visual sensibility. From there he can apply his law to realms which are less perceptible, but he will always make use of the most amenable substances for his own first experiments and his demonstrations to the rest of the world. The same may be said of subject matter in art. Subject matter is chosen by common experience, or through the demonstration or discovery of some particular genus shown to be the most amenable vehicle for the purpose of expressing and communicating the artist's particular notion of reality.

We therefore propose to examine various points in the history of plasticity, identify its subject matter, ask why it occurred, and explore its particular sympathy for the artist's notion of reality or its suitability for making that notion manifest.

In examining the subject matter employed by artists in various epochs we are struck by this essential difference: that the artists of antique civilization have a much more restricted subject matter than the artists of the present. That is true not only of the scope of earlier artists' subject matter, but also of their treatment, which at least superficially exhibits a much greater uniformity than do the works of art of more modern artists. In fact, when considering the art of the Egyptians, Greeks, Assyrians, and Hindus, we find it difficult to see distinguishing characteristics between two works of art within any of these traditions, even though we know that different artists executed them. Of course, this is true only to a certain extent, but for our practical demonstration we can say that this is true as a whole.

The exception to this is the work of the Hellenistic Greeks, where we see examples of individuality that we do not find exhibited elsewhere in antiquity. With the exception of this particular instance, it is not until the Renaissance that one can perceive those wide divergences of expression between artists which indicate differing notions of reality. We must remember here the similarity between art of the Greek Hellenistic period and the art of the Renaissance, and also the extent to which this period served as a prototype for the civilization of the Renaissance. During the Renaissance, while we still find a similarity in subject matter between works of art, we find it twisted for different ends, as if prophetic that its inorganic nature will be readily abandoned.

In view of what we have already explained regarding the function of subject matter in relation to the artist's notion of reality, we must ask what is the particular function of the subject matter found in antique art and why its compelling uniformity?

SUBJECT MATTER AND THE MYTH

Here, then, we must consider the relation of myth to painting. A myth is really a symbol of the notions of reality of a particular age. It is a series of appearances within a definite set of relationships whereby man, at any particular time, symbolized those aspects of the world about him that he had been able to coalesce with his known sensations. We may call it a human representation in-so-far as it exemplifies the abstractions which contribute to man's notion of reality by depicting a series of actions that connect to him by means of their human qualities.

In painting, then, we may call the myth the subject matter in its most comprehensive sense. And as we have already explained, there must be this subject matter for the purpose of the corporeal embodiment of the abstraction so that it might be made manifest to man by including him. For doubtlessly man will accept no generalization concerning the world that does not at once include him, as well as his apparatus for perceiving it. Briefly, myth is the formulation of the abstraction of reality in a series of relationships involving human action and perceptions subjective and/or objective. The myth is a symbolic anecdote.

Now if we were to say that the artist since the Renaissance has also had a myth, we would have to note the different limitations and properties of the myths of antiquity and those of the modern world. These differences would provide a clue to the differences in the subject matter of the artists' representations from these two times.

The myth of ancient times had this particular quality: it possessed a singular unity. There was no division of functions in the ancient world such as we have today. Today

we have religion to serve our souls, we have law to serve our notions of temporal and property justice, we have science to qualify the structural world of matter and energy, we have sociology to deal with human conduct, we have psychology to deal with man's subjectivity, and within each category we have an antagonism of ends. That is, we find within each discipline one tendency to reduce all of existence to subjective categories, and a second tendency to reduce all to subjective quantities. The balance shifts from one to the other almost hourly. Within this duality I believe we can state one constant, and that is man's faith in the ability of the mind to clarify, to bring more order into the world of diversity than we have now, and further, his hope in the improvement of his lot; that is, his hope to understand both man and his lot in the world through the medium of his understanding. Even that notion has been challenged. But if we are to judge by the feeling of man in our particular surroundings—that, we would argue, is the binding belief.

Not so in the unities of antiquity. For there we have the miracle of comparative unity. Religion, law, ethics, science—that is, the explanation of the properties and functions of natural forces—are unified into a single system, and their relevance—that is, their immediate relevance to human conduct—is symbolized by the myth. In that sense, their philosophy was basic: its ends were always how man shall act in relationship to the gods who were the source, at once, of his blessings and blights, both of these meted out by the forces in his environment. So we have a series of anecdotes of human action wherein this relationship is exemplified, one anecdote designating both man's limitations and his avenues for movement or expansion.

So complete, in fact, is this philosophical unity that when the development of observation begins to contradict it, the ancient must still return to the myth for the verification of his new findings, for only by the reinterpretation of the myth can he find the substantiation for his new ideas. So Socrates, in positioning his new skepticism, actually calls upon the same gods he is questioning, in their traditional roles, to verify his doubts. The Greeks put him to death, and rightly so, for he was stabbing by this ruse the unity, that is, the completeness, of their universe. For they instinctively sensed the danger of Socrates' rationalization, and they anticipated that Socrates' line of thought would lead to dissolution. They, in their wisdom, understood that their moral and intellectual security rested not on the discovery of new truths but rather on the substantiation of the old ones. The same is true with the end of the Christian era, when the Moors' introduction of Aristotle began to undermine the security of the Christian philosophical unity. The Christian thinker needed to call upon his authorities to find in them the reaffirmation of his beliefs by showing that there is no substantial difference between his Christian beliefs and the teaching of Aristotle.

Our own golden synthesis of eighteenth-century materialism is even today making a similar stand. But this battle is not so intense because that unity never did achieve the influence—the cohesion—which the ancient myths did. Like Socrates this materialism carries with it its own destruction by positing human investigation, rather than a higher authority, as its basis.

What is important to note about the ancient myths, however, in contrast to our present myths, is the directness of relationship to the gods, who are really the representations of the forces of nature in relation to the actions and conduct of man. It may be said, in fact, that no postulate of abstraction is made without relating it directly and immediately to human conduct. Human suffering in the Greek myths has no virtue outside of the fact that it is the expression of either the harmony or disharmony of conduct with the elemental forces. This will be an important factor when we note that suffering has altogether a different significance in the Christian myth.

In contrast, whatever the synthesis we can achieve in the framework of our present knowledge, human conduct is never a direct expression of any of the laws that we have established, and to find its place in these systems it must go through a circuitous path, with whose byways we are not as yet thoroughly acquainted. Our philosophies that attempt to establish this relationship are as divergent as the almost infinite facets of nature, each of which we must investigate separately.

It is because the myths of antiquity relate all their abstractions to expressions of the human personality, and do so thoroughly, that they provide the artist with the most enviable sort of vehicle for the representation of his plastic notions. For, from the very beginning of things, the human figure has always been the artist's most complete exemplification of plastic coherence. And it is the ancient myth that made this plastic appearance symbolic of not only that formal perfection, but also of the inner perfection, whose harmony with the formal must always be the end for the artist. For this is the preoccupation of the artist, to resolve all known abstraction to a particular instance which will, in turn, serve to reinforce the generalization. As we have said before, unless the artist does so he has nothing to say, and at best his painting is an illustration of some aspects of the particular for their own sake. That is why, too, in the art of antiquity, we find that supreme integration between the subjective and objective which, in all work done since the Renaissance, is seldom achieved so completely. Very often we have to accept the heroic quality of the search for that unity as the substitute for the unity itself.

Since the myth is so complete and so unswerving, we find it a perfect vehicle for expression, for here is the anecdote employing sensible forms in dramatic relation-

ships, reinforcing the plastic movement through both the medium of its own unity and the living person's memory of the integral quality of the myth itself.

We do not say that every inhabitant of Greece or Egypt was aware of that unity in the manner that we speak of here. But they lived as if they were aware of it, and they were made aware of it through their worship and through the dependence of their actions upon the values implicit therein. Furthermore, they thought of nature in such a manner that seemed to corroborate the particular relationships implicit in that unity. Art simply reinforced that security, by restating it and presenting another aspect of it.

We find that the dogmatism of Christianity produced a similar condition, and again we find little incentive to vary the interpretation which seemed so admirably to account for everything, and whether true or not, in fact, nature in its manifestations seemed to submit to the Christian notion of reality. It is a lesson for us how the various aspects of reality, no matter how removed from what for us seems to be fact, can be made real and substantial if the subjective elements are favorable to the conclusion. It is a corroboration of how truly important the senses are in revealing the aspects of nature that seem desirable to the sort of proof we demand. Let us remember that both the Greeks and the Christians demanded "works as proof," and, being essentially naturalists, they were not admonished for that demand as were the Jews. Their senses found those works in the phenomena around them. In a sense, both Jesus and Zeus were in the position of scientists who were called upon at will to demonstrate their power to order nature.

There is no discrepancy, then, between the myths of antique civilizations and their representations of them, that is, their subjects. Both express the ideas of the ancients.

To summarize, we have stated that the artist always chooses the subject matter that can most directly illustrate his particular notions of reality. In what way did the myths of antiquity provide that subject matter?

1. Man was the end of all their notions of reality, hence man was the most adequate vehicle for showing the unity of the subjective and objective. The figure seems the artist's instinctive choice for the manifestation of that unity, for man is the prime example of subjective consciousness in its most developed degree and directness. It is interesting that in the more pantheistic mythic systems of Egypt and Syria, where beasts are a more formidable adversary of man, or Confucian China and India, where pantheism gave a position to the beast which was commensurate in importance to that of man, the representation of man is not so exclusive or disproportionate as it is in Greece.

2. The myth also provided the forms to show man in a relationship of action

to other men and toward the gods. Both in physical representation and in the terms of memory, intelligence, and anecdote, myth provided a sensible symbolization of relationship between the separate factors in the ultimate unity. There were no deviations because dogmatism made these relationships absolute, and practice made them satisfactory. Man was not devoted to the investigation of these truths, but all of his acts were designed for their reaffirmation. Virtue was not to question but to add examples for the purpose of corroboration.

SUBJECT MATTER AND ANTIQUITY

In relation to beasts we must point out, too, that in Greece, and from that time forward, except for a short time during the life of Saint Francis, the beast was a symbol of evil. The Assyrians respected him because he was still powerful. The Greeks, however, had already more or less conquered him and, as if like a bad dream of the past, he occurs as a symbol of evil very much in the sense of the dragon conquered by Saint George. The domesticated beast, on the other hand, such as the sheep or horse, was used as a symbol of gentility, the latter an accessory of elegance and a symbolic representation of the gentle character of the figure next to it or of the situation in which it occurs.

Among the Egyptians the animal is a god, and he is venerated and feared not as a beast but in relation to moral transgression. And since the Egyptian is vaguely pantheistic, he does not hesitate to crown the human body with the head of an animal. The Chinese loves the animal with the same calm detachment and the same penetration to form which he imparts to man, and therefore represents it with the same attributes of perfection and intelligence.

In other words, man's relationship to the animal is one of predominance to the extent that he establishes a degree of consciousness which becomes for him the objective of sensibility. The Renaissance painter, therefore, who takes such immense pride in his intelligence and in the power of the rational mind to subdue the forces of nature, reduces the animal to the status of a gracious accessory. The exception is Saint Francis, as we have already mentioned, and the difference of the role of the animal there is at once apparent.

Now we turn to the plastic continuity in relation to the figure, which we shall take here as an example of the subject. If we take Greek art as an example, we find that it inherits from the achieved balance of Crete and Egypt, not only the figure, but the particular attitude and canon of proportions of the figure. The Egyptians had produced this canon by endless experimentation and achieved an ultimate balance between the various

parts. That particular balance remains the symbol of plastic completeness. Only reluctantly does the Egyptian artist gradually part the legs and allow the figure to assume the similitude of grace. The art of Greece, venturing more representations of the ultimate balance contained in the figure, produces a more varied art.

There is one more consideration we must treat here before leaving the world of antiquity: why is art preoccupied with the nude? In what sense is the nude, as subject matter, a vehicle for the artist's notion of reality? I think there are two explanations which, in varying degrees, will clarify the matter. First of all, the nude is the physical symbol of procreativity, for the sensuousness of the human body in its very appearance is unmistakably the most tactile stimulant to procreativity. If we feel that this notion is far-fetched we need only examine the extent to which ancient life was preoccupied with that notion in its ritual. We find in antiquity a continual procession of the reaffirmation of this principle in all their festivals. Moreover, the stimulation of that notion through imagery and symbolism is present in all its religious imagery as well.

The actual act of procreation forms much of the ritual in Babylon, Egypt, Greece, and India. Frazer has made a very detailed study of the whole matter, wherein the universal prevalence of the procreative act in ritual is shown to be a definite pattern in all of these civilizations. It is true that ritual is very often concerned with the notion of stimulating fertility of every sort. Nevertheless, the concern with fertility in relation to the human race is not the same as the inducement of fertility in the field or other places upon which man depends for sustenance. Instead, fertility symbolizes the biological necessity for procreation—for the extension of self—of which the whole art process, as we have already described, is itself a part.

The second factor which makes the nude figure such a universal vehicle is that it is the most sublime and perfect exemplification of the unity of motivation—and the machine to realize this motivation. It is the true physical system containing the union of the subjective and objective. It is the embodiment of the trilogy of mechanical perfection, spiritual perfection, and beauty to the senses unified within a single form. In the end, the unison of the three must remain the ideal of perfection of any age, and for that reason the human figure and the nude have held the supreme place as the universal vehicle for the artist's notion of reality, having only left the domain of art, when so thoroughly proscribed by dogma or the sword as to make their rendering incompatible with the artist's continued existence.

We need to point out here the different attitude of the Christian painter in relationship to the human figure. The human figure is still employed. But seldom the nude, particularly the female nude. We might point out that the notion of procreation is no

longer an essential link in his whole philosophy. Existence is continuous in time rather than in substance. Insofar as man is the end of all mystery, that mystery still can be represented only in him. Yet he need not procreate to ensure everlasting extension of himself, for he shall live on forever anyway, no matter whether in purgatory or in paradise.

We should note, by corollary, that psychological expression makes itself manifest for the first time in Christian art. In primitive art, the terrorizing appearance of the masks and statues is not really a human expression but rather an expression of a demonology intended to frighten the enemy with the terror of the natural forces, which are terrible both in themselves and because the enemy is ignorant of them. For nothing is so terrifying as the unknown. Now. the art of India, Egypt, or China has no particularized expression. There is simply one cast of the face, one of quiet exhilaration, which imparts the joy of life rather than any specific human emotion. But in Christianity suffering becomes a way to salvation, and so we have here the first depiction of emotion—pain, suffering, sorrow— as integral parts of man's march to eternity. We might say here that, consistent with the tactile quality of all this art, the emotion is not a memory but rather a symbolic representation of the individualized feelings of individualized types which are developed during the Renaissance.

ANTIQUITY AND PLASTIC CONTINUITY

All that we have said of the paintings of these early civilizations is indeed conjectural, for in fact few of their works have survived for us to examine. We have some sort of indication of what their painting must have been like from the study of their bas reliefs, because in most instances they bear a striking resemblance to the few remaining shreds of painting that we can find from these peoples, and because bas relief, as used by all these early peoples, is itself simply a variation of painting employing, rightly, the concepts of relief in the round rather than draftsmanship. We can also conjecture from the sculpture, their plastic attitude toward the painting of the figure, for the two media, at least in relationship to the use of symbolism, always bear a marked relationship. In the case of the Renaissance, in fact, we might say that the new movement of painting was indeed induced by the examination of Hellenistic sculpture. In the instance of bas relief, it is indeed interesting to note that the fresco painters expressed their kinship with bas relief by means of actually incising their drawing into the wet plaster and allowing this indentation to function as a part of their design.

We know about Greek paintings only through accounts and through Hellenic treatment of lay subjects in Byzantium. Even here our knowledge is incomplete because, by

the Hellenic period, the art is no longer what we consider purely Greek but is already a mixture of all the predilections of the Alexandrian empire. Our best notion of Hellenistic paintings comes from the paintings of Pompeii, where we suppose that the Romans copied the Greeks with the same exact ardor that they copied her sculpture. Here, too, we have, on the whole, an unpolluted presentation of the Greek myth.

It should be emphasized that, in all these discussions, we are speaking of the unpolluted Greek art prior to the influences received as a result of Alexander's conquests. We can make such unequivocal categorizations only because of our ignorance of the civilizations which either were contemporaneous with or antedated the early formative centuries of Greek civilization. As the archaeologist's pickax digs deeper and deeper into the soil of antiquity, and the insularity of Greek genius dissolves, we may find the Greek Hermes, prancing lightly from Samos to Samothrace, from there to Crete, sojourning on the Nile, then back again to the islands, leaping to the bridgeheads of Assyria, and from there north and south and east, bringing his spoils for the Greek to mix within his own caldron. We should note, however, that the Greek tended not to taste each influence separately but to compound new portions.

Actually it is the awakening of Greek genius to the knowledge of self—the impulse not only to view the objects of his senses with penetrating acumen, but also to turn his mind upon those senses themselves as if they were as external to himself as the objects they examined—that binds and endears him to our own particular era. And the transmutation that occurred there seems very similar to the awakening of that spirit during the Renaissance. It was not given long to the Greek to pursue that incising inclination, however. Wars and Christianity forbade it, although the Greek avenged himself by enshrining sensuality in a hypocritical garb which enslaved the senses and minds of the world for a thousand years.

Therefore it is the Renaissance to which we must turn in order to understand fully the unfolding of this modernism, which has proceeded ever since in creating—in different places and at different times—its votaries, which have carried on the organic life of this type of investigation, circumventing factionalism and its antagonisms.

This universality of the cultural spirit was at once exemplified in the wars of Italy, where to be an artist was to receive a free passport from camp to camp, from the palace of one party to the camp of the fiercest adversary. A man could build fortifications if he chose, or continue to paint his Madonnas if he liked. The artist who worked for Siena could in the same year serve the Pope, who was starving the town by siege.

Our two points of study are therefore Greece and the Renaissance, for in those two civilizations we find the transition from older forms and ideas to those of our present

day in an order and direction that is particularly vivid and revealing to us—our language being what it is and our forms having developed as they have. While a similar transition can be found in other arts, such as the Chinese or the Persian, their direction has not precisely ours and hence would not be as revealing as our two chosen examples in the explanation of our heritage and development.

Particularly of note is that new subject matter does not appear spontaneously but is always the result of new plastic occurrences. When the view of reality of an age shows no perceptible change, the notions of plasticity remain constant since, as we have expressed, they are the artist's notion of reality, and to that extent he participates equally with the notions of reality of his particular time. We might say that insofar as society's view of reality remains constant, the artist's view remains constant.

Therefore the early subject matter of the Greeks remained substantially the combination of the subject matter of his contemporary civilizations, which were the composite of his own. For them subject matter was predominantly Egyptian—as Egypt produced the most comprehensive contemporary synthesis—plus a conglomeration of influences from the other coexisting Aegean civilizations, with the possible addition of Teutonic subjective inclinations brought by the Achaeans from the Teutonic lands whence they came. Again, all of those relationships are conjecture, for they may be the product of contemporary wishes for those kinds of correlations. But we know that Greece partook mainly of the Egyptian notion, which was the most fully developed of its time, and assumed that prototype almost intact in all its most essential characteristics. And for hundreds of years, as long as that particular dogma seemed to be satisfactory, there was hardly any visible change. Only when a new notion of reality began to dawn, did the Egyptian rigidity begin to relax, and then only slowly, for one does not quickly abandon something which has functioned so satisfactorily. Little by little the legs move apart, the head leans, the joints begin to articulate, and the soul begins to speak of many more aspects of itself, which in the past it had not considered a portion of its heroic heritage.

The Myth

THE MYTH OF THE RENAISSANCE

Here we must discuss the matter of myth. We all know that the myth provided, let us say, the corporeal body or vehicle for the artist of antiquity, that is, the Greek, Roman, and Christian artist. The same kind of myth functioned similarly for the Egyptian, the Hindu, and, at least partly, for the Chinese painter (particularly the creator of Buddhist Chinese art), as well as the Persian artist.

When we approach the Renaissance, we find that the myth still exists, yet the variety of its presentation is unprecedented in the thousands of years of antiquity. Already during the Hellenistic period of the Greeks we find the uniformity disappearing. Yet the change in itself has a greater uniformity. We find that it takes place in the manner of a transition, forms extending themselves from the stone bit by bit. Here it corresponds with the skepticism which is contemporaneous with Plato, yet that skepticism is well grounded in reverence for tradition, and we see that Plato's skepticism comes simply from the desire to reinforce the Greek unity through the examination of the tradition in the light of new perceptions and finally to reestablish it upon firmer grounds than ever. There is no shift of emphasis. The unity of the state as the symbol of ultimate unity is still his concern. But it is significant to note that he would throw out the poet, who is the most concrete manifestation of the old unity, and replace him with the philosopher, who is the symbol of the vision of a rational unity.

His problem is that he wants to record all deeds as seen from the point of view of individual sensation and responsibility, and to make ultimate unity conform to them rather than make individual sensibility conform to an a priori unity. In that sense he posits the problem of individual responsibility whose challenge Christianity accepts. However, Christianity solves the problem only by reducing the responsibility to individual conduct, by making it amenable to a higher unity who is master of the forces of nature, whereas in Greek philosophy the natural forces—or their energies—constituted the Gods themselves. In other words, Christianity substitutes the Hebraic abstraction of Jehovah, who cannot

be seen, whose name must not even be spoken, and whose representation must never be made, for the tangible ultimates of the Greeks.

Yet Christianity makes this concession to the old Greek unity by creating a hierarchy of intercessors, whose function and accessibility is comparable to the humanity of the Greek gods and which, in a sense, brings them even closer to man in that they are in fact creatures in a hierarchy of men. It is a democratic action in the sense that men achieve their station in this hierarchy not through some mystic means but through their piety and deeds. So while Christianity stressed the individual, at the same time it placed his salvation elsewhere. It therefore admitted the artificiality of ultimate unity, and those elements it could not incorporate into its system it called sin and banished from immortality and therefore from permanency in ultimate unity.

The Renaissance is to throw off this arbitrary form of adjustment to unity, and henceforth man is upon the uncharted course of achieving unity through confidence in his own equipment. This accounts for the lack of uniformity from this time on, for the succession and contemporaneous existence of conflicting unities, and for the lack of conviction necessary to establish either a moral or aesthetic system commensurate with the finality of those of antiquity. Man pays in this fashion for his untrammeled independence. Faust, here, is the prime example.

For one short moment in the eighteenth century, it was thought that the mechanical principle would, in the end, give birth again to the finality and the conviction of the ancient a priori unities. So great was that hope, and so necessary to faith, that our world today still proceeds from it. Yet the mechanical principle is not identical with its application in the machine, and its own development bore the seeds of its own destruction. Our present notions of functionalism and three-dimensional sociology, and their popular acceptance with enthusiasm, are almost a hysterical clinging on to an already insupportable dream. Yet the dream is so desirable, as much so to us today as it was in the early days of the Renaissance, when man hoped to travel directly on this route through the power of his mind to a satisfactory conclusion.

That ultimate unity which the ancients achieved is never found again, perhaps with the exception of the Venetian painters and Shakespeare. For the ancients had combined within their plastic world the three all-important elements of human experience within a single symbol. These three are sensualism, sensation, and objectivity. From that time on, the paintings emphasize one or the other, and express at the same time the anguish of their unsuccessfully Promethean effort to combine all three.

For even the Christian religion had to deal with sensualism. Although it made every effort to transfer it to the mystic plane, it reaffirmed the importance of this element

by its struggle against it. And therefore, for Christianity, the prostitute, and the triumph over her, as well as the birth of the Lord coincident with the negation of the fertilizing process, served to reinforce sensuality's actuality. The Christian formula is comparable to that of Islam, where the most mystic and unterrestrial of unities find their compensation in the greatest sensuality. The Mohammedan substitutes the endless sensualism of the world to come for the limitations imposed here, even though, in any sense of the word, that sensualism represents the utmost liberalism. The Greek, in discovering drapery, seemed only to enhance the sensuality of what it covered. And the Christian enhanced it even more concretely by his emphasis of the tactile, tactility being the primary element of sexual sensation.

The Renaissance might well be called the last stand of the myth. The last kind of myth, which might be characterized as an allegory, is a satisfactory combination of all the factors of a conscious existence. It stands, we might say, at the precise point in relation to the reality of the world in which Socrates stood when last expounding, on his deathbed, the wonders of the world to be, as related in *Phaedo*. Already we see a hint of the Christian paradise when we compare Socrates' notion to the Stygian darkness which Achilles frequented in search of his friend. Already you have the notion of duality in that the speaker pictures the future world as one that is a feast to the senses, after having decried the validity of the senses throughout the entire discourse. In other words, he hopes from the world to come the undiluted delights of sensorial pleasure of which his mind has robbed him in the present world.

Christianity, by all appearances, has accepted this solution whose incompatibility Socrates did not: mortifying the senses in this world and repaying them a thousandfold in the world to come. The idealistic reunification of the two in the Renaissance is again heralded by the sensualist Dante. His notion of the world to come is the most intense visualization of sensual suffering and revelry known to man.

The duality between mind and senses that Plato articulated is reclaimed by the Renaissance, with this difference: Plato stands at the close of an era, and the men of the Renaissance are at the beginning of one. We might say, then, that the myth in Plato is at the beginning of decay, and yet we can include him within the functional world of the myth for he still works within it. Its final disintegration is brought on by Christianity, which really never deals with it but deflects it, and by amalgamating it more thoroughly with Jewish and Oriental traditions produces the semblance of a new unity, which the world of the next ten centuries accepts.

But the Renaissance, being at the beginning of a new era, reclaimed that duality, sapped the Christian myth of the power it held until that time, and degree by degree

annihilated the existence of the unifying myth. Mankind never again has had a myth which is so absolute in its comprehensiveness, and as the years pass and pass, the mythic forms— that is, the allegories used to express them—go, too, with the passing of the myth. In other words, the Renaissance is the beginning of the degeneration of the particular allegory or anecdote as the vehicle for the artist's expression of his notions of reality.

In all art from that time on, the duality between the world of sensations and the world of the mind is the basic expression of the lack of unity. The amalgamation of these two worlds within a single system—a new unity comparable to the completeness of the one that could no longer serve—becomes the motivating incentive for all inquiry and all artistic expression. Investigation as well as expression becomes specialized and therefore diverse.

There is, however, one unifying element which allows the two processes to occur at once, and that is man's faith in himself—in his own mind—to maintain, simultaneously, consciousness of himself and of his surroundings. It gives man a new heroic stature of self-dependence in relationship to the gods. The gods are no longer the forces themselves, but rather are the custodians of powers that man must wheedle or wrest from them, one by one. Prometheus is no longer a god but a man forever badgering or being badgered in this heroic quest. Man has assumed responsibility, but the new responsibility is primarily in relation to this quest for power and independence. This, then, is the new myth. The unity is no longer a fact to be described by an anecdote but instead is an abstraction of status, to be intimated and depicted.

It is this heroic contemplation of the status of man which makes it possible to continue the heroic forms of the ancients in its art. The gods became men in ancient art. Here, the men became gods. In ancient art, the gods assumed human attributes of weakness, deceit, dishonesty, irrationality, etc. In the new art, the men became gods by shedding triviality, by the development of their godlike superhuman traits in the pursuit of this heroic quest. In the former system, the infinite partook of the characteristics of the particular, and by that act it generalized the particular. The Renaissance took the particular and exalted it to the plane of the infinite. Thus, in ancient art, any human action was on the plane of the heroic. In our art, we must exalt a human action in order to make it partake of the essence of the heroic. That is why Greek anecdotes seldom fail to voice their infinite implications, whereas it is almost impossible for us to lift any anecdote to that dimension. Christian art was able to depict a heroic incident because, through the figure of Christ, human activity and suffering partook of the significance of salvation through human acts, for every act was conceived as contributing to the salvation of man. Our own struggles, however, are individualized and remain our individual preoccupations, and in the main never connect to the stream of the infinite. Similarly, we cannot paint human relationships. Our

groups cannot have anything to do with each other. They come together at the same place only by pretext, be it beach, street, or some other location.

It is this matter of the heroic that really differentiates art from mere illustrative anecdote. For art is always the final generalization. It must provide the implications of infinity to any situation. And if our own environment is too diverse to allow a philosophical unity, it must find some symbol to express at least the desire for one.

The Renaissance artist, however, did not dwell forever on his inability to combine this duality of the general and the particular, the infinite and the individual, but became fascinated by the new discoveries propelled by his renewed faith in the senses. The works of many of the Renaissance might be called Faustian. However, they went about their business of discovering new principles of vision, of line, of atmosphere, and seem to pass their years in complete absorption by the application of these new plastic principles to the representation of their new myth. Still, the Renaissance artist clung to the anecdotes of the old myths, both pagan and Christian. For he could find no other myth to replace it with for the representation of the interaction of man to man. And there has never been found since the kind of motivation for human interaction that the ancient myth provided. From that time on, there is no longer the presentation of that interaction. When an artist wants to show interaction, he must invariably go back to these old myths, but if anything these myths represent a type of nostalgic paganism, or in the case of the Christian myth, a forced emotionalism, where the gyrations and suffering are more a devotion to the past—and in that sense academic—than the presentation of a meaningful experience. Right up through Poussin and David, who could not conceive of a representative classicism without the Greeks, artists were able to reestablish formal classicism only by borrowing, at the same time, the mythological anecdote of classical times. And that is true of all neoclassical movements. In fact, it could not be otherwise.

Therefore, we might call the Renaissance the death of faith, the death of unity, and the death of the myth.

THE MYTH SINCE THE RENAISSANCE
INTRODUCTION

The study of the Renaissance painter is the study of the succession of death agonies by which the myth is lost as the symbol of the artist's notion of reality. The plastic reality, as well as other realities—whether they be of physical phenomena or the conception of the nature and functions of the soul—become specialized. They can no longer be described within the same system. Hence, the plastic world begins to evolve through a series of devel-

opments which allow it to symbolize its own trinity of reality without the aid of the myth. This trinity consists of the mechanical, the sensorial, and the sensual.

In a sense, the whole artistic process since the Renaissance can be described as a nostalgic yearning for a myth and a search for new symbols that will enable art to symbolize again the utmost fullness of reality. The search still continues, and perhaps we are nearer the solution than those who first understood the nature of this problem. Again and again we find in different lands, at different times, the attempt to rehabilitate the old myths, when the despair of the search becomes too bitter. These attempts were made possible, indeed necessary, because nostalgia became a narcotic substitute for reality.

And so we have a series of neoclassical revivals. Yet they have been, without exception, abortive, for they could not have been truly convincing to the artists who employed them as children of their own environment. The high point of these revivals was in France at the time of Poussin, David, and Ingres. The great value of these revivals has been, in the main, their emphasis on the desirability of the organic life of painting, and the perfection of plastic relationships expressing complete unity. They have also provided a certain check of spurious coherence found in paintings which lack that unity. And pathetically enough, they have had to carry the flesh of their yearnings—that is, the mythic anecdote—with the spirit, for they found no new symbolic representations of human action that could duplicate the nobility and infiniteness of those represented in the plastic unity of classicism which they so loved.

The same was true for those artists for whom reality was captured in the particular spirituality of the old myths. Here we have painters whose predominant representations were subjective, and who consistently had to revert, as did Rembrandt, to the Christian myths for the symbolization of the interaction of human beings in the sphere of human emotionality.

It was not until the turn of the twentieth century that a more logical response to this problem developed. Here the artists understood that the then present concept of reality did not possess a myth for the representation of the interaction of human beings within an anecdote. Hence they made their subject matter referable not to the anecdote but rather to the abstractions of form and sensations, wherein the human mind lived most profoundly in relation to reality in its own day. Similarly, the artist of emotionality abstracted emotion itself, and referred to this abstraction rather than to the portrayal of emotion in human interaction. In that sense subject matter began to operate on a plane wherein our own age finds its own utmost coherence, in the plane of atomic elementals, where everything is reduced to an abstraction of the lowest denominator of all existence. And like in our sciences, we have a basic duality in art: one must choose between the representation of objec-

tive and subjective reality. It is the purpose of our chapter now to describe the various devices which the Renaissance and the painters since that time have employed for the representation of their notion of reality.

THE MYTH AND ITS PRESENTATION IN THE PLASTIC LANGUAGE

It is significant that the myth, or, rather, those places where the myth functions fully as it did in the world of antiquity, always employ the tactile kind of plasticity for its representation. When we say employ, we are of course misstating the relationship, and it will be well to make clear that the two, myth and tactile plasticity, are not separable. So let us say, rather, that the presence of mythical subject matter in a painting is always coexistent with tactile plasticity. This is logical because, as we have said, there is no separation in the world of the myths between reality and unreality. To the progenitors of myth, all appeared real, both their symbols and the objects of their symbols. They well understood that their gods were symbolical names for forces, yet those symbols were functioning as a part of reality nonetheless. Hence the Greek, the Christian, the Hindu, and the Mesopotamian never made the attempt to produce the likeness of reality as an end in itself in their art. Although they used a great deal of material which appealed to visual memory in a slighter or greater degree, which varied with times and places, their objective was never to reproduce the particular attributes of visual mechanics. Their representation of the gods, even when they partook more and more human characteristics (which is a common progression of the arts of Greece and India at least), are never attempts to produce the appearance of a man, but rather a reference to the genre of man.

Here an example from mathematics may be helpful. The letter x in algebra is definitely an abstraction in relationship to the numbers with which it can intermingle as a factor. It is true that the numbers are also an abstraction, yet x is even a further abstraction from the qualities of the numbers. Yet this letter functions in all of the calculations as a real quantity. In other words, we have a symbol which admittedly represents the unknown. Yet our faith in the system is so great—that is, our faith in the absolute relationships of all quantities—that we can affirm this symbol of the unknown as a definite, real, and calculable element. We might say that the Greeks understood the quality of the unknown, but so great was their faith in order that the unknown, although always symbolized, functioned for them as a part of reality, and entered as a real attribute in all their real relationships. Now, the substitution of the letter x, or, in fact, of any of the numerical quantities by real objects, would immediately remove the whole relationship from the sphere of generality and place it into the particular, for real objects would introduce a host of qualities

which would impress themselves upon our attention and consequently confuse the absoluteness of our equations.

In this sense, the Greek never particularized the objects which he introduced as vehicles for the statement of the plastic equivalent of unity. All the objects are made impersonal, having definite functions as symbols both in appearance and in the portion which they play in the anecdote. All the relationships are therefore symbolic. This is made manifest in the figures represented, whose attitudes and relationships toward not only each other, but in relation to the cosmogonic forces which they symbolize, are symbolic; the meaning of the symbol itself being identical with the notion of reality which the artist is to symbolize or to make manifest plastically.

Now, in the world of the painter, his sense of the essential and the infinite must be realized plastically. He must express his notions of reality in the terms of shapes, space, colors, rhythms, and the other plastic elements which we have previously described, for they constitute the language of painting, just as sound, timbres, and measures constitute that of the musician, or words and sentences that of the linguist. Or rather, the painter must represent them by the means of colored shapes arranged in certain rhythms constituting certain ideated and controlled movements toward a particular effect, this effect or end being the subject of his picture.

SENSUALITY AND THE MYTH

Now it is the function of art, as of all ultimate unities, to reduce all notions of reality to the human element. In the antique unities, as we have seen, all knowledge was directed and integrated with human conduct, human emotion being subservient to it, too. The Renaissance artist, in the strict emulation of the Greek, was again both scientist and artist, often confusing the function of both. This is easy to understand because he had the prototype of the Greeks, for whom scientist and artist were one. But he did not realize this discrepancy at first, because his science was founded on Aristotle, who was a Greek unlike the others and who would have disrupted the identity of the two if the Greek genius had not been interrupted by Rome and then deflected by the Neoplatonism of Christianity. The Renaissance artist, therefore, inherited his myth from Plato, and his scientific method from Aristotle. They soon found that Aristotle's categorical method could not be amalgamated, once they developed it, with the unified morality of Plato. From that moment on, you have a series of specializations, each further and further removed from the ultimate unity of phenomena or its explanation, and from the conduct of man. The separation had to come, or a new set of symbols would have had to be created which would bridge this discrepancy.

Here we must digress for a moment to investigate the whole element of sensuality. Any art that achieves finality or perfect fruition cannot evade the consideration of sensuality. The distinction, in fact, between the sensible and the sensuous is not as clear as we might suppose. If we speak of sensations in the illusory or ideological sense we are of course one step removed from sensation in the tactile notion of sensations, which we have already described in the treatment of textures. If we speak of sensations in the ideological sense, we are again another step removed from tactile sensation, or perhaps removed by a series of complex steps from the basic experience of sensations which is the tactile. But the distinction between the sensual and the tactile sensation is by no means so clearly defined. For we are never able to divorce sensations abstractly from the amount of positive or negative pleasure which they give us. For textures on the whole are an index for tactile sensations. They are either more or less pleasant or unpleasant. That it is actually possible even to include the unpleasant in an entity which to us appears satisfactory is simply a corroboration of this sensuous element in tactile sensation. We need not describe the circuitous paths by which the connection is made, for modern psychology has pointed to a variety of explanations, each probably valid for this phenomenon. It can be likened, too, to a philosophical concept which must make the pain of evil conducive to the general harmony of the whole.

The important thing for our discussion is that it is essential for the sensual element to be included in some way or another in any work of art, for that basically is the reduction of the plastic unity to the human element. We may add here that even the modern artists who have attempted to eliminate this element from their paintings, with a motivation of purism not far removed in actuality from religious puritanism, are, like those puritanical religionists, simply reaffirming the necessity of the sensual element by the vehemence of their effort to exclude it. For pain itself is, in its nature, textural and hence sensuous, and the elimination of this quality as a factor in expression requires the manipulation of artifices to that end, which reveal the sensuousness which they are trying to hide. (In a sense all purely illusionistic pictures, or those which stress this end most, are the most sensuous by that denial.)

Now Greek art, as well as all antique art, dealt with sensuousness very clearly. It showed this not only by its preoccupation with the nude, but by the general voluptuousness of its art, as well as by the frank inclusions in its myth of sexual and allied anecdotes. It was in this respect harmonious with all of the Greek ritual and customs which set aside various state and ritualistic functions for the symbolization of their concepts of fertility, as fertility constituted a preponderant portion of their notions of reality. Christian art, of course, forbade the representation of sensuality. This was the Hebraic heritage. Sensuality,

however, was simply hidden from apparent view. And we know today that much of the ritual of the church emanates from those rituals related to fertility which were part of its Asiatic as well as its Greek heritage. In art, the same parallels occurred. The representation of sensuality in man was forbidden, but man avenged himself by loading all his textures with a direct and narcotic sensuality which the Greek had never felt the necessity of exploiting since the expression of that important element was vouchsafed by his society in a more easy and natural manner.

It is this quality of sensation, whether it be a direct derivative from the sensual or perhaps a derivative from a common source, which distinguishes art from science in our own day. This is a distinction which the periods of dogmatic unity did not make. Science today has the notion of objectivity which divorces the absolute laws of relationship from our machinery for apprehending them. The study of the senses themselves is conducted in the same manner, objectifying the machinery and establishing a separation between the machinery of sensation and the effects produced by phenomena upon them.

In other words, science today is at its best and its most definite when it examines isolated phenomena and establishes the laws innate to its single operations. In this sense, our study of art here is being conducted in the same way. For first we have to establish the laws of plastic continuity in themselves. Then we must establish the laws of sensuality, etc. And then we must establish another system of logic in order to make order in an entirely new category. Such is our own method for ascertaining the greatest reality, and one must think this way in our age in order to attain satisfying results.

We, of course, pride ourselves upon our empiricism and believe that we have established the only known method for ascertaining truth. Yet we are not without our challengers, for the pragmatic school, being aware of the inadequacy of our rationalism to affect a desirable unity, posits the old notion of works as the demonstration of ultimate truth. Pragmatism being the dogmatism of the practical is not compatible with the rationality of today. Whether it displaces our own mode of thinking or not, whether it deserves to or not, is something which we cannot undertake to discuss here.

Hence we have, beginning with the Renaissance, the separation of the functions of the artist and scientist. We have the establishment of a series of specializations which have grown more numerous with each passing day. It took the Renaissance, however, a hundred years to see clearly the necessity for this separation of functions. For at the beginnings of the Renaissance in Florence, this inevitable separation was not understood. We have there, as a result, a confusion of the two operations. The painters of Florence are both scientists and artists, and we can say as a result that their work as a whole does not attain the finality which the school of Venice achieves in the sixteenth century. Michelangelo and

Leonardo and Ucello, and a host of other artists, often use their art to demonstrate the scientific discoveries of the laws of vision, both linear and atmospheric, and therefore in many places in their work we find an understatement of essential plastic ingredients, primarily the proper function of the sensual element. Leonardo perhaps understood the discrepancy and hence we sometimes find an exaggeration of the sensual in his work. But so thoroughly was he a scientist, at the same time, that in his understanding of the nature of specialization he shifts from science to art, and then from art to science, never bringing either to complete fruition.

During the Renaissance, still another specialization was established. Since the mechanics of rendering tactile visuality were not understood, since psychology was the least developed of the sciences, the illusory representation of sensuality and feeling was developed as a substitute in order to connect science with its human element. It is the full exploitation of this illusory process in conjunction with the further developments of the laws of vision which were best synthesized by Raphael, and in that sense he is the author of the most complete painting of the early Florentine development.

Here, then, we have an exploitation of human feelings through the representation of expression and the heightened effect of these through the discovery of atmospheric light, which replaces both in representation and in surface the tactile sensuality which the older artists achieved. The need for this illusory approach to sensuality can be partly accounted for by the fact that psychology remained within the domain of the Church throughout that age, and that the functioning of the mind was the last area of the investigation which man undertook regarding sensation.

It is in Venice where the trammels of the ascetic are finally cast off and where we have a reaffirmation of sensuality. With this reaffirmation we find the most complete painting and the only real reconstruction of the myth of Greece. For in both the subject matter and in the methods we have the complete sway of sensuality and the reconstruction of the mythological, which directly and pertinently brought the notions of reality of the Renaissance to the level and vocabulary of man.

The Attempted Myth of Today

As discussed previously, observing the synthesis or unity that we believe the Greeks or Christians possessed cannot but imbue us with a feeling of envy and desire to formulate one for ourselves. This desire has been intensified by the growth of the collective spirit in our social concepts and institutions. It has been pointed out that the abandonment of the myth was due to the development of, and new emphasis upon, the individual and individuality. Today, by contrast, our economic life and the development of our social responsibilities in an unindividualistic and communal sense have formed the proper conditions for the evolvement of such a myth. Further, the cult of materialism—which has been adopted in one way or another in many parts of the world—is a substantial basis for the evolution of symbols which could bring to life, in terms of pictorial symbols, human interaction in relation to this new myth.

This is a program which must be clearly differentiated from the point of view of those who desire a genre art as the expression of our society, or from those who would build our art from popular beginnings, or make popularity the basis of our production. I do not believe that we should, or can, deny ourselves this desire for synthesizing myth. And it is only by making this differentiation from popular genres very clear that our efforts in this direction can become intelligent and potentially fruitful. Unfortunately, this differentiation is not made, and the two are often confused by the erroneous juxtaposition of words and notions.

First let us examine the relationship of materialism and naturalism, which is implied by genre art. Naturalism, or illusory resemblance of nature, has been allied with materialism. The basis of this misunderstanding has several roots. First of all, historians tell us that the development of materialism in the Renaissance was synonymous with the development of naturalism, and that the Renaissance artist was able to adopt the new naturalism to his presentation of the myth in his own paintings. What these people forget is that the Renaissance culture did not succeed in creating its own myth, and that its successive developments toward naturalism were the succession of steps by which the anecdotal

myth was exterminated. The representations of the myths which the artists did employ were never convincing in relationship to the myth itself, but rather were a demonstration of their lack of mythical developments. Who would deny that Mantegna's crucifixion is less revealing of the Christian spirit than that of Giotto, and the *Ecce Homo* of Titian is an excursion into sensual romanticism rather than the exaltation of religiosity, or that Rembrandt's rendering is a romantic expression of individualized suffering rather than the expression of a communal crucifixion?

It must be clear that particularization, which is the end of naturalism, is the most potent expression of individualism and the direct antithesis of the communal spirit. In other words, if labor is the hero, the representation of a workingman must be all workers and not a particular worker. And any representation of the relationship of one human to another must be referable to the interaction of all humanity rather than the relation of one individual to the other or the representation of the job which they are performing. And the emotion, which the sum total of the representation evokes, must be a feeling referable to the basic feelings of all humanity rather than the particular expression of the joys and pleasures of the particular individuals. Conversely, the more we are lost in the participation of the actual expression of the individual object or objects, the far less likely we are to refer it to the general.

Those who have realized the discrepancy between naturalism and a heroic anecdotal art have therefore relied upon the subjective expression of the day, for those artists, at least, achieve, within the current plastic notions, the reference to subjective universality (the expression of the objective universality today has been achieved by the abstractionists). Therefore we find artists who have employed anecdotes that supposedly relate to social generalization by means of the plastic languages evolved by these subjective arts, namely expressionism and surrealism. Their failure here to achieve their purposes is due to their failure to recognize the organic and indivisible character of subject matter and the plastic elements. Hence they have achieved simply another variety of surrealism or expressionism, and the feeling which is evoked is not of the anecdote but rather of the particular mystifications of surrealism, and the emotionalism of expressionism. For in using these forms of expression they have had to convert their anecdote into the expressive forms themselves and have therefore lost the identity of their anecdote, except by such associations as they have been able to conjure up through the titles which they affix to their creations.

Again we might learn our lesson clearly from the known practice of children. Any child will use a great variety of subjects. Yet all his pictures amount to the same expression which can be characterized by the description of his plastic predilections. His artworks will all display the same kind of fantasy, the same preference for certain textures or kinds

of calligraphy. The subject is lost in the contemplation of the effect. And it is only a careful examination which will reveal a difference of intention as to the matter represented. But children are wise in this respect. They are very clear about their interests. Impose a subject on them, let us say a historical subject, and they will select those episodes which will allow them to use those forms which they have found to be the best expressions of their predilections. The girls will find dresses to design, the boys soldiers and movement, or a house or whatever shapes they find most sympathetic.

Ultimately, this attempt to represent the universal rests upon one of a few solutions. The artist must either fall back upon the treatment of a single figure, for it is here wherein the artist since the Renaissance has been the most successful in attributing generalized implications to the human being, or they must await the evolvement of a series of anecdotal myths which will give a universal significance to their newly found unity, or they must fall back upon the allegories of the past which have used a form of symbolism signifying communal interrelationship. It is noteworthy that the Mexican painters who have adopted the Aztec plastic terminology have used it mainly for the purpose of portraying subjective terror, whereas for the portrayal of human interaction they have had to revert to the symbols of Giottoesque Italy. In that sense their art has never yet been integrated into a unity, for we do not know, in any scene which they represent, whether it is the terror that is uppermost or the hope which they wish to announce.

In our hope for the heroic, and the knowledge that art must be heroic, we cannot but wish for the communal myth again. Who would not rather paint the soul-searching agonies of Giotto than the apples of Chardin, for all of the love we have for them?

Primitive Civilizations' Influence on Modern Art

When discussing primitives and ancients, as we have at various points throughout this work, a distinction must be made between the antique civilizations—that is, the civilization of Greece (and all of the civilizations to which it was indebted at its beginnings, and which were in turn indebted to Greece through their own interaction with it)—and those civilizations which have more recently become the objects of intensive study: the primitive civilizations, as exemplified by those of Africa and the Indian tribes of the Americas. This latter group, either contemporaneous with us or at least much closer to us in time than the civilizations of antiquity, are further removed from us by their notions of reality.

We have treated both these types of civilizations as a unit until this time because their arts share a common factor which allows us to unify them in our study of subject matter: they all have a myth which symbolizes completely their notions of reality. We must now turn, however, to the investigation of their differences in order to discover why the civilization of Greece and all of those other civilizations which approximate it—those of the Aegean, the Nile, and even India and China—have had so direct an influence upon Western art, up to the present century, to the exclusion of the other civilizations.

It may be said that our knowledge of the primitive arts was very meager until the turn of this century. This is true only to a limited extent, for travelers have for many centuries reported the strange tales of the aborigines, and the civilization of the Aztecs was well known in the middle of the sixteenth century. The exotic qualities of the negro—but only the exotic qualities—were very well recognized during the succeeding two centuries, where they began to appear in the paintings of the Venetians and their successors. We find the American Indian serving as a prototype in Shakespeare, and he was apparently a darling of exoticism in the courts of both the Russian and the French aristocracy. He is also the inspiration of the naturalism and primitivism of Rousseau. Yet it was not until the present century that his art and his particular myth entered as a stimulant in the art of the Western world. Similarly, Titian was painter to the sultan and must have seen Islamic art, but again only the romantic aspects were recognized.

So while we find the primitive as the object of exotic admiration we find no reaction to his art—with which the Renaissance must have been acquainted, at least by the middle of that period. It was certainly no sense of geographical indigenousness or of honesty which kept them from making full use of the new forms they must have encountered. For the Renaissance artist appropriated everything from everywhere, making no distinction between the innovations of his next-door neighbor and those from across the continent. He embraced the newly articulated scientific spirit to its fullest degree. Advances in the arts were advances in knowledge, and hence any method or manner or innovation was the property of all to develop, very much in the same sense of the science of today, which considers the whole body of science, and not any particular segment of it, as the objective of growth, and its ideas, rather than jealously guarded, are at once published and placed at the disposal of anyone who might make accretions to the body of truth.

Now what is the reason that the Renaissance artist was unable to appropriate the symbols and the forms of the primitives, and why does the modern movement find such sympathy for them? Indeed we may call the modern movement a new Renaissance in that it uses the sculptures of the primitive with the same objective purpose which was characteristic of the Renaissance use of Hellenistic sculpture.

It is interesting to note that it is sculpture in both cases which produced the revival. This is partly attributable to the fact that sculpture is the least perishable of the arts and was therefore available when the paintings of a period were no longer extant. I believe another factor in sculpture's influence stems from the medium itself, which, due to its limitations, excludes the intrusion of spurious materials and hence better preserves the manifestations of the artwork's essential principles. Perhaps due to these factors, in both Renaissance art and modern cubism, each of which was derived from the sculpture of ancient civilization, we find the tendency to produce the sculpturesque. In the case of the Renaissance, the artists made, at first, no differentiation between the two media, and actually attempted to achieve in painting the sense of relief, which is the compelling sensation in sculpture. In the case of the cubists, they already understood the difference between media and therefore bound their increased sculptural thrusts in the third dimension by rigorously limiting the extent of the pictorial recession in very much the same way we have described Giotto as having done.

Modern art, however, is not only the result of this sculptural tendency. For simultaneously with the cubist interest in African art there arose interest in the Arabic and Persian arabesque. In the case of Matisse, this influence resulted in the actual deliberate reaffirmation of the flat design by the complete exclusion of modeling and the reduction of the role of chiaroscuro to a mere decorative and slightly used device. But more of this

later. The cubists in fact appropriated chiaroscuro, using it to actually produce a heightened sense of tactile recession. They solved the problem of the supremacy of the frontal surface by bringing the form back to it as often as they moved it inward.

But let us return more generally to the role of primitives. The Renaissance artists could not use primitive forms, because, in a sense, their entire period is a protest, a denial of the supernatural element, of symbolism, of dogma, of the phantoms which Greece had already begun to refine into an indelible system of rationality. The primitives must have seemed to them as the acme of irrationality, as a basis of the dogma which eventually beclouded the life of the mind unto their very doorsteps. In that sense, primitive creations represented to them hobgoblins which their own reasoning and investigation would dispel forever and banish entirely from human consideration. The fantasies of the Renaissance artists were, by extension, exclusively romantic, picturing the unknown in terms of what appeared to them idyllic in their known world. Therein lay their sympathy for the Greek and even the more civilized of the oriental civilizations, wherein could be witnessed everywhere the human effort to reduce the world of chimeras to the terms of cognizable and measurable forces.

But the modern artist had already at his disposal a new reality in which these chimeras were not seen as sheer delusion, but were instead given a place of priority in the motivations of our acts, over those elements which the Renaissance had created, that is, the elements of reason. We should note that the word *rationality* gave birth to the word *rationalization*. Psychology and psychiatry have examined, in recent decades, the world of reason and, in looking beneath its surface, have uncovered other mental forces that, lo and behold, have the features of these chimeras of the primitives. Research revealed that man was far more motivated by the dark regions of these primordial beginnings of life; that these fears and terrors of the child's nightmare had never been banished, and in fact could not be banished; and that they lurked and directed much human action. They were, in fact, the real powers behind the human personality, and reason was simply a convention, giving man the illusion of order and of consciousness, so that his conscience and self-respect could be placated in his servility to these abysmal forces. This is, of course, the most dismal view of the subject. The important thing is that these fears, of which the terrorizing images rendered by the African or the Aztec and the cruel idolatry of the Babylonians are symbols, have been reinstated into the world of reality and have come to be considered the basic sources of human action.

It is not surprising that here, too, the artist has found the most elemental and direct expressions, and the least prolix of all plastic forms. Seeking the basic in both—that is, the most elemental feelings and the most elemental expression—and viewing them

107

through the lens of objectivity in the age which gave him life, the modern artist finds the two amalgamated in primitive sculpture.

So the cubist, and from him the abstractionist, who together constitute the objective side of the modern objective/subjective duality, become fascinated by the manifestation of these elemental values and examine them dispassionately—both the form and the emotion—producing their dispassionate summary of the rediscovered basic elements of emotion and appearance in their new art.

Neither can the subjectivist, for his part, discard the new reality. For him human feeling (which is his conscious emotionality in relation to his sensation) is the basis of the life of the conscious being. He must certainly find in these newly discovered dark pools of feeling the derivations of his mystical excitements. And hence you have an art which strives for an emotional experience within this newly uncovered stygian darkness. Emotions become an exaggeration of themselves, and the cleavage between the objective and the subjective is widened further, to the point where the artist abandons the articulate and, by a series of stutterings and onomatopoeic gruntings, tries to communicate the incommunicability of these regions of darkness. Hence we have expression, which daily rebels further at the inability of rational order to convey the essences of reality, and which attempts to voice unpolluted the emotionality of emotion. The surrealists, on the other hand, preoccupy themselves with symbolism, and the study of dreams and other atavistic, subconscious repositories of this, at once, new and old demonology, hoping that through ordering the symbols they can reconstruct the expression of this essence. In a sense they are attempting to bridge the impassable darkness between the world of the mind and the world of emotion.

Primitive art is therefore the manifestation of terror, the symbolization of man's basic horror of insecurity, in which the environment was a mist of terrors, darkness, and evil forces in both his waking and sleeping state while conscious life was the eternal fending off of the powers of evil who would destroy him. These basic emotions are expressed in the essential plastic elements, whose nakedness is commensurate with the basic quality of man's reactions. How he found these elements one cannot say, for history here lapses into conjecture.

The civilizations of the Nile and the Greeks had already effected a truce with these powers of darkness; those forces were apprehended in the terms of the familiar. Man mitigated their terror somewhat by the study of their properties. They still wreaked havoc, but man, through the order of his mind, learned to prognosticate and discovered his chances for evading them. They became anthropomorphized and could be cajoled and entreated, bribed and sometimes duped. Perception produces familiarity, and familiarity reduces fear. One fears what one does not know. This was close to the spirit of the Renaissance. Man was to complete what had only been begun. Knowledge, in the end, was to establish complete security.

Modern Art

MODERN ART AS THE REASSESSMENT OF ART EXPERIENCE

The modern art movement must serve us as the springboard from which we can carry on our investigation. Born in the midst of a cultural spirit which has reevaluated the entire panorama of man's knowledge, it has applied itself to the task of doing that very service for the laws of art. This does not necessarily lead us to the conclusion that its function is simply to tear about and posit rules. Rather, it tears apart in its passion for achieving a synthesis close to that found at the springhead of art itself. In the process of achieving this synthesis, the modern artist has traveled through all of man's plastic experience.

What motivates this spectacular journey? We might say first that, fundamentally, it is the modern artist's identification with the intellectual structure of the age to look at nature in that particular way that necessitates tearing it apart in order to rebuild. Gone is the a priori unity, and he can no more accept the old as a basis of development than can any other field of thought. What has fermented more actively this whole tendency to tear apart is the modern artist's impatience with the tired and the prosaic in current painting. Weighing on the artwork are the centuries of accumulated trappings, relics, and conventions which have become so heavy and opaque as to completely hide the beauty of the body beneath. This might be blamed upon the lack of the myth, which no longer has the vitality, the faith, or the necessary intellectual corroboration for its continuance. With the myths having been destroyed—that is, the essential universe of symbolism having been removed—the continuance of those forms used in its expression, the heaping on of the decorative garments, serves only to emphasize the frailty of the tubercular body beneath.

Yet the absence of the myth cannot deprive man of the desire for heroic deeds. The Dutch, who had earlier discarded the myth, attempted to evolve a poetry of the mundane. Yet their poetry was shrill and prosaic, as men could not live long without gods. The plastic elements of these painters had no more poetry than the motivations inspiring them. Therefore new gods had to be created, and man sought to deify himself, his own mind, his own power, to find within his own nature the grandeur of conceptions and proportions which heretofore were symbolized within the realm of gods.

The new gods of the world of nature became forces, matter measurable in quantity and described in quality, relationships within a unity that was a further cog in a greater unity. In short, man attempted to create a unity through its dissolution—a unity of forces held together by a mutuality of function, rather than subservience to a single will. The notion of the ultimate was not abandoned but, through the study of human understanding, was declared unachievable. Heroically, man posited this unity as a limit to be sought after but never attained, and instead he pursued reality humbly through the establishment of relationships.

It was a kindred, abstract unity which modern painting sought and has achieved through its process of tearing down, although at great sacrifice in the expression of human passion. Shoulder to shoulder with other intellectual activities it has made its researches, first in the three-dimensional domain, and then expanded, with science, into the multidimensional. It has done this, however, with tragic abnegation for the human spirit, except for melancholy and nostalgic deflections for the happiness of man.

Therefore, in our analysis modern art is very useful because it directly examines the established relationships of the past centuries. For not only has it achieved the recapitulation mentioned earlier, but as a symbol of its joy in its researches it has always allowed the scaffolding to remain. Unlike the story of the Egyptians who secretly pulled the levers behind the statue of Moloch, these artists take pride in displaying the human quality of the magic of their world.

Modern artists have therefore taken all of man's plastic achievement and separated it into different antagonistic components. Therefore, in their abstractions they have carried the world of tangibility, and the tactility of the plastic world, to their logical conclusions, producing pictures which have made of the painting a thing in itself, as freed as possible from human associations. On the other hand, in the world of illusory painting, they have carried the pictures into the realm of its utmost illusions: the subconscious. And they have consciously made varying arrangements of the two simultaneously in the attempt to hint at the ultimate unity of these worlds—a unification we are yet far from achieving. In the sincerity of their search, having stripped these essences of all the obscuring traps, they have been able to give us notions of how the clock of art ticks. They have definitely provided for us of this age, therefore, the language for our re-apprehension of the whole world of art, in language and terms commensurate with our present knowledge and understanding.

It is interesting to note that those very same persons who decry escapism in art repeatedly warn us how impossible it is to escape from the exigencies of environment. The two positions are, of course, mutually exclusive. It does not need much examination to see that, of the two observations, only the second can be true. It is indeed impossible to see how man can continue to live and not make some sort of working relationship with his environment. One can go even further and point to the fact that man is incapable of a single act which is not the result of the effect of environment upon his personality. To say, then, that an artist has succeeded in escaping environment in his art is to credit him with powers of which a superman of yet unconceived dimensions might well be proud.

Man's adjustment to his environment may be of three types. He may take the easiest route and continue within its immediate dictates upon the lines of least resistance, he may struggle against it, be overcome and, as a result, perish, or he may defy its dictates and bend it to his own desires. In any of these cases he has encountered it, has grappled with it, and has proceeded to live with it. Environment is not a static thing, for every time man acts he has both augmented and changed it.

In the case of modern art, when it is accused of escapism and of not responding to the environment the explanation that is often made is that it is simply an evasion of competition with the camera. This explanation, in which the artist is rushing each day headlong further into obscurity pursued by a camera, may be fine for those whose notion of occurrences in life correspond to the sequences of the Tom Mix movies. I, however, do not know of anyone who is occupied at present in that chase. On the contrary, one may safely say that it is the camera that is chasing the artist. For man is too proud to remain the slave of an automaton, and so we find the photographer contriving little tricks to blur the objective accuracy of his machine to achieve for it the soul of paintings. So let the proponents of this explanation discover for themselves who is running and who is chasing.

It will be well, then, to dispose of the photographic or daguerreotypic bugaboo here and now. And this not only in view of what has just been said but also in view of what modern art has achieved. The proponents of this explanation forget that among the original fauvists was Derain, whose chief preoccupation in his best period was with representative art derived from the chiaroscuro practice found in portrait painting on Coptic tombs. And chiaroscuro is the heart of photography. Not only this, but Dalí and other surrealists have evolved the montage in which photographs pasted to the picture are a common device, and in the rendering of certain details they have excelled the camera in fidelity. And further, the abstractionists, being dissatisfied with the partial visual truth of the camera,

111

have pasted actual materials on their pictures in order to, in the words of Braque, "achieve greater certainty." If photography has taught the moderns anything at all, it is the poverty of the duplication of visual appearance as an end of painting.

It would indeed be a shallow mind that would visualize our current art from this point of view. For not only does modern art show photographic concerns, more importantly it actively engages with the myriad ideas in the contemporary environment. We know that all art is inescapably entwined with all the intellectual processes of the age in which it is functioning, and modern art is no less an expression of that state of mind than were Christian or Renaissance art of the intellectual aspirations of their own times. In an age that is preoccupied with the dissection of matter to arrive at the basis of its structural life, where all perceptible phenomena are being dissolved into their abstract components, art can do nothing else but follow the same course in relation to the laws of art. And the degree and quality of its analysis follows closely the working of the age's greatest minds in all other intellectual pursuits. When science was materialistic in the three-dimensional sense, impressionism was born; an approach to painting that is essentially a three-dimensional analysis of vision in relationship to the seeing apparatus and its subjective solution in our minds. When all investigation probed deeper and disintegrated matter even further, art followed suit and tore apart the art of all centuries to find the evolution of matter and spirit which brought about these plastic wonders. In this sense, modern art is a recapitulation of man's known art experience. This process also shows modern art directly addressing the concerns of the intellectual environment, which demonstrates clearly that it is anything but an escapist pursuit.

It has often been charged that modern art has torn apart but has failed to put the body of art together again. These critics claim that modern art in its investigation has lost contact with the human spirit and hence is no longer able to make valid interpretation of human feeling and contact, which, they say, is the end of all man's expressive functions. This may be so. We shall not stop here to argue either the premise or the conclusions. But even if these critics are correct, let us remember that the task that modern art admittedly has accomplished is gigantic. And even if these pioneers have not reached the promised land, they have led us to the mountains from which it could be viewed. So let us remember that man venerates his martyrs as well as his heroes, and sometimes the valor of the conquered is of longer memory than the prowess of the victor.

Our attitude toward, and use of, the lessons of modern art therefore can be quite valid without the making of those final appraisals, the accuracy of which, in our own time, we cannot in any case guarantee.

Primitivism

POPULAR PRIMITIVES

One of the most disheartening manifestations of popular misappropriation in the world of art is the present boom in the traffic of the primitives. Here is another example of how the misappropriation of similarly sounding words that have a contradictory meaning can be so misused as to create whole sciences and, what is more critical, markets, which are a veritable poison to the creation of a real art vernacular in this country. The word *primitives* has been applied since the time of Ruskin to painters such as Giotto, to the Byzantines, and to certain phases of Greek art that preceded the Hellenistic era. It is used by those misguided spirits who believe that developed, or "civilized," art is exhibited only in those works which are naturalistic and undistorted from the point of view of Renaissance romanticism — which is the only form of distortion they conceive as being compatible with civilized art.

In other words, the word *primitive* is today applicable to all the great vital art of classical, oriental, and Christian art, where distortion for the purpose of showing expressive and formal relationships was the dominant motivation in their creation. Modern art has put these "primitive arts" back into the category of mature and fully realized creations. It has removed the implication that they are the product of ignorance and it has, in fact, established their supremacy as art, placing as the highest objectives of art just those conscious simplifications and distortions; they are the proper and only domain of great art.

Now the word *primitive* has also been applied recently to those pictures produced today which are being discovered by sociologists throughout both this country and the world as a whole. These are pictures made by untaught people, amateurs who live away from the current of art centers and who paint very much in the way the whittler in our village whittles. These paintings, on the whole, contain a good deal of charm, great preoccupation with detail, distortion for the sake of the human and, particularly, the picturesque.

We can say that two philosophical notions lie at the center of the great appeal of these pictures. First there is, of course, the back-to-the-land movement and the romanticization put forth by such writers as Jean-Jacques Rousseau, who, in the idylls and the

naïve remarks of the peasant, finds the very soul of natural man. This discovery is made through some sort of devious connection such that the farmer, immersing his hands daily in the soil, undergoes some type of chemical action with the soil itself, which tinges his soul with naturalism. Therefore the vernacular, which so confuses the snatches of partial truths which leak into the hinterlands, marks everything which has the naïveté of ignorance, yielding an ambiguous result that is very picturesque and charming. This is much the same as baby talk, which is a parrotlike mixture of sense and nonsense, glossed over by the charm of cuteness. The resultant chuckle from the observer brings him wonderful delight in his recognition of being smarter than the baby, while at the same time his knowledge of the ingredients of this ambiguous mixture makes him tolerant, therefore having scored a double superiority over this harmless musical baby.

In this connection, they say also that children who create artwork automatically are primitives, and that their babyish renderings are really the *summa cum altima* of the soul and spirit itself. Nothing can be further from the truth. The paintings and drawings of children who work without any training and self-consciousness, which may happen until they are the age of six or seven, in no way resemble the work of these primitives. Their work shows an absence of nothing so much as of charm. Their work is gruesome, barbaric, animistic, and completely lacking in detail. It is barbarously expressive in generalities rather than in the manifestation of detail. It is typically around the age of seven or eight, when they fully understand the meaning and the usefulness in rewards which their childish charm brings them—as they are urged by their teachers to continue these lisping incongruities because they stir the association with childishness which the public expects—it is only at this point that their work begins in any way to resemble that of the popular primitives. If the really automatic work of children resembles any art, it resembles the paintings of the wildest of the expressionists, or the subjective abstractionists in their paintings, and the work of primitive races in their sculpture. But nothing is further from the natural art of childhood than the insipidity of the popular primitives.

What is more disconcerting than the enshrinement of genuine primitives is the spectacle made by a score of painters who have deliberately engaged themselves in the manufacture of baby talk pictures, through the influence of both the market and the sort of spurious reasoning we have been discussing. In their case, the notion of genuineness as being a worthy attribute of art is no longer available. They are the extreme of hypocrisy. What about the good Douanier? Henri Rousseau, they will say, was he not a primitive in our sense and at the same time a great artist? Here we come upon an example which will cause no end of contradictory discussion. But let us point out a number of differences between the Rousseau primitive and that of the more modern manufactures.

First of all, let us make the distinction between the one who simply is not taught and the one who does not learn. No doubt there are many examples of primitives wherein there is really an intellectualization and apprehension of plastic laws in relationship to generalization, whether they have been taught or not. A man may learn and evolve plastic means without having gone to school, just as a man may discard all of his schooling as being unsuitable for the expression of his notions of reality.

Rousseau, quite in contrast with all the other primitives, exploited the plastic notions of his age and produced a rendering of spatial reality which is directly in line with all the other expressionist painters of his time. Secondly, while many of his pictures are composed of multifarious objects such as his foliage, the principle of his painting is still generalization toward form, which is manifest through a highly specialized notion of simplification. The only thing that really binds him to the other primitives who claim a kinship with him is a certain kind of subject matter which does not really exist. For he followed the current fashion among French artists of going to far-off places for exotic subject matter, which was true of Delacroix, Gérôme, and Matisse, and he exploited these places not for the picturesque, but for their essential romanticism. In that sense he is closer to Matisse than to the primitives. And the sum total of his pictures, or of his best works, is not cuteness, but an essential romanticism which was heightened by exotic subject matter. It is true, some of his pictures do definitely contain a humorous anecdote, but on the whole this is not characteristic of his work, which avoids the locality of the genre as well as the intimation of the direct expressions of humor.

It is true that the popular primitives do make use of the tactile values and do make a plastic generalization. Yet this work is really illustrative, and the plastic artifices are simply sensual attributes which attempt to make poignant the generalization of cuteness. Cuteness, or the charm of the picturesque, while they may serve well for the fortification of our notions of superiority or tolerance, cannot be considered as a valid expression of anyone's notion of reality, nor do they even achieve the unity of great sardonic humor, in which the failure to perceive the unity of dignity or justice becomes a tragic preoccupation of deep-rooted skepticism.

The work of these "popular primitives" must be placed in a position of even less moving quality than sheer decorativeness itself, and below even the French frill painters, such as Boucher and Fragonard, in profundity. For these French painters' notions were romantic, and they visualized an ideal utopia of grace and largesse commensurate with some aspects of universal values. These faux primitives have not the decency or honesty to enjoy the particulars which even banal naturalistic paintings have. If any paintings can be placed in the escapist category of irrelevance it is the popular manufactured primitives of today. Nothing, therefore, can be a greater traduction of the truth and of all values than the placing

of the mantle of Giotto or the great animistic primitives upon the shoulders of these confectioners. Nothing would do greater insult to their memorable achievements. Even the cartoon has a dignity which these cannot lay a claim to, for the cartoon at least makes a generalization in relationship to type and therefore becomes a commentary upon human foibles, which, in its place, becomes a valuable thing.

PRIMITIVES AND FOLK ART

Folk art differs from the type of primitive art just discussed in that it is a traditional form rather than a manifestation of individualized cuteness. While folk art does not enter as an influence into painting to a very large extent, it sometimes furnishes prototypes for decorative detail which the artist may exploit. On the whole the plastic arts do not exploit folk art to the same extent that music or poetry does. In Mexico, for instance, the Aztec art is traditional art exploited by the painter. It is a hierarchic, traditional art, and cannot be considered a plastic art comparable to folk songs or tunes. Nevertheless, the subject should be mentioned here because of the confusion between primitive and folk art.

Folk art in general has obtained a great vogue today precisely because of our revived interests in what is considered automatism and the value of instinctive inspiration. Insofar as folk art is a manifestation of these attributes it is of course worthy of our study. I believe that, especially in the Anglo-Saxon and Germanic countries, the revivification of folk art is particularly significant, for it serves as a reaction to the artificial puritanism which the arts of those countries, on the whole, exemplify. For folk art has always been a strain of the vulgarly sensual, which is a fine reaction to the Victorian prudery that has been, let us say, a major deterrent to the development of the plastic arts in our country and in England. However, since the folk art of England and America is not particularly sensual, it has not been as important as its use by Shakespeare and by composers of music. In their cases, there was a return by means of folk art to vulgar sensualism, animism, and supernatural implications, which were allowed because of their traditionalism.

In the plastic arts, however, folk art's significance is slight and its attempted exploitation rests simply upon the old Rousseauian notion of the essential guilelessness and goodness of the peasantry and of childhood. This is, of course, a fable, for the actions of children, unless they are restrained, are full of ferocity, malice, and cruelty, much like what we see in their paintings. The influence of folk art in painting therefore is purely decorative, and it is useful in-so-far as the decorative element may refer indirectly to the animism of primitive thinking. As for a prototype for the message of painting, however, it is even more spurious even than the affected faux primitivism, although by no means as hypocritical.

Indigenous Art

The word *indigenous* is employed often today by those writers who are concerned with the study of the cultural state of our society. It constitutes an implied wish for an art which might be truly called an American art, in the same sense that there is a Spanish art, or a French or an Italian art. It denotes a self-consciousness about the dependence of our country upon the art of other lands. It expresses awareness that our most lavish esteem extends itself to the arts of other lands as well as to their traditions, and that the artistic products of foreign lands are considered more important than those of our own artists. This has passed into an almost axiomatic desire. Everyone wants an American art.

Just what would constitute an indigenous art is not so clear. There is no general agreement among the legion of its advocates. We shall try here to classify the various categories which have appeared. While there is considerable overlap, for the sake of discussion they may be roughly classified into two groupings: Regionalism and American Traditionalism.

REGIONALISM

Regionalism is the most powerful tendency in American art. This is a form of native art which is defined by geography. The country is divided into a number of sections. These sections are distinguished from each other by differences of landscape and occupation. They are also distinguished by differences in the history of their settlers and the historical conditions at the time of settlement and since. The proposal here seems to be to produce a genre and illustrative, historical art dealing with the reproduction of the appearance of the region and the dramatic episodes in its history. A combination of the two is finding great support from that segment of the fine art world that allocates wall space for murals in public buildings. The murals as well as the easel paintings in this style usually reproduce the scenery of the area along with the products, types, and occupations of the people in these particular regions.

The Midwest has been the most prolific in the production of such work. This coincides with the growing myth that the Midwestern rural scene is really the ideal representation of America, a sort of concession that the agricultural rather than the urban existence is the ideal state of American society; that therein we find the original American strain and character in its purest and least polluted attributes. The inevitable corollary is that the city is really a stain on the face of the American map.

AMERICAN TRADITIONALISM

This is a form of indigenousness that presumes to recognize the traditional factors which are necessary to establish an American art. These artists study the painting of the past generations in America. They choose good painters who seem to point to a style which they call American. They also advocate the anthropological study of the country's past for the discovery of shapes and symbols which would be characteristic of America and nowhere else. To this end we find studies of the American Indian and his art in the hope of identifying such forms. Mexico has been an inspiration in this respect insofar as the Mexicans seem to have incorporated the demonology of the Aztecs into their current mural productions with signal success.

In this respect the geographic notions seem to take a curious turn. To many the art forms of the Mexicans and other Central Americans seem to be more acceptable for emulation by artists in this country than the art forms of Europe, although in physical distance they are not much closer to us. Apparently longitude contributes more closely to indigenousness than does latitude. Or, we might say, it is the extension of the Monroe Doctrine to the realm of art. Even the art of the Eskimo, were it completely incorporated into our art, would be more acceptable than an influence from France.

France in particular seems to be in disfavor as a foreign influence. Its art is at once branded as alien and as a violation of the native trend. The schools of Holland and Britain are somehow not in the same danger of castigation. Why is it that the traditions of Bruges, London, and Venice, or the return to the Renaissance, are acceptable as the basis of an indigenous art, while the schools of Paris or thirteenth-century Florence are not? Why the Eskimo is considered closer to our current lives than the African Negro or the Australian aborigine is difficult to say.

In relation to the first classification—that is, Regionalism—there is also a notion of objectivity as exemplified by journalism. Undoubtedly the Currier & Ives print, which has recently been enshrined as real art along with other popular arts such as the cartoon and

comic strip, plays a part in the formulation of this tradition. So the motivation for this type of art comes really from a notion of literary objectivity as applied to a genre tradition of art. The folk and primitive arts, which have been discovered about the country, are also part of the influence in Regionalism. The whole movement is aimed at the production of a popular art whose accessibility to everyone will be a sort of further reinforcement of democracy. This ambition, however, has made them strive to give this popular art the station of great art.

Class-conscious political movements have mingled with both of these tendencies. Although they have extolled the genre and popular idioms for their democratic attributes, these advocates have a dialectical purpose which celebrates the heroic as well as the genre, which are really irreconcilable wishes. Their inconsistency arises from their lack of a myth for illustration.

The proponents of Regionalism and American Traditionalism are really basing their point of view on the basis of subject matter. Essentially their advocacy does not concern us. The particular subject matter neither lifts the picture into the realm of art nor does it destroy its efficacy as art. Two pictures may deal with a scene in Holland, let us say, even the same theme. Does that give them the same value as art? Similarly, a portrait of the same person by two different artists does not make the two pieces commensurate as art. In other words, it is the painting that determines its value as art and not the sitter. This is obvious enough. So when the advocates of these two genres put forth a certain subject matter as truly American, they must convince us by the convictions which their paintings carry, not on the basis of a political or social agenda.

I think that this can be seen more clearly when we study, specifically, the position of the traditionalists. We can include them in our study because, as a group, the traditionalists are also interested in finding indigenous shapes that would occur naturally in the use of local subject matter. Their position is more pertinent to our study, however, because they realize that American shapes and symbols become such when they have been convincingly employed by American artists. They are also looking for indigenous art forms rather than for illustrative materials.

It would be interesting from this point of view to survey historically the work of the great American painters, or representative ones from various periods, to ascertain what lessons we can learn from them. Take two of our earliest portraitists: John Singleton Copley and Gilbert Stuart. In the work of both of these Americans, who used American sitters for their portraits, we find artists actively emulating the work of their British contemporaries. Benjamin West, however, working at the same time, painted American historical scenes in the manner of French historical painters such as Jacques-Louis David and Jean-

Auguste-Dominique Ingres; a style perhaps arrived at secondhand through some second-rate British emulators of this same genre.

If we go somewhat further into this area, to Fuller and Morse, we shall find still other influences from either the school of Munich or the British. These influences find further and greater expression in the work of Thomas Eakins, Frank Duveneck, and William Merritt Chase. Now these are all contemporaries of Winslow Homer and Albert Pinkham Ryder. Homer seemingly graduates from the illustrators' field and is undoubtedly influenced by Eakins. George Bellows, a little later, is a descendent again of Chase. And what relation has Ryder to any of these, for his work is a mixture of Florentine and Pre-Raphaelite or Blake-like conception? Yet these men *do* constitute an American tradition.

It may be said that these painters shared the dependence upon European sources which was typical of all American culture at that time. This may be true, but is that a picture of American culture only? I think here lies the misconception. Examine any school or tradition of painting in any century, anywhere in the world, and you will find that the plastic genius is no respecter of geographical boundaries but goes everywhere and appropriates to its own use the most advanced plastic discoveries of the age. These plastic discoveries are an outgrowth of what preceded them wherever they arise.

Here we should examine the whole geographical point of view from a logical standpoint to determine its actual value. The geographical viewpoint argues that different localities have different environments. The artist is sensitive to his environment, and art is really the result, expressed in pictorial terms, of the interaction of this environment with the artist. Hence artists from different localities would produce art which would be different from one another. Stated differently, they would produce an art indigenous to their particular localities.

Let us grant these assumptions and carry them to their logical conclusions. A painter living in New York City between Avenues A and B actually lives in a different environment from one living between Avenues C and D. Logically, there should be a difference in their art quite apart from the effect of their personalities. Yet on the whole we might say that they are living in the same environment. Why? We may answer that the communication between these two sections is so easy due to their proximity, and the aspects of one flow so continuously into the other that we consider them to be a single environment. Now at what point is the distance sufficiently wide so that one would consider two different places to be different environments? The Bronx and Brooklyn might easily be conceived of as belonging to the same general environment because easy communication still exists.

Obviously, the factor which isolates a community from other coexisting communities is its communication with other places. To consider any section of our nation as

isolated and capable of complete, introverted indigenousness is therefore particularly ridiculous when newspaper, radio, transportation, and telegraph all connect us intimately with every section of the world. And to enforce an isolationism which does not exist is far more fundamentally artificial than the artificiality of alien influences, which these advocates of Regionalism so moralistically oppose. It might be true only of those backward regions like the Ozarks or Appalachia, where circumstances and heritage have caused the inhabitants to militantly oppose the introduction of newfangled influences.

The ridiculousness of this form of logic is all the more readily seen when we trace the origins of those great traditions of art which seem to us today to be the unique expression of the Italian or the Hollander or the Greek, whose particular relevance to their own environment our isolationists would emulate. In the history of art this sort of indigenousness exists in neither space nor time. Greek art is simply a slow evolution of the art of Egypt and of Crete, which were the great cultures when the Greek personality was a fledgling just trying its wings. It took centuries to disengage itself even from the common conventions and appearances of the Egyptian prototypes and is nonetheless Greek for that. And Byzantine art is simply the combination of the Hellenistic traditions in Alexandria, Antioch, Syria, Mesopotamia, and the Greek Peninsula itself. The elements of these artistic traditions were carried over bodily, and often faithfully reproduced, in the art of Byzantium. Similarly, the Christian art of Italy was achieved through the transplantation of these prototypes by artists who traveled from place to place, by itinerant missionaries, or by peddlers, and it was these foreign influences which are summed up in ·the work of Giotto.

The Renaissance masters violated even the integrity of time and found their inspiration from the dug-up fragments of Hellenistic art, copied by the artisans of Rome, and from the trophies looted from the East by the Crusaders. They were not ashamed to use these as models for their own work, as their only concern was the production of the greatest art: the culmination of all the knowledge of the past and present. No sooner did Flemish art flourish but it was in the hands of Frenchmen. Nor would Velázquez disdain the teaching of the Flemish Rubens or the Venetian masters simply because they were not Spanish. These traditions have little concern for geographical boundaries. Who would deny that Chardin has more in common with Rembrandt than he has with Watteau, or that Velázquez has more in common with Rembrandt than he has with his compatriot Murillo? Or that Watteau, in turn, has more in common with the Venetian masters than he has with Chardin?

We might well say that the work of Velázquez would not have been the same were he not a Spaniard. We might just as well say, however, that his paintings would not have been the same were he not Velázquez. It is undoubtedly true that a person is the sum total

of his equipment and the action of environment upon it. That is why the work of each man differs from that of everyone else. That is why Botticelli and Michelangelo, both living in Florence at the same time—in the same environment, appreciative of the same cultural and environmental factors—produced work which could very well be separated by several centuries.

A study of the work within any of the great, accepted traditions would find them studded with as many dissimilarities. Points of comparison for either can always be found. The significant fact is that within any tradition we always see the preoccupation with the most advanced plastic elaborations of the age, no matter their derivation. They may come from the next-door neighbor or from a distant place across the continent. In fact, to study the origin and the development of traditions is to speed with a streamlined train across time and space to the most unexpected places, with a rapidity which belies the conception we have of the slowness of their communication. What produced this speed of communication was the intense desire of these great artists to participate fully in the greatest work produced at any particular time.

And a tradition—a great one—is achieved when you have a body of work in a specific community, which can hold its place with the great works of art anywhere. Copley was a great contributor to the American tradition not because he was indigenous but because he was a great artist. The same is true for Eakins and Ryder, not because they reflected our civilization or because they were similar, but because they both achieved monumental results while happening to live in our land. They could not but in some way reflect our environment because they were part of it.

Only in the case of the very primitive races can we perceive the sort of indigenousness which the proponents of Regionalism and Traditionalism desire. This is true for two reasons: first, because the perspective from which we see their art is so distant that the view imparts a sense of homogeneity which an examination of greater detail would not substantiate; and second, because our lack of knowledge of the preceding ages, and even the civilizations which were contemporary with them, makes it impossible to trace the artistic borrowings. But as archaeologists continually discover, with every journey or conquest cultures find something valuable and pertinent, and immediately appropriate it for use.

We know, for example, how Diego Rivera discovered the school of Paris, as recounted by Walter Pach. At that time Rivera was a student in Madrid (considered indigenous then to a Mexican). Pach wrote a letter to a friend of Rivera's by the name of dela Roche, telling him of the new goings-on in Paris. And off Rivera set to see the new land of wonders.

The artist is like the explorer of the early Renaissance, always looking for new artistic riches.

America's coming of age. Consciousness of self—the desire to hang the portrait of one's own features on the ancestral walls—is indeed a human frailty. In truth we must condone it as one of those human failings which, on the whole, makes life more gracious for all the attendant unhappiness it may involve. In a sense, this self-aggrandizement is an expression of that laudable individualism which is the basis of our life here. Pride in acquisitiveness and ownership. At any rate, this desire is by now a formidable presence, and operates as a motive that cannot be ignored. The educator in particular must consider it, for in his hands lies the propagation and the nurturing of this desire.

In the field of art education in this country, the educator must consider two objectives. First, how does the practice of art contribute to the life of the child during childhood? Secondly, how does he prepare the child for his future participation in the cultural life of the community? How is the educator contributing to our tradition, and what development of that tradition is both logical and desirable? Are these virtues which we would like to develop further, or are there miscarriages of virtue we would like to correct? For the field is a serious one. Here we have the power of turning the machine in one way or another. The powerful effects of dogmatic teaching upon the direction of the society is well enough documented in the past, where the church and the state controlled education.

The educator must therefore examine all of these questions with the greatest regard for truth, and must be thoroughly courageous if the demands of fashion are not fully in accord with it. For unfortunately, the power of these demands is not proportional to their identity with truth, and injustice is no less compelling because it is not based on equity or fact. It is here where the educator must think clearly and take the issue solely upon its merits.

Obviously we cannot but look with envy at those societies where, within the span of a century or even less, a series of geniuses appeared who contributed endless pleasure to the world and who made the locations within which they worked synonymous with the greatest cultural achievements. We also look enviously at those ages, in various places, where the state, the populace, idealism, painting, and philosophy had a common rapport and a universal support; in short, a synthesis to which every person and every activity, no matter how humble or exalted, contributed. Such, at least, is the picture we have of certain times: the Greece of Pericles, or the Florence of Giotto, or the France of the cathedral. "Thirteenth century unity," as Henry Adams lovingly described it. These all constitute golden ages for us, and our desire for one is no less strong for all our doubts to its possibilities.

We can see that no society could very well continue to exist unless it had some objective as its ultimate dream. It is simply a collective manifestation of the creative impulse. The nostalgic reappearance of the golden age is the expression of the yearning of art— for only in its formal achievements is an age counted as golden, not in its actualities. Society profits most not when art at its highest applauds its appearances, but when it pictures its society's highest aspirations. The Renaissance was an age of murder. Greek freedom was based on slavery.

How truly unified these supposed unities were is open to question. Distance and the varnish of time obscure many painful differences, and the sweetness of the practice of nostalgia is something we cannot ask man to deny to himself. In fact, so desirable is the phantom of this synthesis that there is movement afoot to create one even if it does not exist. Germany has proceeded to do so. Of course, that sort of synthesis is unacceptable to us. We should like to achieve the benefits of dogmatism without its bitter effects. We want to eat our cake and have it, too.

Since we are a rational race, we feel that we must prove the desirability and the validity of the synthesis at hand. Hence, if facts do not exactly corroborate our desires, will it really matter so much if we warp them just a little? If some of the facts really contradict those desires, is it really so serious to forget them, when making an order which will do for us just what we want?

The best type of education in this country, however, and the one to which we subscribe, is that education which exemplifies the principles of liberalism. This is a set of principles which places utmost faith in the power of truth, developed as a result of the best available methods of investigation, and, to our mind, is the best method for achieving good. With this as our basis, we cannot accept a synthesis simply because it seems desirable to have one and because that synthesis seems to be the only one at hand. Therefore we must delay the satisfaction of this tempting dream, pending our investigation.

POPULAR ART

One of the most attractive features of a supposed synthesis is the universality of the message which art holds for the entire community of the time; that it speaks directly and clearly, to and for the great majority of its people. The attractiveness of such a notion is particularly seductive to a democracy, whose aim to make the joys of culture available for the greatest number of people is implicit in its philosophy. The image of Masaccio, therefore, acclaimed and borne by the populace with revelry and dancing through the streets of Florence to the church of Santa Maria Novella, and the suggestion that such great art was

acceptably addressed to so many, cannot but move us deeply to a wish for emulation. Yet was this a demonstration of the public's participation in, and appreciation of, the art of Masaccio, or simply of its love for spectacle? This populace was, but a short time later, no less enthusiastic about Savonorola's pyre of burning masterpieces. And think of the facility with which we ourselves can gather for any unveiling. Do we really know that the populace followed all the circuitous labyrinths of scholastic thinking, or did they accept both church and tyrant—and their paintings—with the same token of submission, and then stole their more immediately satisfying pleasures when and where the occasion afforded?

That the latter might be the case, lamentable as it might appear, is hinted at by what happened in Holland when the church and state were no longer in control of what should be loved and what should be condemned. We find in the good Dutch fold, who had won for themselves so dearly this independence, and with it a comparative right to use their tongues, less sympathy for all of Rembrandt's plastic peregrinations. Certainly Rembrandt need not have offended their sense of reality any more than Masaccio. Rembrandt's fate is similar to that of many other subsequent artists who had not the authority of a powerful patron to validate, with his approval, the mastery of their performance. And we find Ingres, David, Corot, Manet, Courbet, and Delacroix battling against the excoriating indifference or hostility of the populace. It appears that when the public evaluates art, the more realism in the work—the greater the apathy. It is idols that receive the greatest adulation.

Actually, a painting in those days was integral with ritual, and ritual with spectacle, and the masses wallowed in the whole willingly, and at times unwillingly. We do not know when they had the first opportunity to express their own thoughts. We need only remember that these masses were quite as enthusiastic about vandalism in the various opportunities for iconoclasm presented to them as they were about the spectacles for honoring works of art.

The whole notion that art should be a popular medium is particularly attractive to a democratic society. This society holds rightfully the faith that education can bring to many those pleasures of the mind which have in previous times been the exclusive pleasures of the privileged. It envisions the constant extension of the base in numbers of those who, through increased facilities for the seeing and practice and discussion of art, will actively and genuinely be moved by the creations of their contemporaries.

The desire that art function in this way has a sentimental root in our own particular democratic myths. We all love the newsboy who became head of his corporation, or the rail-splitter who became president, and, extending this notion, we are inclined to view with glowing love the musician who found his way to Carnegie Hall after years of playing

in speakeasies, or the artist who wins a place in the velvet-walled galleries after years of cartooning for a newspaper. The Cinderella story has for us a great fascination. What we have in these myths is a symbolic expression of the opportunity principle of democracy: that here through the free play of opportunity, the very humblest beginnings are not a preclusion to the most sublime achievements.

To deny this premise would be to deny the very foundations of our society, and to do that would be to end this discussion altogether. Yet the danger of this point of view is not in its corroboration, but in the extension of this truth to its converse. For some people would have it that only the humblest beginnings can reach the most sublime heights. It is very well to admire Lincoln because, in addition to being a wonderful president, he presents a lovable, heroic picture of overcoming adversity; his greatness as a statesman becomes more heroic when considered in light of circumstances overcome. Yet it would be an unhappy result if we were to say that Washington was not a great president because he came from an aristocratic background, and that Jefferson's democracy is suspect because he was reared in the opulence of a plantation.

Extended to the field of painting, we have a sort of inverse snobbery. This or that painting does not address itself to enough people hence it cannot be great art, at which point one must ask when the number of people who respond to it is great enough. Must it be one, ten, or a million? Or is a million enough? The dangers of this type of thinking are obvious. From this point of view, the box office would become the measure of our culture. Maxfield Parrish would then be the true representative of American art, since his work would be found in more American bedrooms and parlors than that of any other artist. It would make the comic strip and the *Saturday Evening Post* an index to our culture. Now, art of that sort is to be found in every country in the world: *Punch* in England, *Judge* and *The New Yorker* in America, *The Illustration* in France, and similar examples wherever else you might go. Yet it is only in this country where these pieces are being varnished, framed, and put up as art. The arguments that are created by our critics to enshrine these cartoons as art, have the same philosophical validity as the cartoons themselves. As anecdotes or humorous comments, or as descriptive embellishments for the pages of a popular magazine, these illustrations still have far to go to exhibit the good taste possible for those purposes, but as art they become the tawdriest and cheapest commentary upon our abilities to think in any sort of terms.

It is really one of the most serious faults which can be found with the whole conception of democracy, that its cultural function must move on the basis of the common denominator. Such a point of view indeed would make a mess of all of the values which we have developed for examining works of art. It would address one end of education in

that it would consider that culture which was available to everyone, but in that achievement it would eliminate culture itself. This is surely the death of all thought. Should it not be, rather, that the means for perceiving the highest points should be the basis for evaluating and spreading our culture, rather than diluting our culture to meet the requirements of the present average level of taste and sophistication?

From the point of view of the educator, the extension of the base of participants in the cultural life of the community presents its own questions. What is clear is that this end must be achieved by increasing the number of those who, through opportunity, can appreciate and contribute to culture on its most exalted plane, rather than lowering the level of culture to the equipment of all. History has shown us the persistent vandalism upon cultural life, and with what difficulty and danger a few courageous souls have, through their devotion, preserved what they could and rekindled the flame when the social temperature allowed.

In conclusion, we wish to say that a great work of art might indeed be popular, just as it might be unpopular, and that unpopularity should no more be an index of its worth than an index of its lack of it.

To analyze the specific aspirations of the popularists would really be the most helpful method of ascertaining the value of their demands. If we examine the paintings of which they approve, and their programs for the achievement of those approved ends, we will find the following characteristics: the popularists will say that the themes should be close to the experience and knowledge of the spectator, and the themes should be expressed in a shape easily recognizable and enjoyable to everyone. So actually they have an identical program with those who would have genre art as the plastic expression of our culture.

Historically they have very weak substantiation because, during the entire history of art, the only known school to have accomplished this end is the Dutch genre school. We should note that we are speaking here of the lesser masters; the really great masters of that school did not occupy themselves with this objective. Further, we should remember that this school is at the tail end of the Flemish tradition, and that it incited nothing but violent reaction. For the entire story of painting thereafter is to renew the exalted and heroic quality of art which the Dutch had lost in their bourgeois, journalistic reporting of their own surroundings. The Currier & Ives print in this country is the logical outgrowth of this tradition.

In the two words we discussed earlier—particularization and generalization— we find the distinction, the all-consuming difference between what we can properly accept as art and what we term derogatively, and properly so, as illustration. And when we say "derogatively," we do not derogate those arts which definitely recognize their popular func-

tions. Our own great painters, such as Winslow Homer and others who began their careers as illustrators, saw the distinction between art and recording, and one cannot say that they themselves pretended to an identity between their work as newspapermen and as artists. They made a definite distinction both in their paintings and in their writings.

Instead, we dismiss that art which, while fulfilling all the functions of popularity, attempts—through advertising, or through the imitation of the sheer surface qualities and characteristics of generalizing art, or by appealing to some moralistic jingoism—to usurp the place of great art, as in the popular mind it always does. For we find these imitators of the great generalizations of the age by their concessions to the spectator's desire for the familiar, and by including the superficial characteristics of the new, reaping the monetary rewards that have been denied to the real generalizers.

For the spectator generally likes novelty, and loves above all the familiar to be presented in the garments of the latest fashions. These fashions, of course, achieve their popularity when the stream of art has moved further onward. In other words, the new becomes fashionable a generation after the new truth has been promulgated. Witness our own academy exhibitions, where the pictures are proclaiming, almost without exception, Monet's impressionism, or even our more modern galleries where expressionism is first finding support some twenty years after its greatest impulse became apparent.

In fact, there is not a single notion extant today, whether cubism, surrealism, or expressionism, that has not been employed for some alternative, popular use, whether advertising, propaganda, or decoration. Those traducers will now say that all of these movements are very useful because they have revealed new techniques which they can now put to use in the service of humanity, and since they are the ones doing so, actually their works are the works of art and the originals mere exercises.

We have already discussed this phase of the argument. But let us point out that every new step in the plastic continuity of art has been greeted in exactly the same manner, has been vulgarized for exactly the same purposes, and has seen its imitators seek distinction for themselves by the same sort of reasoning. If this fact was not so noticeable until the post-Renaissance era it is because the popular will had no spokesman and therefore left few records of itself, and also because the rewarding of the artist depended on patronage or the support of the state. But since the time when art was placed upon the open market, and particularly recently, when art must be sold in a mass production market, we find that this pattern holds true.

Rembrandt discovered that his patrons were not interested in his plastic preoccupations with light when he painted *The Night Watch*, and that they preferred the obvious illustrative gifts of his contemporaries and followers. Monet and Cézanne discov-

ered the same, watching Sargent and the exhibitors at the academy sell far inferior goods, succeeding because they adopted the French masters' method in its superficial aspects, while including enough familiarity so that the spectator reveled in the familiar while he was talking about the unfamiliar.

We find, therefore, that the basis of popular art is illustration. And it is the emphasis on, or rather the adoption of, the illustrative elements as the objectives of the picture which differentiates popular art from what we must here consider as great art. The function of great art is to produce generalizations, no matter whether they are derived from the particular aspects of our environment or from a purely imaginary source.

Of course, the relationship between the plastic arts and illustration is not always antagonistic. As a matter of fact, in every nation there are popular arts which exist side by side with the plastic arts. These popular arts derive their characteristics from the plastic art of the day, usually at a period which lags by a decade. That it, too, as a part of the vernacular, feeds the plastic arts is undeniable, and not necessarily an evil. Greatness has no biases as to the derivation of the objects which it employs for its creations, although it is impossible to foretell which one will be the fortunate one to be chosen. The vases of the Greeks, the little Megara statuettes, our own streamlined housewares, the window displays of our day, the general relation of our popular designs to the French tradition, all testify to both the vitality of the artistic tradition and to its influence upon decoration. It might be said that modern art is so used because its best function is really as decoration. What about the paintings on Greek vases, then, or the carvings on sarcophagi, or the opulent decorations of the baroque? Just because a piece of art can be used for the purposes of decoration does not mean that it falls short of greatness.

In general, as a result of this popular movement, it may be said that a tremendous confusion has arisen between the valid art of our times and decoration. Let us say here that there is no connection. The function of art is to express and to move. The function of decoration is to embellish. We would indeed have not a quiet moment if every one of our useful objects proceeded to move us, or inspired us to philosophize. It may of course be pointed out that art, too, is decorative. But let us say here without any hesitation: the decorativeness of art is spiritual and philosophical, adhering to and demonstrating basic laws. The decorative principle adds merely to our sense of sensuous rightness. We should of course expect a road sign to be pleasant rather than ugly. Yet the pleasantness is greatest when it merely performs its function without destroying its surroundings. Therefore decoration is the expression of good taste. A picture can be the direct castigation of good taste. Therefore let us beware of teaching art through the lessons of decoration. For in the pursuit of the body the presence of the spirit will be completely obliterated.

Index